THE STUDIO HANDBOOK FOR WORKING ARTISTS
A Survival Manual

Ross

I HOPE & TRUST
THE SHARED JOURNEY
OF THE BOOK WILL
BE FRUITFUL.

[signature]

THE STUDIO HANDBOOK FOR WORKING ARTISTS
A Survival Manual

by

Ted Godwin RCA LLD

illustrations by

Luther Pokrant RCA

Canadian Plains Research Center
University of Regina 2002

Canadian Plains Research Center
University of Regina
Regina, Saskatchewan S4S 0A2 Canada
Tel: (306) 585-4758 • Fax: (306) 585-4699
e-mail: canadian.plains@uregina.ca • http://www.cprc.ca

National Library of Canada Cataloguing in Publication Data
Godwin, Ted, 1933–
 The studio handbook for working artists

(Trade books based in scholarship, ISSN 1482-9886 ; 6)
Previous ed. has title: Messages from the real world : a professional handbook for the emerging artist.
ISBN -88977-141-3

1. Art--Vocational guidance--Handbooks, manuals, etc. 2. Art--Technique--Handbooks, manuals, etc. I. Pokrant, Luther, 1947–
II. University of Regina. Canadian Plains Research Center. III. Title.
N8350.G643 2002 702'.3 C2002-910463-7

Cover Artwork: Luther Pokrant
Cover Design: Ted Godwin

Printed and bound in Canada by Houghton Boston, Saskatoon, SK
Printed on acid-free paper

TABLE OF CONTENTS

List of Illustrations

A WORD ABOUT THE ILLUSTRATIONS

There is an old saying that a lawyer who is taking care of his own legal affairs has a fool for a client. I suppose there is some sort of relationship to the thought behind this saying and my decision to get someone else to do the illustrations for this handbook. Being a professional, I have some notion of where my strengths lie. While there was no question that I could do the illustrations, there was also no doubt that my good friend Luther Pokrant could do a better job more efficiently than I could. It was a professional consideration that led me to the decision to consider and, ultimately, use the illustrator Luther Pokrant. Looking at the results, I am convinced I made the right decision.

—Ted Godwin

ACKNOWLEDGEMENTS

Having received word that my little book is about to go to press, I realize that there is one chore that I have overlooked. While many have spurred me on over the years, there are a few that have been absolutely pivotal in getting the book this far, and it would be churlish of me not to mention them.

As with everything I do, the silent witness and partner to it all is, of course, my wife Phyllis. It was my daughter Tammi Lynn Shanahan who was the first to collate and edit the material. She got it organized enough that I could see how much I was missing.

John Allan, the then Vice President of the University of Regina, brought the manuscript to the attention of the Canadian Plains Research Center, leading to its publication.

—Ted Godwin

Prologue

In 1985 a heart attack cut short my teaching career. As a result, the last great lecture—the one that would cover all the important "in the trenches" stuff that I had gathered over the years—just didn't happen. Somehow there had never been enough time to teach my students all the "street stuff" that can make the crucial difference between a winning and losing strategy. The simple basics of how to manipulate oil paint left no time for such mundane subjects as inventory, accounting, dealing with dealers, and crating works of art for shipping. It had always been in the back of my mind to do a "summing up" lecture series spelling out the "real life, in the trenches, front line stuff"—sometimes funny, sometimes tragic—that had been part and parcel of my journey. This little book is that series of lectures—and more.

In retrospect, the heart attack forestalling the lecture series was quite fortuitous. As it has turned out, the information and strategies in this book were far too important to waste on a one-time series of lectures. In the book I could cover most of the thorny subjects that

simply aren't, and probably shouldn't be, part of the regular curriculum. I could also touch on areas of concern that a professional artist must deal with as soon as success rears its ugly head. For me, the learning curve was drastic, traumatic, and immediate. Thrust overnight into the limelight, I was required to conduct myself in a professional manner in a game where I didn't know the rules. It was a situation that I would not wish upon my worst enemy. Hopefully the lessons of this book will be of some use to artists who will be able to avoid the pitfalls and profit from the mistakes I have made. The book is written as if I were having a studio conversation with a fellow artist. The anecdotes drive home some of the more important points; the aphorisms are meant to be thought—and smile—provoking.

This isn't another "how to" book. Rather it is a "what to" handbook written by a working artist for artists and those who wish to become artists. I hope and trust that you will find something of worth within its pages.

 # 1. Overview

Pretty well everything you need to know about the business of making art, plus some things you didn't want to know!

An ancient Indian treatise on art begins with the following tale of etiquette: A king summons the court sage and makes known his desire to learn the whole meaning of painting. The sage informs the king that he must first know the theory of dancing. To this he agrees because the laws of dancing imply the principles that govern painting. The wise man further insists that the king begin by studying music and song, for without a knowledge of all the arts, their effect on time and space cannot be fully understood, nor their purpose achieved.

MOVING BEYOND THE ART PART

So it is with the profession we have chosen. While your most important concern is the area of art you have chosen, the doing of that art is only part of the total reality that one must confront to be successful. In today's art world you must promote yourself. If you don't

believe in yourself enough to promote yourself, who will? Now if you are a promoter, you are also, by definition, a salesperson. Once you become a salesperson, you realize that you must present the "product" well. So, in addition to being a salesperson, you have to be a fine art framer, packer, and often a crate maker. Dealing with the foregoing means a working knowledge of carpentry, so you had better add "carpenter" to the list. This is a lot to juggle. To keep it all straight you must be an accountant: add "accountant." Finally you must be an office manager to deal with all the bookkeeping, inventory, and correspondence.

If the reader is anything like the writer, a reality check of this nature was not a welcome bit of news. When I was starting out, I thought all you had to do was make good art and someone (the good fairy, perhaps) would take care of the rest. Many young artists, seemingly unable to cope with such broad demands, leave important decisions in the hands of others. The problem with this strategy is that, if you are paying an accountant, an office manager, a packer, a framer, and a promoter, there just isn't enough left to make a living. You did plan on having your art support you, didn't you? (Incidentally, if someone does come along on the "good fairy" plan, do check out the size of their teeth. Most artists I know who have had experiences in

The longest journey begins with the first step.
—Lao Tsu

this realm have ended up selling their first-born to get out of the mess.)

Let me begin by saying that while these challenges may look formidable, things are not all that bad. I take pride in a well-built crate. Balanced books and up-to-date inventory can be almost as satisfying as a good painting. For better or worse, they are all part and parcel of being a professional artist. It was ever thus. I enjoy reading the account books of Auguste Renoir, Peter Paul Rubens, or Michelangelo Buonarroti; I often quote Renoir's observations on the subject.

THE GENESIS OF THIS HANDBOOK

Much of what is contained in this handbook I have learned the painful way. The lessons best learned were of the trial-and-error sort. I got into trouble and made corrections as necessary. However, it is a system I don't recommend, and, quite simply, it is what led me to writing this book.

Throughout my years as a practising artist, I always wanted a book that I could consult regarding practical aspects of the business on a "need-to-know" basis—a reference that would kick-start the process of dealing with all the disparate elements an artist must deal with. If I'm not making crates, how to make crates is the farthest thing from my mind. When crates are on the "to do" list, this little book provides just the sort of thing to jog my memory and bypass all the dumb little mistakes that I tend to make over and over again. It doesn't have definitive answers on all subjects, but it addresses the various issues an artist has to confront on a daily basis. This book will be of great interest to artists engaged in the day-to-day business of being an artist, as well as the traumatic transition from the cloistered environment of art school to real life.

Before getting into the nit and grit of it all, I suppose I should tell

you why I feel qualified to pen such a book. I am one of the last of a dying breed: a full professor of art in a North American university who got there via the streets without benefit of a degree. While teaching painting, drawing, and foundation in a university for more than twenty years, I sustained and maintained a full career as an exhibiting professional artist in public and commercial galleries. During the 1970s this often meant three one-man shows a year. This "double life" has provided me with a perspective that many have said would be of some use to other artists, and particularly to young, emerging artists. So let's get at it and get into it!

FROM ART SCHOOL TO THE STREETS—REAL LIFE

Once you have the degree that says you are an artist, the gentle life of forgiven deadlines is over. Welcome to a world that doesn't need you, doesn't want you, and, most distressing of all, doesn't have time for you—a world where there are already hundreds of others just like you waiting for their first break. Life for the young artist of today is more problematical than ever. How curious that with more opportunities there are actually fewer chances.

Life used to be simple. My generation took it as a given that we would work at something else to support our "hobby," just as we knew that if we didn't paint in oil we would be using watercolour. The way it was was the way it had been for the past four hundred years. We also assumed that somebody out there wanted us even if they couldn't support us. What a difference nowadays! It is exactly the opposite. Nobody wants you, yet there is a common belief that one can make a living doing art!

When you hit the street there is a whole new set of rules. For the most part, they are different from the ones you learned in art school. Fresh out of art school, I quickly encountered the wall of my

inadequacies. My initial reaction was to blame those to whom I had entrusted my education. I recall overhearing at a party a former instructor of mine relating the sad tale of how he hadn't been taught the right things at art school. While he was laying out his tale of woe, I was doing the same to another group. Had one of my students been there, he or she would have likely been doing the same thing. I have every confidence that there was a caveman who grumbled to another that he had never been taught to do "legs" properly. Whatever you were—or weren't—taught is history! Get used to it and get on with life!

Most of the topics I'll be covering in this book simply aren't art school material. There is so much ground to cover on the sacred side of art that there just isn't time in the classroom to cover the mechanics. When I started out, there was plenty about the art business that was a complete mystery to me! Some issues I managed to avoid for a very long time. I realize now that I was in complete denial. The last barricades to fall were accounting and inventory. Revenue Canada's investigation team was quite instrumental in helping me face the issues (see chapter 10 for the details). While it wasn't much fun—and an exercise in pain I don't recommend—it sure got my attention.

This book is a guide to ease the transition from a community where art is the only concern to the real world that we must live and exist in. In my experience teaching in a university, I found that there was precious little time to deal with the physical aspects of making art. The demands of the craft didn't leave time for the peripheral issues that professional artists must nonetheless deal with on a daily basis, such as accounting, inventory control, pricing, shipping, gallery relationships and responsibilities, dealers, clients, commissions, or studio concerns. I considered my mission successful if I was able simply to initiate a spirit of enquiry that ignited the learning process.

The process of showing your work to a prospective client or dealer can be daunting, humiliating, and unproductive if it is handled the wrong way and in the wrong spirit. Simply setting up a studio can be a frustrating experience. The advice and insights I offer on these topics are not carved in stone. Take what looks to be of use and adapt it in whatever way you find convenient to your situation. Perhaps there are parts that aren't relevant now but might be in the future. Perhaps there are parts that will never be relevant. I would like you to respond to this book in the same way that Picasso responded to critics of modern art:

We now know that Art is not the truth ...
but rather a way of approaching the truth.
—Picasso

Although all of the topics in this book are interconnected, it is certainly not necessary to begin at page 1. For that matter it isn't necessary to start at all. Put the book on a shelf in your studio and consult the appropriate section when a problem arises or when you feel like taking a break.

2. First things first

Talking the talk and walking the walk: the stutter and stumble part.

My career as professional artist spans five decades. Over twenty of those years were spent at the University of Regina teaching foundation, drawing, and painting at all levels. Over those fifty or so years, I've experienced (or know of others who have experienced) most of the joys and challenges that artists and artist educators face at one time or another: much of what I share in this handbook is presented in the context of those experiences and the stories which arise from them.

Initially, I suppose I should answer the question as to whether there is something of value here for anyone other than painter or draughtsperson. Let me answer that by telling you where I come from and how I got here. I certainly didn't start out wanting to be an abstract artist. My idea was that I would live in Vermont, smoke a pipe, and make *Saturday Evening Post* covers. I had it all figured out.

In my second year of art school, I was privileged to see an exhibition of Lawren Harris's arctic sketches. The experience was an

epiphany for me, and it really let me see for the first time how spiritually evocative and powerful art can be. At this time, I also discovered the joys of sculpture and decided to commit my life to sculpting. I came out of art school a fully committed sculptor with a full set of stone-cutting tools. Once I hit the streets, however, I found myself living in premises that didn't have the space or storage facilities necessary for the pursuit of sculpture. The few things I did make were too bulky to move. The clay pieces were too large to get fired. If I did manage to get them fired, I didn't have room to store them. I figured out that if I was going to stay alive creatively, I would have to do flat art. It was so much easier to store, and I could bring it out and put it away at will. Thus I became a painter. My experience is certainly not unique.

A PROFESSIONAL ATTITUDE

By my third year in art school I was working in a studio and looking for places to exhibit. The first "biggie" was being accepted in a juried show for emerging young artists held by the London Ontario Gallery. This was a big deal for a twenty-two-year-old from Calgary. The show toured nationally, and a year and a half later, I happened to be in Regina on the very day it was opening. Kenneth Lochhead, who taught at the school, informed me of it and invited me to the formal opening in the evening! Thank goodness I had the presence of mind to sneak into the gallery in the afternoon to have a preview of the show. The proud young artist who strutted in turned tail and ran upon viewing his work among the work of others! The actual paint application was okay, but subject matter, framing, and title were one embarrassment after another. The painting was a small, horizontal, one-by-two-foot depiction of people with very small heads holding up lengths of cloth and fighting over them. The title of the work was *Bay*

Day. To this day I can hardly believe that I had priced it at $99.99! The final humiliation was the frame. It didn't quite meet at one of the corners. Seeing it, I remembered a late night finishing off a frame that only met on three corners. With time running out and no more money for framing, I said to myself: "Maybe three is good enough." It wasn't, and it never will be.

Painting and frame have long since been destroyed, but the story is still fresh and reveals some of the pitfalls a young artist might encounter. I was so embarrassed when the work returned that I destroyed it. Silly me. What was $99.99 back in those days is now up around the ten-grand mark and I am kicking myself for having destroyed it. In this game, stupid can definitely beget dumb.

A year and a half had passed between painting the work and seeing it on view. In that space of time, my style had advanced so dramatically that it was as if the painting had been done by someone else. In retrospect, I realize that I made four tactical errors:

- premature release of the image—when you decide to go public, make sure you are ready;
- treating the price as a joke was juvenile and unprofessional;
- unprofessional presentation with poor framing;†
- destroying the work without considering the implications.

Take yourself seriously in all that you do and always—always—ALWAYS think and act the way a professional would. Price the work

† Some years later I had the good fortune to be at a workshop led by Barnett Newman and his words still ring loud and clear. When asked how young artists could make a name for themselves, his answer was beautifully simple and very clear: "Make good paintings." As an afterthought he threw in "and hide as long as possible." Much like the old New Yorker joke where the violinist asks a taxi driver how to get to Carnegie Hall and gets the reply: "Practice, man, PRACTICE." Barnett Newman's final words on the subject were: "If the paintings are good enough, you don't have to find them ... they'll find you." It doesn't get any clearer than that.

as a professional, and always present the work professionally. There are side benefits to operating this way. You can sometimes get away with a real stinker of a work if it is well framed.

Life for the professional artist of today is very different from what my colleagues and I encountered. When I was starting out, life for a young artist was simple. We knew that there was no future in our trade and we immediately sought ways to augment our income so that we could support our habit. Galleries of the day were actually embarrassed to charge the artist twenty percent commission in the event of a sale. Balanced against this was the knowledge that until you had practised your craft for a sufficient number of years, there was just no sense in even thinking about selling your work in a commercial art gallery. Today it is not uncommon for an art student to have his or her first "one-man" show in a commercial gallery in the same year that he or she graduates or even before. The young artist, therefore, doesn't have the luxury or advantage of a protracted apprenticeship. Currently, it is not uncommon for New York dealers to receive a sixty percent commission fee and I have heard of even higher commissions on full studio buy-outs. The poison pill of studio buy-outs is that—while the dealer does create interest in and promote the artists—when the dealer's financial goal has been realized, the artists may very well be left

God, the king of artists, was clumsy.
—*Auguste Renoir*

with a price scale so high that they can no longer sell their work. These are just some of the pitfalls that one must be wary of.

IMAGE CONTROL—KIND OF

Let's look at image control. A studio is the only place where the artist has control over the work. Once the works leave the studio, they are on their own and, while we wish the best for them, we can never be sure that they will be well treated. The client who buys them can destroy them at will as in the case of Robert Rauschenberg, who bought a Willem de Kooning pencil work on paper for the express purpose of erasing it. Although it was done with the permission of de Kooning and was retitled *an erased de Kooning drawing*, the message is still clear: once the work leaves the studio, it is no longer controlled by the artist. There is also the case of a collector (in Pittsburgh, if I recall correctly) who bought a David Smith sculpture and, not liking the colour of the raw metal, painted it bright orange!

Artists in Canada appear to retain copyright unless it is expressly mentioned as part of the sale price. However, there is a wide gap between theory and practice. An oil company reproduced one of my works without my permission, without remuneration, and without the lower third of the work! To this day, they believe they did me a favour by exposing my work to a wider audience.

Andrew Wyeth's painting *Christina's World* was sold to the Metropolitan Museum of Art in New York for something like $2,500. Informed hearsay twenty years ago estimated that the Met has made well over a quarter of a million dollars in profit from the sale of reproductions and, of course, they still have the original work. That was twenty years ago and they still market the image in a variety of ways and formats. If one only knew which image would become a big money-maker, it would be a simple matter to copyright that work and

start looking at Caribbean properties. Unfortunately, life doesn't work that way. Faced with copyrighting images on a "shotgun scatter" approach, most artists throw up their hands and give up.

Sometimes the stories have comic opera overtones and sometimes the stuff of high tragedy. The only given in the game you have chosen to play is that you are sure to gather a few laughs and some pain of your own. A successful western artist who was known as a painter was given a box of clay. He messed around and came up with a cowboy head. A Texan who was in his studio to purchase some other work saw the head and enquired as to the price. The artist explained that the work wasn't for sale. He was just messing around with the stuff—and it wasn't even fired yet. The Texan's reply was "everything is for sale" and, offering $600, bought it. Some months later, the artist discovered the Texan had made an edition of thirty bronzes of the head which he was selling for $900 apiece. The artist immediately bought one to keep as a reminder for the future.

Money isn't the only issue concerning copyright. As my good friend Morris Shumiatcher has observed to me on more than one occasion, the price one pays for an item is often directly related to the way one treats it. This observation is borne out by one of my own experiences. The story follows.

A number of years ago, I happened to notice that the slide library at a university Fine Arts department included some of my work. Since I had not been approached regarding the acquisition of slides of my works or copyright payment for the same, I decided to look into which works were there. As it happened, the slides were copies of reproductions from an art book I had been included in. Since the book was a Canadian first, the publishers had scrupulously adhered to copyright concerns. Each artist reproduced received reproduction rights payments, while the works themselves were all treated quite respectfully

He who persists in his folly shall indeed become wise.
—Egyptian proverb

with full-page, full-colour reproduction. The slide library was not quite so respectful. One of the slides had been incorrectly mounted on its side and two had been cross-titled. Not only had I not received copyright payment; in addition, my work was misrepresented because someone had not been careful enough in preparing the slides. This story more than anything else illustrates the dimension of the problem. When the priests in the temple (remember, this was a Fine Arts slide library) have little or no professional ethics-cum-respect, how can we expect people outside to behave in a different manner? Sometimes the stories do indeed have a dark side. Following is yet further evidence that artists—young and old alike—need to be wary of those who do not respect their right to compensation for their work.

With rent overdue and no food in the house, a young artist I knew went door to door with his materials doing on-the-spot pastel portraits of anything—children, dogs, cats, whatever. He finally connected with a small portrait of a child, and after completing the work, was told to come back for his money in two days. Being a trusting soul, he agreed. When he returned two days later to pick up his money, they insisted that they had never seen him before. A growling Doberman pinscher prevented him from pressing his suit.

An artist who had established an area of trust with a dealer was

advised that the gallery had been sold. Prior commitments were such that he was just about to have a show of twenty-eight works priced at $2,000 to $2,400. The new owners had the show, sold the work, declared bankruptcy, and disappeared from sight, leaving the artist with zilch.[†]

The anecdotes above are not intended to make you reconsider your career, nor are they indications of how you should approach life. It is my firm belief that the true innocence and purity of spirit that is the foundation and basis of the career you have chosen can be maintained, albeit with some difficulty and a bruised ego. This, I believe, is one of the prime functions of the studio. It is the only place where the artist is in complete control.

THE STUDIO AS "TEMPLE"

The "temple" aspect of the studio cannot be realized if you are making art on a kitchen table. Your career will accelerate if you begin with the premise that you are a real professional artist, not the Sunday afternoon variety. So, the first thing you have to do is set a space aside where you make art and only art. Create an environment conducive to the making of art. Over the years I have gathered an impressive array (for me, at least) of objects and things that help define the space as a studio. I look upon them almost as icons or spiritual relics. There is a red wooden chair I have had for some thirty-odd years. It has been in and gathered memories from every studio that I have had since I acquired it. For me, the mere act of placing that chair in an empty space automatically transforms it into a studio. There are photographs, old unusable paint brushes, and other objects too numerous

[†] For yet another sad tale of artists left unpaid when a gallery closed, see the *Globe and Mail* article in the appendix on page 250.

to mention. All contribute in their small way to "sanctifying" the space. Music has always been a part of any studio I have had and is an active ingredient in many artists' studios. Let the music fill and activate the space. I don't use earphones in the studio. The experience is just too private. It seems to me that at the best of times the studio, the painting, and I almost become one in the act of discovery. With music filling the space everything seems to operate better—a small point but worthy of mention.

Since the studio is an extension of the most intimate, private space of your mind, it becomes in its nakedness the most vulnerable. When your space is attacked, it is also a frontal assault on your innermost personal beliefs. If someone parks a bicycle or motorcycle in your studio, it ceases to be a studio. Be extremely guarded and most careful about who or what you allow to enter the space. It is your temple, and your place of worship. You must decide whether, how, and when an individual or group of people will be given the freedom of your studio. For instance, do you allow a critic or gallery director to view works that you haven't completed, knowing there is the distinct probability that they will be commenting critically about those works, possibly changing the intent of the work by doing so? A studio is like the interior of a mind. If I can't avoid a critic or art writer coming into the

We invent the past and remember the future.
—Isak Dinesen

studio, I make very sure they see only what I want them to. If I can avoid it, I try to keep groups out. By the same token, you should respect the right of others to privacy. Always wait to be invited into their space. I stand at the door of a studio until the person whose space it is invites me in.

The final word about the studio is best illustrated by an incident during the Emma Lake Workshop conducted by Barnett Newman. It was raining continuously on the day in question and there were only three people left in the studio: Newman, a young student who had been allowed to stay for the workshop after summer school, and myself. With my brushes cleaned and put away, I left Barnie talking intently to the young student. Opening the door for the dash to the kitchen, I was startled to see Barnie's wife, calmly standing outside, getting drenched to the skin. I held the door open for her and suggested she come inside to wait. I will never forget her wistful smile or the quiet "No." Barnie, she explained, was talking to someone and she didn't want to "break" the space. Interesting that one of the most important lessons I was to learn at that historic workshop should come from such an unexpected source!

The studio is your private temple. Give it the respect it deserves.

SUMMARY OF TOPICS COVERED IN THIS CHAPTER:

1. A number of things not to do.
2. A brief discussion of copyright.
3. Some examples of how artists get ripped off and how to avoid it.
4. The studio as temple.

 Notes

Anyone can make the simple complicated.
Creativity is making the complicated simple.
—*Charles Mingus*

 Notes

Always dream and shoot higher than
you know how to. Don't bother just to be better
than your contemporaries or your predecessors.
Try to be better than yourself.
—*William Faulkner*

3. Studio options

Design considerations and setting-up concerns.

An artist can expect to have a number of studios varying in size and suitability throughout his or her career. For the most part, these will be "make do," temporary spaces with one constant: they will always be less than perfect.

Downtown and industrial-site studios seem to be most desirable, but they have their own problems. You'll realize this as you struggle down six flights of stairs with a large painting that won't fit in the elevator. With a downtown space, you are also at the mercy of the person from whom you are renting. Slight shifts in the economic climate either create studio space or erode what you have been enjoying. If you can afford the space, there is probably something wrong with it.

On the other hand, having a studio in the place where you live seems the perfect solution only until you've tried it. Life can be somewhat trying when you're either bringing your work out, putting it away, or tripping over it! At any rate, each new studio will necessitate a rethinking of the problem of making the space work for you.

OPTIONS

Here are a few basic guidelines and principles concerning studios that I've found useful. First and foremost is the principle that the "studio" exists as a space unto itself dedicated to the making of art—some place, *any* place, that is set aside specifically for the act of making art, wherein only art and art-related activities happen. With that as a starting point, the solutions are as varied as the spaces themselves. Anything from a basement to an attic and all the spaces in between (such as a pantry in an old house) may be considered; perhaps a jog in the living room or a bay window leaves a usable space that can be co-opted. If such is the case, something as basic as a bamboo curtain or a rug arranged vertically or horizontally will define the space. Whatever it is that defines where living room ends and studio begins is secondary to the actual act of creating and defining the space. With this solution, of course, the studio is always close at hand—sometimes a little bit too close. I've always found it difficult to concentrate on painting when other parts of my life are crowding in. I suppose there is a curious system of justice at work here. When artists are just starting out and can't afford the luxury of a studio somewhere other than where they live, youth gives them the energy to deal with the accompanying distractions. Then again there are those who seem to thrive

Life is a series of collisions with the future.
—Joséé Ortega y Gasset

on distraction. The American artist Stuart Davis had a rack of four televisions in his studio—all tuned to different stations and all playing at once.

Once some small successes begin to appear and it looks like you're in the game to stay, odds are you will want a studio detached from your living space. This generally takes one of two forms: a converted garage or some sort of space in the rundown business section of town. Both have their hazards. The warehouse-type space would initially seem to be the best, although some of my friends with studios of this type now travel to and from their spaces armed with clubs or chains after a few unhappy experiences late at night. A sign of the times, I suppose. At any rate, the benefits of a warehouse space are immediate and quite intriguing. High ceilings, lights, and water, not to mention the romance of a New York loft-like setting, are the chief perks. I have had studios of this type and, while I did enjoy them, I always ended up listening for strange noises at night. Who knows? Maybe the tension helped me to paint better. It certainly made me paint faster!

However, the glamour of a downtown studio wears a bit thin when you've forgotten at home something you were supposed to bring. There are also times when, after a frustrating day of false starts in the studio, the solution comes to you somewhere around midnight when you're in front of the television in your skivvies ready for bed. The notion of having to get dressed, warm up the car, and travel some distance before putting brush to canvas usually ends with inaction.

A garage, on the other hand, always needs a lot of work before it can be used as a studio—and I mean a lot of work! You will need lighting, insulation, and heating; some rafters will probably need moving; more electrical circuits will be called for; some solution to a water supply will have to be devised; and a good ventilation system is a must. If the garage is one of those new "garage packages," there is

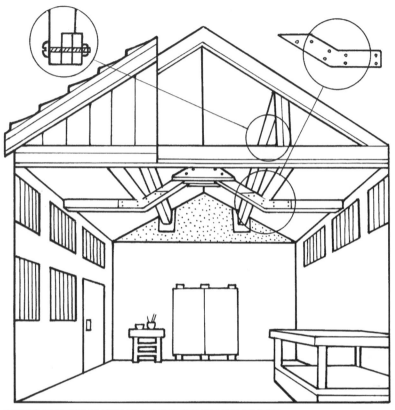

STUDIO INTERIOR SHOWING RAISED CEILING TREATMENT

every chance that the ceiling is too low. Now *there* is a problem. Do you raise it from the bottom or add on to the top? If you plan to use an existing garage, it will probably also have an existing dust build-up that should be dealt with before you start doing anything. Depressing, isn't it? Well, if you opt for a garage conversion, these are the kinds of basic issues you will have to deal with before you can even start to make a coherent plan of space use. Who said life was easy?

For the past decade, I have been painting in a converted double-car garage and find that it works quite well for me. My first garage studio had been used as a base for a plumbing, and subsequently carpentry, operation, so most of the major renovations had been accomplished by the time I got there. The only major additions I had to deal with were lights and a painting wall. It is only fair to mention, though, that a lot of grease, grime, and dirt had to be removed before I could do anything.

My present studio was in similar condition. Most of the amenities were already installed. The major issue I had to deal with was a low ceiling, a feature that most garages share. The accompanying drawing illustrates solutions I have used or have seen used. If you are planning

CAR GARAGE CONVERTED INTO STUDIO
(8' CEILING RAISED 1'6" AND WINDOWS ADDED)

to use a typical "garage package" purchased from a lumber store, the ceiling will definitely be too low unless you happen to be under five feet. You will seriously jeopardize a successful tenancy of the space if your spirit and being are constrained by a low ceiling. Although it may seem a trivial concern, it can be very oppressive to continuously feel constrained in this way.

If you are working in a house, you will want to separate the painting section from the carpentry section unless you are working in a basement or don't mind eating sawdust for breakfast. The only sure thing is that, whatever space you have, something will have to be done to it! Even if you did find a perfect space, chances are you would still change something. And remember that, when it comes to evaluating a space for its potential as a studio, even "perfection" is a relative thing. For instance, I have never worried about the "north light" supposedly favoured by artists. I read somewhere that Seurat painted under artificial light because that was how his work would eventually be viewed—a very smart move on his part, I think.

MOVING FROM "SPACE" TO "STUDIO"

Establish possession of the space as quickly as possible. Before starting any renovation, it is important to make the space your own. My method of doing so is simply to make a painting in the space. Don't rush in and start moving walls right away; instead, "camp" in the space for awhile. Getting a feel for the best way that the space works will pay off in the long run. Because of the varied type of work that you will be doing, it is important that careful and considered thought be given to how the space can best be utilized.

After I've camped in the space for awhile, I draw a floor plan to scale. On another page, I make the widest possible list of activities I think I might be engaged in, and then prioritize these various

activities. My list might go something like this: painting, drawing, printmaking, carpentry, and sculpting. Next to each activity I make an inventory of all the paraphernalia associated with that particular activity.

PHYSICAL NEEDS FOR OIL PAINTING
1. Wall to paint on
2. Space to view work in progress
3. Taboret—palette, paint, etc.
4. Storage for painting materials
5. Canvas storage
6. Storage of finished works

PHYSICAL NEEDS FOR WATERCOLOURS
1. Sloped surface to paint on
2. Taboret—palette, paint, etc.
3. Paper and work storage
4. Water

PHYSICAL NEEDS FOR STRETCHER CONSTRUCTION
1. Storage racks for wood
2. Tool storage
3. Carpenter's bench
4. Construction surface
5. Storage after construction

DRAWING
1. Identical to watercolour

FRAMING
1. Identical to stretcher construction

CRATING AND SHIPPING
1. Similar to stretcher construction
2. Storage of old crates

Next, I assign space for each activity with transparent overlays on top of the basic floor plan. You may immediately assume that whatever space there is, it won't be enough. I attempt to solve this by putting activities against a wall and letting them expand out into the centre as needed. Using coloured felt pens, I "rough in" the sort of space that various activities might take when they are the dominant activity of the studio. Since I am a painter, my painting wall is the first consideration. Were I a print maker, it would be where the press is.

It is useful to try out different models. Perhaps the first one has the sawdust of the carpentry a little too close to the storage of the wet works. Maybe the drawing area is in conflict with the oil paint area. The most common mistake I run across is putting the access area of an activity on the left side of a right-handed person. This means that every time you want more paint, you have to turn away from the work to get it. By the time you get the colour mixed and turn back, you've quite often forgotten where it was supposed to go. It is also quite possible to mix the wrong colour. You would be surprised at how common a mistake this is.

After the basic floor plan has been completed, I can then start to assign storage areas for the various materials I will be using. Since I

The advantage of growing old is that you
become aware of your mistakes more quickly.
—*Auguste Renoir*

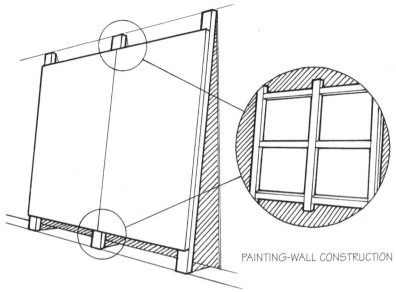

PAINTING-WALL CONSTRUCTION

have never had the good fortune of being able to have the same sort of space twice, I have found this to be a very useful exercise in making sure that I fully utilize the space. Generally, the artist's studio exists in a state of "organized chaos." There is absolutely nothing more frustrating to me than wanting to do something and being unable to find the right tool for the job. The number of times that I have spent thirty minutes looking for a tool to do a three-minute job is astounding. These adventures usually befall me after my wife has done me a favour and cleaned the studio. To the outsider my studio may seem to have no rhyme or reason. Nothing could be farther from the truth. Every tool, as well as every activity, is assigned a space, and where the tool is stored makes sense in relation to the activity with which it is associated. More importantly, I know where everything is supposed to be. If it isn't there, it might be anywhere. When planning my studio, then, I complete the plan by assigning general and specific

storage areas for the tools and materials needed for the various activities I've already determined will be happening in my studio space. Following is an example of such a list:

ACTIVITIES

1. Oil Painting

 Materials

 oil paint, sizing (gesso, exterior acrylic[†]), oil-paint canvas, benzene, turpentine, xylene, lacquer thinner, rags, metal container for paint rags, and Varsol brush bath

 Supports

 painting wall (fixed and movable) (illustrated on page 27), easel (sketching and studio) (illustrated on page 29)

 Tools

 brushes, rollers, trays, cans, compressor, paint sprayer, rag disposal can, turpentine brush bath, palettes

2. Watercolour Painting

 Materials

 watercolour paint, paper, and water[‡]

 Support

 drawing board adjustable to different angles

 Tools

 brushes, sponges, rags, pencils, erasers, pastels

3. Drawing—covered under oil and watercolour painting

4. Constructing stretchers

[†] Exterior acrylic is useful because it is manufactured with the #2044 family of acrylates. This means it is inherently "plastic" and not given to cracking like the #2046 series which is used for interior paint and is cheaper to manufacture.

[‡] While it may seem strange to list water as a requirement for doing watercolour, it is amazing how many artists start out to do watercolour in a studio that doesn't have water.

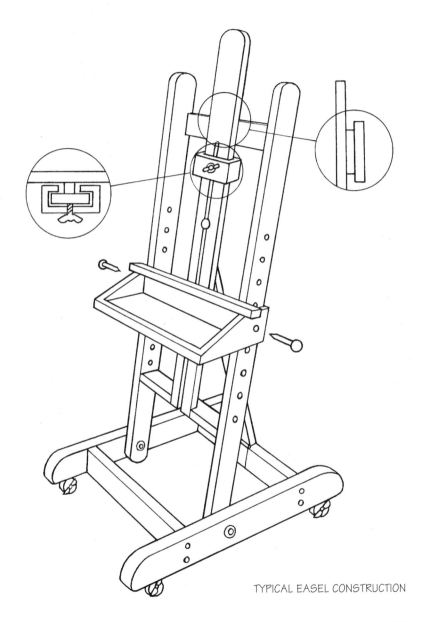

TYPICAL EASEL CONSTRUCTION

ENEMY NUMBER ONE: DUST

The worst enemy of the artist is dust. In a multi-use space such as a studio, this can be really deadly, as well as costly. A scarred or marred surface is often a lost sale. I deal with this problem in three ways. Frequent cleaning of the space is number one. Second, I have an exhaust fan which removes most of the sawdust in the air and paint overspray when it is at its worst. Lastly, I have put doors on most storage areas. The rest I try to live with until it gets too intrusive. When this occurs, I seal whatever I can seal, put away whatever I can put away, cover whatever it is feasible to cover, and do my best to isolate the area I am trying to clean. Next, I turn on the exhaust fan, put on a mask, open all the doors (if applicable), and, with the air hose compressor, flush all the dust off the surfaces on which it has come to rest, raising it into the air. If I can keep it in the air long enough, the fan does the rest. A good industrial-grade exhaust fan is an absolute must. Remember you are dealing with some fairly dangerous materials and exhaust venting the airborne pollution really helps a lot. Whether you are venting out a window in what used to be a dining room, venting a basement, garage, industrial space, or whatever, the fan is essential. Try to plan the studio so that activities that benefit from the use of the fan are as close to the fan as possible. There is a better than even chance that many of the solvents you will need to use are highly toxic. Prolonged exposure will do irreparable damage to your respiratory system and inner organs. For my part, I consider this risk to be one of the hazards of the trade and accept it, while being as sensible as I can in the use of toxic products. For those who have

respiratory problems, there are now air cleaners which seem to work well. I have recently installed one in my studio and for the first time in forty years, people remark how fresh the air is.

Each decision creates another problem. You can't avoid raising dust when you are building a stretcher for the wet painting on the wall. Dust is also cumulative. If you don't deal with it, you won't be able to walk into the studio without raising dust! I can sympathize with an early Flemish artist who had a rather unique way of dealing with dust. He had a room built below his studio with a removable trap door and a rug covering it all. He then suspended a chair from the ceiling above on a pulley. Built into the arms of the chair was everything he would need for a full day's work. As he sat in the chair with his materials for the day, his assistants would raise the chair, roll back the carpet, remove the flooring, and lowering him into the space, replace everything again, leaving him to work in the presumably dust-free atmosphere below—a trifle excessive, perhaps, but indicative of the dimensions of the problem.

My solution for the wet painting problem is a roll of plastic sheeting attached to an overhang above the painting area. I leave it rolled up when I am painting and let it down when I wish to protect the painting surface from dust of any sort. Mount your exhaust fan to the immediate right or left of the painting wall. Whether it is sawdust from construction, toxic fumes, or overspray from a final varnish, the offending material is drawn away from the activity surface and drawn outside. (There is nothing worse in a studio than overspray varnish dust: if it is on the floor, your shoes stick to it; on a brush, it is sticky and accumulates additional dust; on table tops, coffee mugs stick and paper gets glued.)

In my studio, I have arranged a plastic curtain wall so that it contains the overspray—in effect, a spray booth. An old drapery track

with some plastic tarps works well. The plastic that wood for lumber yards is wrapped in works very well. The mega-lumber store in my city assures me that I can have it for the asking. Large camping stores also carry the product as tarpaulins. It is re-enforced, lasts a long time, and tucks away fairly well. A simple sheet of plastic will do. My arrangement is set up so that I can have the curtain either straight across or redirected so that the painting wall is shielded. Most of the fine sawdust from the saw gets removed by the fan. Well, that's the theory!

Keep the space clean. Put covers over and doors on everything you possibly can in your studio. This will at least keep the dust in the centre of the room where you can deal with it better. When you are finished using the space for carpentry, clean it. You are no longer in art school with a janitor who comes around every day and cleans up your mess.

CLEANLINESS IS NEXT TO...

One of the great dangers of having a studio in or near the house is that its close proximity at all times makes it a constant temptation.

Remember that a painting — before it is a battle horse, a nude model, or some anecdote — is essentially a flat surface covered with colours assembled in a certain order.
—*Maurice Denis*

For instance, when I come home from a party, I'm almost always compelled to have a look at the painting on the easel before turning in. This is a very dangerous game. Inevitably, I end up doing a little bit of painting. While there is no denying the thrill of negotiating wet oil paint in an $800 silk suit, this activity still ranks number one dumb and stupid. However, since I'm addicted to my work, I always chance the studio before going out as well as upon returning. It is no surprise, therefore, that I often end up with bits of oil paint on my good clothes. I must admit that while I don't mind it all that much, it drives my wife to distraction. She has had a difficult enough time trying to civilize me over the years, so when I get paint on my clothing, I try to remove it before it sets. This is a two-stage process that goes as follows:

Step one: Remove the article of clothing and find a clear place to lay it down. Take a clean cloth which you have folded four times and place it under the stained part of the material. Take another piece of clean material and soak it with a penetrating solvent such as Xylol. Place the solvent-soaked cloth over the offending paint spot and apply pressure. Repeat, using a new clean part of the solvent cloth, pressing firmly. After three of four applications, refold the undercloth to provide a clean surface. Remove as much of the paint as possible in this way. If some paint remains, proceed to step two.

Step two: Damp the spot and using a bar of Ivory soap, work the soap in liberally. Take hold of the fabric on each side of the spot between right and left thumb and forefinger. While running warm water over the spot, agitate vigorously until the soap is well worked into the fibres. Continue until all traces of the offending paint is removed. You'll find that Ivory soap is a wonderful studio companion.

SUMMARY OF TOPICS COVERED IN THIS CHAPTER:

1. The importance of separating studio and living quarters.
2. A number of different studio possibilities.
3. Pros and cons of different studios.
4. How to design an efficient studio.
5. Dealing with the problem of dust.
6. Getting paint off clothes.

 Notes

Painting is easy when you don't know how,
but very difficult when you do.
—*Edgar Degas*

 Notes

Every artist dips his brush in his own soul, and
paints his own nature into his pictures.
—*Henry Ward Beecher*

4. Tools of the Trade

What it was, what it is, and what it means to us.

When I was a teenager, being a fine artist just wasn't considered an option for an occupation. The few who made their living at commercial art were the exception. Most of those concerned with art were of the weekend variety. Often self-taught, with little or no formal training, the "hobbyists" were not taken seriously as a market. Art supplies, therefore, were either of professional quality or of the quality relegated to school children. The situation had its advantages. Because manufacturers of arts supplies and tools had not identified a "hobbyist" market, prices were reasonable for those who considered themselves serious, and the overall quality of materials, when they were available,† tended to be quite good.

Today's situation is quite the opposite. The artist's materials

† "When available" was, of course, the tricky part of all of this. I recall the envy we had of someone who had been to Toronto, New York, or San Francisco, where they had real artist's stores.

market is driven by the wants of the amateur[†] or hobbyist. The concerns and needs of professionals are of little or no consequence to manufacturers. Combine this with the industry's penchant for patenting generic "look-alike" imitations and you get some idea of the muddle and mess we are in! Most of the nomenclature used for the various materials, procedures, and tools of the business is in the public domain. Apparently, names that are in the public domain can be co-opted by industry for materials that seem to be similar in texture and effect to the original material even though they may be vastly different. Simply put, this means that many of the items you are purchasing are not what they say they are. Art suppliers stock sable brushes that aren't sable, varnish that isn't varnish, and gesso that isn't gesso. For the hobbyist, whether the paint changes over a ten-year span or whether varnish is really varnish is of little or no concern. (By the way, sometimes varnish really is varnish.) The hobbyist may have heard the name "sable" associated with a quality brush. However, he or she is probably not aware that there is no such thing as a white sable brush, and more than likely, couldn't care less. For those of us who are professional artists, the quality of the materials we use to create art is of great concern. Following is a brief description of the "tools of the trade," how to care for them, and what to watch out for when buying art supplies.

THE SECRET LIFE OF VARNISH

The reason paintings are varnished is threefold: first, to impart a uniform surface to the work; second, to provide a protective covering for the work and last, to heighten the colour, making it richer. Varnish

[†] As professionals we should always remember that the word "amateur" comes from the Italian *amourtouri*, a literal translation of which is "one who loves." Those who don't make their living through art can afford such a luxury.

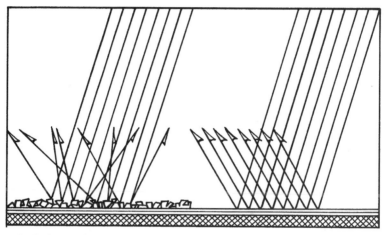

LIGHT BOUNCE OFF GLAZED AND UNEVEN SURFACES

is made when resin from a tree is rendered in turpentine to a liquid state. The traditional varnishes of *copal* and *dammar* are carried by fine art stores. Dammar is a soft varnish usually used on newly finished work, and copal is a hard varnish reserved for works that have gone through the maturation process of oxidation. It is the nature of oil to dull out. A coat of varnish immediately restores the snap, but, unfortunately, results in a shiny surface. However, you should avoid a product called "eggshell varnish" that claims to give a matte finish. It achieves the matte finish by blurring the entire surface. Emulsified waxes, ground glass, and other pollutants are added to the varnish to diffuse light refraction. Refer to the illustration above to understand the process. Instead, achieve a matte effect by spraying varnish at very low levels (10-15 lbs. pressure). Put the spray gun on a slight upward incline so that the varnish arcs onto the canvas, half-setting in the air. With a little practice, you can take the shine off the surface without blurring the image through junk additives.

VARNISH HISTORY

The history of varnish is interesting. There is no way you would want to have to deal with the original varnish. Back in the days of the Flemish masters, varnish was the newest magic on the block, even if it sounds like a horror story to us! Let's imagine that we are back in those times and see what it was like.

Our painting is finished and we are ready for the final "magic glow" to be put on it before we deliver the goods to the merchant who has commissioned it. As luck would have it, we have acquired a varnish ball through our master's connections in foreign lands. The luck is really holding because there's been a hot spell with no wind to speak of. This means that our painting has dried without too much dust accumulating on the surface. The hot, dry spell is holding and we are ready to varnish the work. After making sure that the work is absolutely dry, we remove the varnish from its leather pouch and hold it in our hands. The sticky ball of resin is about the size of a baseball. Even though it is really hot, we make a small fire and hold the ball of resin over the fire to soften it. When it is the right consistency, we tell our apprentice that we are ready. He holds the work firmly to a table

A painting is finished when to have done less would be considered a sin and more a crime.

while we bash the varnish against the surface of the painting in angled sweeps, leaving smears of resin on the surface of the painting. When we have enough on, we put the ball away and get ready for step two. Putting the panel on top of the stove, we let the heat permeate the entire surface. Once it is warm to the touch, the apprentice holds the work steady while we work the heel of our hand vigorously over the entire surface, distributing the resin evenly over the painting. When that is done, we leave it in the warmest place we can find to let it set, and immediately go to the church to pray for continued warm, calm weather so that it will dry without dust obscuring the surface. Dust truly is and ever has been the personal devil of the artist.

Well—I think you can see what I mean about a horror story. After I read that story, I gained a new appreciation for my ability to go to an art store to pick up materials. The artist of today has absolutely no idea of the difficulties that artists of the past had to contend with—or, for that matter, the consequences of those difficulties. I recall running across the following story that illustrates, as no other, the dimensions of the problem of varnish, dust, and the preservation of art in the past.

After World War II, a conservator was engaged by one of the German nobility to catalogue, refurbish, and clean up the works of art in the noble's collection. On his days off, the conservator would explore unused parts of the castle. While going through a section that hadn't been open for eighty-five years, he ran across a shutter that seemed to be particularly well constructed. Immediately he gave orders that it be removed and taken to his studio. The surface that had faced the elements for at least eighty-five years, and probably a lot longer, was a relatively uniform dark brown. Using a piece of alcohol-soaked cotton batting, he cautiously removed a little of the dark overburden in one of the corners of the shutter. What he found

beneath was—as he had expected—a painting. As he cleaned the rest of the shutter, he discovered that he had, in fact, found the missing centre panel of a triptych by the young Albrecht Dürer. The work was in very good condition and, at the time of its discovery, was the only known work in existence from the artist's early period. As far as I know, the side panels are still missing, but what a wonderful gift to have even part of Dürer's early work.

This story prompts us to ask two questions. First, what led the conservator to notice this shutter and search for the painting beneath the surface? The answer to this question is best explained in the context of the following—very brief—history of the artist's search for the ideal painting support. A caveman started the process of finding the best support using the stone wall of a cave to paint on and, in time, using the skins of animals and flat pieces of wood. Eventually artists joined together pieces of wood to create a larger painting surface. However, such a surface was often quite unstable since it would expand and contract as the seasons changed. By Dürer's time, this instability was being corrected by using elaborately constructed wood panels which had keyed horizontal pieces of wood running the length of the support on the back side. Sometimes the key supports were quite visible as in the case of this particular Dürer and sometimes they were concealed on the inside. Of course the wood still split, warped, and checked. The next step in the evolutionary process was to build the elaborately keyed panel and then cover the whole thing with cloth. From there, it was a relatively small step to leave out the heavy wooden structure that was all the bother in the first place and to stretch the cloth over the outside of a simpler and lighter wood structure. So that is how we got from there to here. Obviously the conservator saw the elaborate key setup on the shutter and knew that there was likely something of value on the other side.

The second question concerns how Dürer's painting came to be a shutter in a castle waiting to be rediscovered centuries after it was first painted. The answer to this question takes us back to our discussion of the history of varnish. In Dürer's day, the first varnish was probably the most damaging. During the drying process, which likely took a long time, the work picked up many impurities from the air. A second coat of varnish, with its liquidity, might seem to solve the problems created by the initial varnish; but, of course, on drying, it served only to exacerbate the problem with more impurities and clouding. Successive coats of varnish finally led to the point where there was no discernible image left. The work itself—too sturdily built to throw out, but quite useless as a painting—transformed into a very well-made shutter.

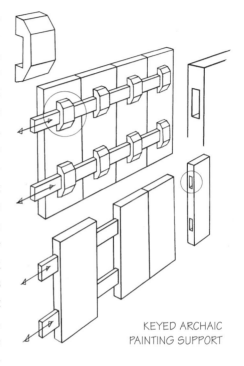

KEYED ARCHAIC
PAINTING SUPPORT

BEWARE THE IMPOSTERS

There is a good chance that what your local art store is selling as varnish isn't. It is most likely N-butyl methyl methracalate cut with a solvent to the correct consistency with some colour thrown in to approximate the look of real varnish. It has enough similarity to real

varnish for the paint industry to call it varnish. The problem with this is that "similar" isn't good enough for the professional artist. "Real varnish" will start out clear and gradually age to a lustrous golden glow. N-butyl methyl methracalate stays the colour it sets to. "Real varnish" is put on and "stretched" with repeated strokes. Not so with the imitation. "Real varnish" may be removed with turpentine. N-butyl methyl methracalate may be removed by using a solvent with a sufficiently high eutectic† that it will re-liquify the acrylate.

Real varnish is still available but difficult to find. Spar, coach, or marine varnish are the names that I look for when I am after the real thing. Even then, I tend to spend an inordinate amount of time reading and rereading the label to make sure that what I am buying is real varnish and not something else using a name that just happens to be in the public domain. I still am taken in occasionally. A little while ago I bought a gallon of stain that I thought was oil based. On examination at home, it turned out to be acrylic water-based.

Similarly, the gesso that is sold in art stores isn't real gesso. It is also a petroleum distillate plastic formulation, an acrylate with characteristics similar to the "real thing"—not quite as good in some ways and better in others.

What is sold for lacquer is actually pyroxylin. Of all the "look-alikes" we have, this is the poorest substitute for the "real thing." Lacquer is a product that comes from the Lac tree which grows only in China. Incidentally, shellac is made from the crushed shells of a beetle that lives only on the Lac tree. For many years, the penalty for smuggling lacquer or anything to do with the Lac tree out of China was death. The properties of real lacquer are so wonderful they defy

† The term "eutectic" refers to the critical temperature at which something changes from one chemical state to another. The eutectic of water is 0°C. This is when it changes from the solid to liquid state.

comprehension. When the Chinese excavated a tomb that had been under water for eight centuries, there was a small lacquer box floating on top of the water. The excavators were amazed to find that when the outside was dried off and the box opened, it was completely dry with no moisture in the raw wood interior.

The artist is an adventurer and any new artistic material is an occasion to begin another voyage of discovery. While it is important to remember the dictum that "play is the work of the artist," it is equally important to remember that an artist is a professional. As such, there is a code of ethics which must govern the production of your work. Don't sell the collector short. Be suspicious of new products and don't simply accept what the manufacturer says. Check the product carefully. Use it professionally only when you can be sure that the product that ends up with the collector will be of a lasting nature.

SUPPORTS

There are two types of supports: fixed and temporary. Temporary supports are used as interim measures to maintain a stable, suitable surface for the artist to work on. It is one thing to have a stable surface and another to have a suitable surface. For the most part, artists are sensual beings. There is an intimate, interactive relationship between brush and stretched canvas surface that is very satisfying when "right." Stretched paper also has this sensual give, imparting an additional overburden of liveliness to the sable brush. One would think that a hard, unyielding surface such as wood would be more suited to the ministrations of palette knives and the metal of putty knives and usually it is so. I have found that sizing birch plywood is the exception. The tight, smooth grain of the wood in tandem with a coating of shellac produces a surface that is very responsive to oil and pig bristle. Birch was the choice of wood for the early painters of land-

scape in Canada and I can see why. I cradle all my birch panels. It stabilizes the wood, and makes it look a lot classier. One should use brass screws so that they won't rust over time.

Using oil will necessitate separating the canvas from the paint with a ground. For the most part, the artist will be using an acrylate preparation such as commercial gesso or exterior latex to size the canvas. Using acrylates creates a new problem. The canvas will appear taut when initially stretched, will become very taut with the application of the acrylate, and will subsequently sag, making it impossible to paint on. Stretching the canvas tighter initially is of no use and may even result in the stretcher being destroyed by the tightening canvas. Let me explain why. In setting, the acrylate goes through a two-stage process. Once the water evaporates, the droplets of solvent that

CRADLED SUPPORT (PANEL)

maintained the liquid state evaporate, allowing the acrylate to set. With the water, the canvas tightens, and with the plastic, it sags. If you persist in working on stretched canvases you will have to get used to double stretching.

My solution is to work on a painting wall, stretching the work after it is finished. Working this way has its advantages. There is always a solid surface to work on, and I can decide where I want the work to begin and where I want it to end. I have always found it troublesome when working on a stretched canvas to discover three-quarters of the way through that the painting's natural size was smaller than the canvas it was on. Faced with waiting for it to dry, taking it off the stretcher, building a new stretcher, restretching it, and having a canvas stretcher left over, I always opted for reworking the canvas and trying to make the painting fit the surface, ending up with extra work and a painting that was less than it might have been.

My painting wall is composed of five ¾" x 4' x 8' sheets of poplar plywood, and is angled out slightly from the wall (illustrated on page 27). It is important to use a soft wood such as poplar or bass to avoid ripping the canvas while trying to get the staples out of the wood, which can be a problem with a harder substance such as fir plywood. Were I to make another painting wall, I would add a one-foot grid of black marker on the surface.

The system for stretching paintings which I have found to be the best is as follows. Using 1" x 4" spruce (which is really ⁵⁄₈" x 3⁵⁄₈"), I rip[†] it lengthwise on an angle of about 15° to 20° with a height of 1½". Ripping the remaining piece to 1½", the leftover thin strip is put aside. It will be used in the framing later on. Using a mitre box, I cut

[†] "Rip" is the term used when cutting wood lengthwise with the grain. Cutting across the grain is called, naturally enough, a cross-cut.

CORNER ANGLE HELPER

the corners and join the frame, gluing and nailing the corners. As is usually the case, this is one of those studio procedures where it really helps to have three hands. My extra set of hands for this process is a jig that I have made. It works well to have a piece of plywood with a 90° corner made with two pieces of wood as per illustration above. Clamp the two pieces backside up to form a 90° corner. Glue and nail the corners together and follow with nailing and gluing a triangular gusset to lock the corner into a perfect 90° angle. Do the same thing in the diagonally opposed corner and finish off with the other two. Never assume that any of the corners will be at true 90° angles even though you've just cut them. After this, build interior strutting (refer to the drawing opposite) so that the struts are 16" to 20" centre to centre. When setting and nailing the interior struts, it is essential that their edges be forward and flush with the edge of the stretcher bar. Doing so virtually eliminates the possibility of the stretcher bar warping from the tension of the taut canvas; if the struts are placed at the back edge, the tension of the canvas can indeed twist and warp

the stretcher bars. While you will, no doubt, try to use the straightest pieces for the outside of the stretcher, whether or not your wood is warped is of diminished consequence. There are sufficient checks and balances built into the system to redress most shortcomings. Even with this system, though, the odd work will go off the square.

Over the years I have noticed that the quality of wood available to me for stretching paintings has gone from bad to worse. Kiln-dried wood on the West Coast has fifteen percent moisture. When this supposedly dry wood is shipped to the dry interior regions of the

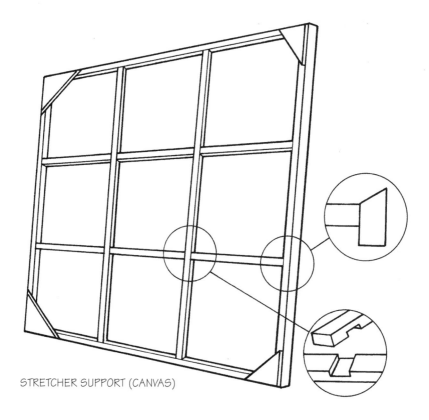

STRETCHER SUPPORT (CANVAS)

continent, interesting things can happen. The system of stretcher building I have just described was devised to compensate for low-grade material, the great disparity in humidity levels across North America, and the warping that results. As much as possible, my system tries to build a consensus of strength out of weakness. Should the stretcher bar be warped, the gussets and interior strutting will pull or push it in the appropriate places to straighten it. The woods that I have found most useful are cedar, pine, and white spruce. Nevertheless, some pieces of wood are so badly warped they are impossible to use. I am seldom short of firewood.

When framing the work, the piece of wood you put aside earlier will come in handy for strip-framing. Saw it into ¼" strips and paint these flat black on the edge. Remembering that the canvas is 1½" deep, get some strips that are 1¾" to 2" by ¼" to ½", depending on personal preference. This provides a good, sturdy gallery frame with a ¼" to ½" lip of protection on the frame edge.

WATERCOLOUR PAPER

The introduction of water to most art materials is fraught with danger, and paper is no exception. Artists deal with this in a variety of ways. Those who are wealthy often buy paper so thick that water isn't an issue. The nice thing about using a 600-pound paper is that you are able to put the paper in the bathtub and wash off the image with a sponge if it doesn't work out. Quality paper holds up well and, after a few washes, the surface acquires a delicate tint that I find beneficial as a ground colour.

Before examining alternatives, we should understand precisely why it is that the paper buckles and warps. Paper consists of fibres that expand with water. Handmade rag-paper is made from a soup of pulp fibres. A fine mesh screen is submerged, catching a portion of the

soup evenly distributed over its surface. As the water drains away, the fibres lock together, forming the paper. Left in this state, it is known as not pressed. The other two kinds of rag paper are cold pressed and hot pressed. Cold pressed leaves a bit of the character of not pressed, and hot pressed removes most of the character, leaving an almost smooth surface. The reintroduction of water allows the fibres to expand and, hence, the buckling. The most obvious solution is to accept the buckling as a natural part of the activity. Sometimes I choose this option because of the interesting effects that can be achieved by the puddles of watercolour drying on the surface.

Because watercolour board is costly, most artists choose, instead, to stretch watercolour paper. If you choose this option, remember that handmade rag-print paper is not the same as handmade watercolour paper. Fibres in print-making papers are shorter than those in watercolour papers, and stretching the paper may prove too much of a strain, resulting in the surface tearing during the drying process.

The best system for stretching watercolour paper is that used by Luke Lindoe. Since I have never seen it mentioned as an option in

any book or run across anyone using the method, I will pass it along to you together with the various improvements I have added through usage over the years. I have found it to be a fail-safe method with side effects that are most desirable. It is true that a picture is worth a thousand words. Sometimes the words are useful too.

WETTING WATERCOLOUR PAPER

The watercolour board: If you are going into watercolour production, you will want at least two boards—maybe more—set aside specifically for this purpose. The board should be at least one inch larger than the paper on all sides. Prior to preparing your paper, lay a watercolour sheet on the board tracing the outside dimensions of the paper on the board.

Wetting the sheet in the bathtub: Make sure that water has flowed over every part of the paper on both sides.

Rolling the sheet: As soon as the sheet has been subjected to water on both sides, roll it up with the watermark on the outside of the roll. Keep the roll about one inch in diameter and make sure that both sides are even. After the paper has

ROLLING
WATERCOLOUR
PAPER

been rolled, drive off as much water as possible. I use a gentle windmill approach, driving off the water while trying not to bend the paper in the process. The reason for rolling the paper is so that the fibres expanding against each other are constricted.

Laying the sheet: If it is the first time you are using the board, lay down a bead of white acrylate glue just inside the line you've drawn on the board. The glue line should be thin and close

DRIVING
WATER OUT OF
ROLLED WATERCOLOUR PAPER

to the drawn line. For subsequent works, simply lay a bead of white acrylate glue on the half-inch of paper left from the last watercolour. Lightly running your finger around the glue bead, make a consistent, thin, flat glue surface about a half-inch wide (inside the line). If you feel the glue is getting out of

LAYING BEAD
OF GLUE

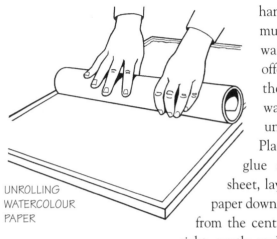

UNROLLING
WATERCOLOUR
PAPER

hand and covering too much surface, lay down wax paper to cover the offending parts. Pick up the rolled sheet of watercolour paper and unroll it about an inch. Placing this on the left glue surface, unroll the sheet, laying it flat. Press the paper down on the glue, working from the centre top both left and right, gently pushing to the corners. Do this on all sides until you are satisfied that the paper has made contact with the glue all around. Set the paper in the glue in much the same way as you would stretch a canvas, working from the centres out to the corners.

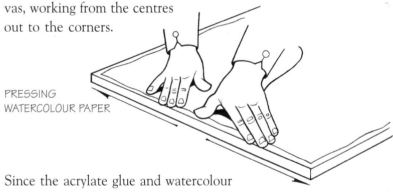

PRESSING
WATERCOLOUR PAPER

Since the acrylate glue and watercolour paper both set through the evaporation of water, they are both setting at the same speed. It is a sympatico system that has always worked for me.

ANATOMY OF THE BRUSH

Let's take a look at the basic anatomy of a brush. It has hair (or stuff that really looks like hair) and a metal part called the ferrule that holds the hair on the end of a stick that has some information printed on it. So what is actually going on here? First of all, only half the hair is visible. The other half is inside the ferrule, performing the function of loading the "spring" in the brush.[†] The weakest part of the brush is the ferrule's attachment to the stick or handle part. Elsewhere I suggest what to do when this connection weakens (page 64). If the brush is a chisel, the lettering on the stick or handle part will be lined up with the flat side. Use the lettering as a reference guide for the proper way to hold the brush when cleaning (see page 63). I always cover the lettering with my thumb so that left-right

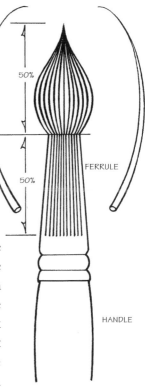

RED SABLE HAIR

50%

50%

FERRULE

HANDLE

ANATOMY OF A BRUSH

[†] All brushes are made in much the same way. Someone who really knows what he or she is doing goes through a process known as cupping the hairs. The expert skilfully agitates a small metal cup holding the hairs (fat end down) so that all the curves of the hairs end up pointing toward the middle. I have seen movies of it being done and it is still one of the great mysteries of my life! Once they are all pointing in, the whole bunch is cinched tightly in the middle. This draws the tips together so that they are all opposing each other in the tension, creating the point of the brush tip. The 50-percent fat end of the hair is hidden in the ferrule. It is the tension of the opposing hairs at the tip that returns the brush back to its original form while imparting a liveliness when in use.

motions re-enforce the "chisel" of the brush. Finally, there is the handle. Watercolour brush handles are short, oil brush handles are long, and there is a logical reason for this design.

USING THE BRUSH

There is nothing magical about a brush. A brush is simply the most efficient implement artists have devised to mix paint, carry paint, and deposit it on another surface with maximum control. For picking up a water-immiscible paint, some springy hairs with spaces to hold the water like a sponge are best. For oil paint, hairs that are flagged (split ends) have proven to be the best. The different handle lengths make sense. When water-colouring, we often rest the heel of the hand on the paper for added control. It is easy to see how a long-handled brush would be in the way. With oil, we aren't dragging our hand in the painting, and since the paintings are usually larger, the farther back we can get from them, the better.[†] One should always consider the entire arm as part of the brush. If you use the brush in this way, you will have incredible reach and control with it.

Take a pig bristle brush and hold it near the end of the handle with your index finger on top. By moving your finger slightly, you move the end of the brush 1" to 3". Move your wrist and you control movements of a foot; with the elbow a yard; full arm, and you are covering six feet or more. Only when one realizes that the 12"-long brush, properly used, is capable of making a six-foot stroke does the genius of it all hit home. Using the whole arm as part of the brush is also a good way to load the brush with energy. Never cramp the

[†] When Henri Matisse painted the murals for a chapel in Switzerland, he had special brushes constructed with handles that were as long as broomsticks. What a hit it would be to use a brush of that size!

movement of your brush by gripping it close to the ferrule unless you are working with watercolour. Your painting will thank you.

BRUSHES FOR OIL

Two characteristics of pig bristle make it ideal for oil paint: it is stiff and flagged (split ends). The stiffness has a sympathetic relationship to the thickness of the oil and the canvas. Split ends are important since they can pick up a lot of paint. Pretty neat when you think about it.

Oil brushes offer a lot of options. There are chisel edges, slopes, filberts, angles, flats, fans, and rounds. In addition, you have a choice of German or French hair. Don't be intimidated by all these choices. With that in mind, here is a brief description of the various brushes and what they were designed for.

The workhorse is the flat. With practice, using the flat side for broad strokes, the chisel side for extended thin strokes and the tip of the chisel for detail work will become as natural as breathing. Rounds are used for long, unvaried strokes. Sloped and chopped brushes are usually used for cutting into difficult areas with better control. Chopped brushes that have the flagged ends removed are good for scumbling.[†] Fans are quite useful when you want to get rid of the "jaggies" (unwanted tips and peaks of oil on a work). A whisper of medium on the brush and a delicate pass over the canvas will usually serve to put the "peaks" in their place. Some use the fan for licking the colour. "Licking" is the practice of brushing back and forth until all

† Peter Paul Rubens was a fan of scumbling. With the drawing set, he would quickly scumble brown glazes, roughly blocking in the tonal areas. The rough tonal blocks imparted a vibrant, pulsating energy to the underpainting that gave added life to the colour overpainting.

character and history of the brush stroke is removed, making the surface completely smooth. Filberts are a compromise between a chisel and a round and that is the sort of brush stroke they impart: a chisel flat with the crispness of the edge knocked off. If you haven't used them, they are definitely worth trying. For certain types of work, they are the very thing.

A "German hair" brush is one with a short amount of hair showing. These are good for working back into an area with a degree of stiffness. "French hair" is usually two to three times as long. A German hair doesn't have the give of a French hair, but is much stiffer and more precise than the French hair.

BRUSHES FOR WATERCOLOUR

The traditional—and best—brush for watercolour work is red sable, made from the hair of Russia's red sable fox.[†] The "life energy" of the brush is vitally important in watercolour, and one that the red sable hair is perfectly adapted to. The red sable is the "liveliest" hair in the world with an incredible amount of "snap" to it. As you can see from the drawing on page 55, all the hairs are delicately poised in opposition to each other. Because the hairs oppose each other in tension, they hold the maximum amount of water. This also makes for a good, stable, well-pointed tip on the brush. Whether moving it up or down, to the left or to the right, it gives in response to the pressure applied. The point snaps back when the pressure is released. This is all naturally accomplished in a lively way that imparts an energy to the stroke and ultimately to the work.

† In the "old days," a sable watercolour brush was almost as expensive as it is now. If you couldn't afford them, watercolour wasn't an option. There were some really awful substitutes such as ox hair. An ox-hair brush is undoubtedly the wimpiest thing I have ever seen and the sorriest excuse for a brush there ever was!

Do not confuse red sable brushes with those brushes now available named "white sable"—they attempt to copy the properties of the natural red sable using pulled nylon. While white sable is usable (the technology of brush manufacturing is getting better), it is a distant second to red sable. Perhaps at some future time, the synthetic product will equal or surpass the original.

Red sable is very expensive, however, so if you are going to invest in a red sable, make sure you have bought a "well-cupped" brush. The test I use is as follows:

TESTING
BRUSH BY
THUMB
SPREADING

1. Roll the hair between a couple of fingers to loosen the sizing in the hair.
2. Hold the brush vertical in your left hand with the lettering facing you.
3. Hold your right thumb flat and mostly on the metal ferrule with about ½" on the hair.
4. With your thumb, exert pressure, splaying the hair apart so that it is at a 90° angle to the ferrule.
5. This will fan the brush hair out into a perfect ellipse with an inner darker ellipse clearly visible. The inner and outer should be vertical and aligned (illustration right, top). If the inner shadow ellipse shows a split or angles off to either side, the brush point will split and be double (illustration right, bottom).

I have a good set of red sables that I have gathered over the years. If they were still making them, I'm sure they would be out of my reach monetarily. I have always treated them like the scarce commodity they are, cleaning them well after each use. This has paid off, as they are still in mint condition.

Your choice in watercolour brushes is limited to either round or flat. Just before we leave the world of watercolour brushes, I offer some additional advice on the choosing and caring for Chinese bamboo brushes. First, a word of caution when purchasing bamboo brushes: those with white hair on the inside are not as good as those with brown hair all the way through. Second, I've found that quite often the quality of the hair may be acceptable, while the brush itself is still a little on the wimpy side. An old Taoist adept taught me to wrap the brush as illustrated below. Doing this can quite often liven up a brush that was lacking in snap. It works well on Western brushes too. My choice for wrapping is either red silk thread (it just looks so good) or a thread from a canvas. I tie off the ends with a few half-hitches and use a few drops of crazy glue to make sure it stays. This puts a little more life into it. Occasionally, I will use acrylic with a bamboo brush intentionally (see page 64). Whatever I

WRAPPING WITH STRING
TO STRENGTHEN BRUSH

can't get out by washing will set and firm up the brush and keep it from shedding too much.

BRUSHES FOR ACRYLATES

All of the foregoing information is irrelevant if you are painting with an acrylate formulation. Acrylic formulations demand a nylon bristle. First, here is a little bit of history. When acrylates were first introduced, artists pounced on them as the new novelty in town. Since they looked like oil and could be handled like watercolour, it was only natural that the brushes we used for oil and watercolour were also used with the acrylates. It turned out that the new wonder paint was destroying brushes at a ferocious rate—the dried acrylate accumulated in the heel of the brush, making it stiff and unusable! Turning imminent disaster into opportunity, the paint companies introduced a brush specifically made for the acrylates. These first brushes were incredibly crude: basically a bunch of nylon fishing line bundled together to look like a brush and chopped off in a straight line. Their only redeeming feature was that they didn't destruct the way the pig bristles and the sables did when used with the acrylates.

It didn't take the paint companies long to remedy the situation—sort of. They devised a method of heating the nylon, pulling it, and letting it set with a curve just like a natural hair, looking somewhat like the drawing on page 55. Once they were able to do this, nylon brushes became quite usable. I use them frequently, getting good results with a wide variety of media. The nylon is almost indestructible and can be used with relative safety in all but the most volatile of vehicles such as pyroxylin and the like. While it is somewhat fascinating to watch a brush fry before your eyes, I don't recommend the exercise. If I'm doing a watercolour, I still use a red sable. You just can't beat it.

SOME FINAL WORDS ON QUALITY

Buying brushes can be a harrowing experience. The pain of spending a lot of money on a product that may be substandard is always uppermost in my mind when I have to buy a brush. For that reason, I have occasionally walked out of a store brushless, after testing all the available brushes in the size I want. For the kind of art we want to make—and for that kind of money—we deserve the best. The most basic rule of the game is to be sure that the tools you have are the best you can afford. The rule too often forgotten is that a cheap brush that is cared for with love will make a better painting than an expensive brush that hasn't been cared for.

BRUSH CARE

It drives me to distraction to go into a young artist's studio and see top-quality brushes being used and abused abominably. Some friends of mine in Ireland once graciously let my wife and me use their country home on the shores of Lough Corrib. It was so picturesque that we could hardly believe our good fortune. Their home had a grand view of the Isle of Inishmicatreer right in front of the picture window. Knowing that they had taken up art as a hobby, I had them drop off the oil sketch equipment and glibly told them I would do a small sketch of the view from their living room window. I sketched the scene in charcoal on the panel and froze when I opened the sketching box to do the actual work. The paint hadn't been cleaned out of the heel of any of the brushes. The hardened paint had flayed, splayed, and spread all the bristles to the point where the brushes were virtually useless—still usable as shaving brushes but not the sort of thing with which to do a painting. I'm sure I worked harder on that little 16"x20" painting than on any of my major (10'x10') works.

Cleaning the brushes I've used is a daily ritual for me and the last thing I do before putting the studio to bed for the day. If the brush is a pig bristle and larger than #2, remove excess paint with a rag, and gently flush out additional paint with a turpentine bath. These supplies are available in any art store. Seeing what they had and what they were charging, I went home and made my own. Your choice. After flushing out as much of the paint

CLEANING THE BRUSH

as you can, take up the turpentine with a paper towel, rag, or some such product. Gather up all the brushes you've used for the day, and turn on the water so that it is on the warmish side but not excessively hot. With a bar of Ivory soap (over the years I have found it to be the best) in your left hand, take the brush as per illustration with your thumb over the lettering. It is important to always clean the brush the same way as it will reinforce and assist the chisel of the brush. Strop the brush back and forth under the water much in the manner of someone sharpening a straight razor. Keep this up until all signs of paint are gone. Next, work some of the Ivory soap into the brush and, setting the bar down, strop the brush back and forth in the palm of the hand with some pressure, working the soap right up into the heel of the brush. If you do this, two things will happen. The brush will never fail you again and will last a lot longer, since through usage and

cleaning, a #4 will, over time, become a #2 and still be quite usable. Red sables, of course, don't get the turps but certainly get the full soap treatment. I always like to point them, sometimes leaving a bit of soap in the brush to help form the chisel or point. I know the hair has a good memory but it doesn't hurt to help it along. I try to keep pulled sables out of solvents altogether. When I do have to use solvents, I always use something gentle like a high quality artist's turpentine. Apart from that, I just soap them and really work the heels because once acrylate sets in there, it is the devil to get out. The other cautionary word is that whenever I am cleaning acrylate out of any brush, I always let it dry with the brush end up so that any acrylate that might be missed will at least head for the heel and strengthen the ferrule rather than destroy the working end.

Brush maintenance also includes the ferrule itself. Quite often usage will loosen the ferrule so badly that something must be done. When this happens, separate the ferrule from the wood handle and use a hot glue gun to stick it back on.

ROLLERS

Rollers are standard fare and there isn't much to say except that they work a lot better if they are cleaned each time they are used.†
Rollers, like brushes, are simply the most efficient way to get the paint out of the can and onto the canvas. For instance, if I'm doing stripes, I may remove some bristle off the roller so it makes stripes. All I'm

† Many artists take the attitude that "they're so cheap—why bother?" A "why bother" attitude is like a cancer that spreads through the studio. Unclean rollers make for unclean brushes and litter out of control. The studio is a small universe that requires continuous maintenance. There is another equally compelling reason and that is simple economics. It makes more sense to spend five minutes cleaning the roller than to spend a half-hour and two dollars going out and buying a new one!

saying here is that you should remember that the roller is simply a device to aid you. Modify it to suit your purpose.

SPRAY GUNS

I use both low-tech and high-tech spray guns. One of my current favourites for sealing charcoal drawings is a hand-held plant mister from a garden centre.† The spray is erratic, producing an uneven surface that is much warmer and more human than the uniform spray of a high-tech compressed-air spray gun such as a deVilbiss. When Jules Olitski reinvented painting with the great "colour rain" paintings of '67 (what an opening that was!), he confided that the sprayer he found the best was the one that attached to the vacuum cleaner. Go figure—for Jules, the vacuum cleaner attachment, for me, the plant mister! The hand-held sprayers last a couple of months and cost a couple of bucks. On the other hand, the deVilbiss costs around $150 for the gun and $300 for the compressor—at that price, you had better remember to clean it!

STAPLERS

When I started out (here comes the "old guy" stuff), there were no electric staple guns. As a matter of fact, the preferred way to stretch a canvas was to use thumb tacks. Some even used real tacks! Tack hammer in one hand, canvas pliers in the other, the canvas was stretched, and a tack picked from a bunch kept in the mouth. I tried it once but was so afraid of swallowing one of the tacks, I had to give

† Amazing—isn't it?—that the very thing a caveman drew with is still the best there is. Good line definition, easy to erase, and chemically inert. What a combination! The cavemen drawings come to us because the lime salts of the cave sealed their drawings. I find it touching that it was nature that preserved the mirrors of ourselves from so long ago. We use a light wash of acrylate to seal or "set" the charcoal.

it up. The manual stapler appeared first on the scene. Thank goodness, electric staplers weren't far behind.

There is definitely a correlation between the scale the artist works on and the technology available. This is as good a time as any to say something about technology. We must never forget that it is there to help, not hinder. My second electric stapler was fantastic—when it worked. I liked it and yet using it was often frustrating for me. One day I had had enough. Working on a sheet of white paper, I began to take the stapler apart, laying the parts out in an orderly fashion. If there was anything tricky, I made a drawing of it. As soon as I got it apart, the problem was easy to see and easy to fix. When it had been assembled in the factory, one of the wires had been pinched, causing an intermittent short. Once it was repaired, the stapler worked like a charm. That adventure was ten years ago. Even though I have two other electric staplers, it is this old tried and true one that I always use.

SUMMARY OF TOPICS COVERED IN THIS CHAPTER:

1. An indication of the problem of public domain names.
2. An historical overview of varnish.
3. A brief introduction to ethics.
4. Building stretchers for canvases and cradling panels.
5. The nature of rag paper and how to stretch it.
6. Overview of brushes.
7. Overview of other tools found in the studio.

 Notes

I've spent my life making blunders.
—*Pierre-Auguste Renoir*

 Notes

Ornithology is to the birds
what art criticism is to the artist.
—*Barnett Newman*

5. For painters—mostly

Some "old guy" tips and some thoughts on the oil–acrylic debate.

This chapter is not meant to be my contribution to the "how-to-paint" book market. There are too many of those sorts of books out there already. However, over the years, instructors, books, and experience have taught me a good number of lessons which I want to pass along to those of you who are involved in the painting part of the art world.

The first requirement of a painting is a stable surface to put the image on, commonly referred to as the *support*. Next there has to be something which binds together the colour, or *pigment*, that makes up the image, and which makes it stick to the support: the *vehicle*. In a perfect world, *vehicle, pigment,* and *support* would all be sympatico. The world is not perfect. Some vehicles and supports are incompatible. Some colours are completely incompatible with certain vehicles. As a result, most "painting systems" have a number of checks and balances set up to correct whatever problems there are. For instance, oil paint goes through an irreversible process known as rampant

oxidation. Once initiated, this process will continue apace through all organic materials with which it comes in contact. Putting oil on untreated canvas will initiate the process of oxidation in the organic fibres of the canvas, rotting it. To counteract this, the artist places a barrier to stop it: the *ground*. The vehicle charged with the responsibility of holding the ground together and keeping it stuck to the support is commonly called the *size*. In addition to setting up a barrier to the oxidation process, the ground must also provide a good surface for the vehicle to bond to. Leonardo da Vinci's *Battle of Anghiari* was a great masterpiece according to contemporary writing. However, since it was painted on an unstable surface with an unstable vehicle, it self-destructed. Whether it was or was not a masterpiece we'll never know.

The foregoing statement of practice is deadly important and curiously easy to forget when faced with an exciting new process. I find it useful to remind myself on an ongoing basis. Oil oxidizes in an irreversible process that takes months and sometimes years. On the other hand, all acrylates, when mixed with the appropriate chemical agent, will return to a liquid state. Used properly, acrylate is stable once set. For example, acrylic under oil is sound practice. The acrylate, in setting, has become stable and oil over top will "bite" enough to establish a good bond. Putting acrylate over oil, however, is unsound. In oxidizing, the oil creates a surface that the acrylic cannot bite into, and you will be able to peel the acrylic paint off in strips! To sum up, the constituent parts are support, ground, vehicle, and pigment. Whatever system you are using, you should be aware of any idiosyncrasies of the individual parts and how they interact.

If you want to remove some paint, there is always a solvent that will do it for you. The following solvents are listed here according to their degrees of volatility (in ascending order): benzene, Varsol,

turpentine, gasoline, tolulol, xylene, xylol, lacquer thinner, methyl hydrate, and nitrocellulose thinners. You would do well to memorize the list. Finally, if you are working with volatile solvents, you really should be wearing an organic vapours mask, since, over time, they will turn your precious insides to mush.

I am often asked why I persist in using oil paint when acrylic is so much "easier." The short dialogue on the "oil paint versus acrylic paint" debate that follows is an outline of the thought processes that led to me returning to oil paint. It is interesting to note that many of the New York "biggies" I respect have also returned to oil. Any consideration of the relative merits of paint shouldn't begin with where we are but rather where we would like to be. Let's make a list of what we want in a paint, and see how oil and acrylic stack up.

	Oil	Acrylic
Time-tested technology with no surprises	Yes	No
Colours that don't fade or change[†]	Yes	Yes
Chemically stable	Yes	No
Good for very fine detail and broad, open brushing	Yes	Yes
Heavy impasto retaining crispness (no sagging)	Yes	No
Wide range of colours	Yes	No
Colour hue, value, and intensity		
constant on palette and painting	Yes	No
Drying time that can easily be manipulated	Yes	No
Surface that stays open to work into	Yes	No
A surface that sets so it can be worked over	Yes	Yes

† This is a difficult one. I tend to regard a couple of hundred years as permanent. Most of the organic pigments that make up the bulk of oil formulations have proven themselves over the years. Some of the new pigments being created because of the acrylates' need for inorganic formulations (this is explained further on page 77–78) are extremely fugitive (see footnote, page 73). Quite often, visible change is noted in weeks, not years.

> People ask me how long it took to make a work.
> I reply by giving them my age.

Acrylic is so user-friendly in terms of cleanup and smell. What a shame it so miserably fails the test of what an artist needs in media. Those who persist in using what the artist R. L. Bloore refers to as "children's paint" pay a heavy price for convenience. Artists I know who use the stuff often seem to be trying to make the acrylic into something it isn't or doesn't want to be. They keep saying things such as: "I can make acrylic look just like oil." What is the point when it will always be an acrylic, never acquiring the glow of an oil painting!

OIL PAINT—HISTORY ON ITS SIDE

The following are some personal and professional observations regarding the relative merits of the two media. Age is very kind to oil paintings! It is a truism that an oil painting looks its worst the day it is finished (the opposite holds true for acrylics). During the oxidation process,[†] the oil's yellow caste harmonizes the disparate elements

† It is important to know that the maturation processes of the two media are very different. Oil paint goes through the irreversible change of oxidation. The acrylates are thermal in nature. When the chemical maintaining them in liquid state evaporates, they return to a solid form. This solid form can be reversed at any time by the reintroduction of a chemical, raising their temperature to the eutectic or critical temperature at which they cease being solid and return to liquid form.

together with a unifying golden glow. When I see my works in galleries thirty years later, I find the differences truly amazing. It is as though someone has softened some of the rough edges and put a warm glow over the whole work. The other thing that happens is equally amazing. Using transparent and semi-transparent paint allows the light to enter the surface and bounce around inside. The painting literally glows with an inner light. Over the years, it will also begin to exhibit some pentimento as paint layers become less opaque and a little more translucent.† Another advantage of oil paint is that anything that has been fine-tuned for over five centuries has most of the kinks worked out. Pigments that didn't work were automatically discontinued, while others that were either slow or fast in drying were adjusted with the appropriate drying oil to either hasten or retard drying time. Over time, a safe, full-colour range has been developed that oxidizes in a reasonably similar timeframe. The earth colours were easiest to deal with; it wasn't until the twentieth century that a good, cheap blue was found. "Brown gravy" pictures of the masters are for the most part just paintings with colours that went fugitive.‡ Over the years what didn't work was discarded; what worked was kept.

† Someone asked Titian whether he glazed or not. His answer was: "Svelature? Tranta A Quaranta." Loosely translated this means: "Glazes? Thirty or forty." The art of glazing is little understood today, and less used. If a red needs heating up, a little transparent glaze of yellow over top will do the trick; a glaze of green, on the other hand, will subdue it and make it recede. One of the most important technical tricks in the art "fix-it bag" is the use of overglazing to make colours hold the space they were intended to hold. In the matter of glazing, slices of Francois Boucher paint film reveals pigment particle counts as low as 25 per square inch. Small wonder the flesh of his ladies glows the way it does.

‡ The term "fugitive" refers to paint that fades or changes appearance over time, either through chemical reaction or through exposure to light and ultraviolet light. Paint manufacturers accept no responsibility regarding the longevity of their products. Jack Bush had a painting on tour that changed so much he refused to accept its return. Subsequent research showed that the culprit was the paint company. Artists hope for at least 100 years so that there is a good chance they won't be around to answer any questions.

When you've been at the thing for five centuries, the major battles have all been fought. On the minus side, oil paint is really messy, smelly, and a definite pain to clean up. Some colours seem to take forever to dry, and it requires some skill in handling. Using a good painting medium solves most of the handling problems. My preference is a mixture of one-third turpentine, one-third varnish (the real thing), and one-third sun-thickened linseed oil. The turpentine emulsifies the other ingredients. Varnish skins up quickly while the oil provides a good, hard, stable surface meant to last a long time.

Lest you think the oil option is free from dreck and angst there is the problem of disposing used solvents contaminated with various sorts of paints. In the old days we artists would simply dump the "ugly stuff" in whatever back alley or field was handy, creating with gleeful abandon our own toxic mini-dumps. Those days of blissful ignorance are at an end. The artist is left with three options. Option one: let the stuff accumulate in corners of the studio. This is unwise since you will eventually run out of studio corners and chances are that the various cans and buckets aren't labelled as to contents. When getting rid of them is finally a necessity, figuring out what is in the various containers is difficult. Option two: label the contents and when the

local fire hall does their annual cleanup of paint and solvents, dump the bundle. Option three: use the services of a waste management company. While these companies usually deal in large amounts there is always one that will—for a modest fee—take care of the small amounts that an artist generates. Dumping it in an alley when no one was looking used to make me very uncomfortable and I am delighted to pay the modest fee knowing that I am being responsible and doing the right thing.

ACRYLATES AND ME: BEGINNINGS

When I was starting out, the plastics—or acrylates as they are more properly called—hadn't appeared as yet. There were only vague rumours about the possibility. When the first of them hit the market, it was with all the confidence and promise of "tomorrow today." It seemed as if the golden age of art was upon us. The first synthetic fabrics were also beginning to appear, Sony introduced its first products, and cars began to look like Buck Rogers spaceships. Pretty exciting times! The only options previously available to the painter for media were oil, tempera, and watercolour.

The first new product was called Tri-tec, and we all rushed to buy the future. It was a casein emulsion paint that had linseed oil and beeswax (possibly paraffin) as additives. The advertising sounded very much like later acrylic advertising would sound. Thin it with water and clean up with water. Use it thick like oil or thin like watercolour! They didn't mention that it tended to go solid in the tube and could also start growing mould. Casein as a vehicle is a milk emulsification process. Needless to say, the product wasn't around very long.

Rumours circulated about another new wonder paint, but nothing appeared. I happened to be in Greece at the time, and there I was able to obtain a product called Vinylite, which thinned with water

and mixed with pigment to make paint. Buying the pigment was wonderful! The paint-supply house on a side street in Mytilene might well have been transported straight out of the eighteenth century—and probably was! In the storage room on the second floor, large double-weave gunny sacks full of outrageous colours were strewn among bins that also held colour. To be in the middle of such vibrant, full-chroma colours was an extremely delightful, sensuous experience. Thus began my experience with acrylates. Vinylite was certainly in the purest of artists' traditions. The French artist Edouard Vuillard was fond of using raw pigment and rabbit-skin glue to make his paintings. Here I was, a century later, doing the same thing, except that I was replacing the rabbit-skin glue with acrylate.

On my return to Canada with all my pigments under my arm, I was shocked to find Vinylite unavailable. There still wasn't any acrylic paint on the market here and I couldn't find anything remotely resembling what I had been using in Greece. In retrospect, this was probably one of the really exciting times of my career. I wrote letters all over the world and received formulations from England, Italy, France, and from several different places in the United States. Although they all had different names, they were simply different forms of the same thing. Of course I didn't know this at the time. Armed with various solvents ranging from the low volatility of benzene to Opex thinner #9, I tried different mixtures. I kept coming up with mixtures that were like model airplane glue and other such exotica, never realizing that they were all basically the same thing.

Trying to use these formulations as paint was like being on a magical mystery tour. The paint would often disappear on me. This was most disconcerting. When I put a heavier pigment over one that was lighter, the solvent opened up the lower layer, allowing the heavier one to seek the lower level. While it all sounds so sensible when it's

written down this way, I can assure you that when you put a colour on and it isn't there when you come back an hour later, you really wonder what is going on and tend to question your sanity. If I had put some with water and emulsified them together with an eggbeater, I would have had my Vinylite. When emulsified acrylic sets, the water is the first to evaporate, followed in quick succession by the solvent it is dissolved in. This is why it looks milky white and turns clear when it sets. The milk colour comes about because all the little bubbles of acrylate in solution are separated by water. The process of emulsification involves putting a solvent immiscible liquid with an aqueous immiscible liquid and mixing vigorously so that they are in suspension together. The outcome of all this experimentation was a major series of works known as *The Tartans* that occupied my creative time from 1966 to 1976. It wasn't all bad.

THE LESS THAN SPECTACULAR BEGINNINGS OF ACRYLIC PAINTS

As you can see, I was around at the very beginnings of the whole acrylate revolution. Its significance has been truly incredible. It seems that there is nothing in our lives that has not been touched by it. We wear it, burn it, eat it, eat off of it, and paint with it. Its difficulties have spawned whole areas of research. Because acrylates are unsympathetic to organic substances which are the basis of most colour in paint, it was necessary to develop synthetic inorganic colours. This sparked a chemical revolution, the beginnings of which in the art world were somewhat less than auspicious.

In their haste to get on the "plastic" bandwagon, many commercial paint companies proceeded without fully understanding what they were dealing with. This led to some rather comical episodes, as well as some bankruptcies. One company used the same organic

pigments they had used to manufacture their oil paint. The line was introduced with considerable hype and new product was shipped all over North America. Artists who bought the product were in for a shock. The acrylate vehicle had reacted chemically with the organic pigment. Red came out of the tube black, while yellow was a dark grey. The only pigments not affected were the inert earth colours such as burnt sienna and yellow ochre.

Another company rushed into the game using a slightly altered acrylate formulation. Going "mod" in one fell swoop, they also used a polyethylene tube. A series of unfortunate labour strikes left the product in transit overly long, during which time the chemicals in the paint reacted with the chemicals used to manufacture the tube. The result was that the paint turned to a rubbery kind of jelly. Consider the following scenario when the artist finally receives the new paint. When the artist releases pressure after squeezing paint out of the tube, the paint scoots back into the tube. With painting knife at the ready, the artist tries to pounce on and cut off the paint before it can get back in. When he or she gets lucky and chops a piece off, there is a little blob of a rubberish sort of thing on the palette that sometimes sticks to the brush and that defies all attempts to get it to mix with

Cover the canvas at the first go, then work at it
until you see nothing more to add.
—*Camille Pissarro*

another colour. I actually witnessed the foregoing scenario first-hand. After fifteen minutes of frustration, the artist did the sensible thing and went to the bar.

Another problem which surfaced concerned brushes (already explained in detail in the previous chapter). The acrylic paints destroyed the natural hair of the hog bristle and sable brushes, so brush manufacturers developed new brushes using nylon, the first attempts at which were highly unsatisfactory.

ONGOING PROBLEMS

While most of these historical problems with acrylates have been solved, there are a number of problems which continue. First, an acrylate surface can build up a static electricity charge, drawing dust out of the air. The best example of this is the typical little, white, plastic sign seen outside "mom and pop" confectionaries. When it is first put up it looks very white. Over the months and years it looks duller and duller as more dust is drawn out of the air.

A second problem that I've heard about but not experienced myself concerns pH. With acrylic paintings, there is a possibility that droplets of hydrochloric acid might form on the painting's surface. Apparently this occurs when water with the wrong pH is used. Acrylic instructions state that the paint should be thinned with distilled water. I've met a lot of artists who use acrylic. I haven't met too many who rush out to the drug store for distilled water before they paint. Using the wrong water can leave a weakened chloride chain. When this happens, the hydrogen molecules are pulled from H_2O by the free chlorides that break off the chain. When this happens, HCL or hydrochloric acid is created, and the remaining oxygen molecules are released into the atmosphere. You get a nice, rich atmosphere. Unfortunately, the painting surface has a rough time. I have never

actually seen the results, but conservators and paint chemists have apprised me of the problem.

I have also heard of problems mixing different brands of paint, since within the general parameters of acrylate formulations, there are always slight variations. As if the foregoing problems aren't enough, it is the nature of acrylates that "what you see is what you get." There is no maturation process for acrylic paint. The best an acrylic will ever look is at the time the work is completed. It is all downhill from there. From then on, the image is at risk from some or all of the processes I have mentioned.

RESPONSIBLE CONSUMERISM

Paint companies are concerned with profit. Their products are formulated primarily to have a long shelf life. Ease of handling in the studio is a secondary concern. Pigment particle count per square inch is strictly a concern of the artist. If the manufacturers could get away with extending a paint to the point of no pigment, they would. When confronted with a new product, then, it is the artist's responsibility to conduct a series of simple tests. Take a few colours. See how easily they are diluted by white. This will tell you how much the paint is extended. After the swatches are dry, cover half of each one and hang

The saints are the sinners who keep on going.
—Robert Lewis Stevenson

them outside for a month in full sunlight. Colour change between the covered and the uncovered parts will indicate whether the product is acceptable for use. Be wary of new products, using them only when you can be reasonably sure that the painting that ends up with the collector will be of a lasting nature.

IT AIN'T ALL BAD

So that's some of the bad stuff. Let's consider the good that is a direct result of acrylates. Whatever may be said against the acrylates, artists will forever be in debt to the revolution and to the new products it spawned, including an expanded range of pigments and the new brush technology. Once the limitations of the product are understood, the artist will still have much that it can be used for. I find uses for it everywhere and anywhere. It's great for underpainting and lousy for the rest of it. Of course I came to acrylates in mid-career. Undoubtedly those who began their careers with them will have a different mindset.

The development of new products continues. Admittedly, I have deliberately avoided dealing with many of these new challenges to my long-held values. Chief among these is the new "oil paint" that cleans up with water. Oil paint that cleans up with water? How can this be? I found this just too weird to think about until a recent trip to Regina jolted me into a reality review. I visited the studio of a former student who had at one time stopped painting because of his allergic reaction to the smell of oil paint. (Some people will come into a studio's rich oil-based atmosphere, breathe deeply, smile, and remark how nice it smells. Others will start coughing, hold their noses, and escape as soon as possible.) His children were also allergic to the smell of oil paint, and since his studio was the attached garage, the fumes quickly invaded the house. Now he uses the new water-based oil paints,

and he can leave the door open between the studio and the house with no ill-effects for the little ones. As I drove away from his place, I knew that I would finally have to bite the bullet and deal with the problem.

When I returned home, I immediately bought two full sets of the paints so that I could check out first-hand just how good they were. I bought two different brands of "oil" paint that cleans up with water. One is the dreaded aqueous-miscible oil paint (you have no idea how hard it is for me to write that) and the other is an updated alkyd product. The alkyd reminded me of my adventures with *Tri-tec*, the first generation of alkyds so many years ago. They said it could be used impasto for oil, with white for gouache, and with water for watercolour. Most of the tubes turned rock hard (actually more like old potato) before I had a chance to get them on the palette. I distinctly remember banging one tube with a hammer in a futile attempt to get the paint out. I ended up peeling the tube away and attempting unsuccessfully to soften the lump of colour I was left with.

I have to admit, though, that these new products have come a long way from the old days. I can report that they do indeed behave like the old paint I am used to and familiar with—kind of, almost. I put in those provisos because they don't seem to have the covering power that an oil paint would have. (This may simply be a symptom of a low pigment count and then again it may be an inherent fault of the product. At this point I just don't know.) Since it was an alkyd-based system, the end surface was dry and did not have the lush sheen an oil surface would produce. I remember getting the same surfaces with *Tri-tec* back in the fifties. It also seemed to me that it wanted to seek its own surface a little too much; in other words, it didn't have the crispness and high-definition brush stroke that one comes to expect from impasto oil. A peak tended to sag into a blob. One thing

I will say for it is that it mixed freely with oil paint. I wasn't any too sure about how to proceed with the cleanup afterwards. After some deliberation I took off as much paint as I could with a paint rag and finished up washing them in soap and water.

The other side of this coin is that I have an artist friend in Oshawa who has become allergic to acrylics. Rather than give up the medium, he has continued to use them and monitor his reaction. He does this by keeping a constant check on his tongue. When his tongue turns white, he knows he has to get out of the space for a while. Apparently, in the process of drying, a significant amount of formaldehyde is released. The released formaldehyde tends to turn things white. If it were me, I would really consider a return to oil, but I suppose that each of us deals with these problems in our own way.

SUMMARY OF TOPICS COVERED IN THIS CHAPTER:

1. An overview of the basic elements for painting.
2. A list of solvents and their relative volatility.
3. A comparison of oil and acrylic paint.
4. An historical overview of oil paint.
5. An historical overview of acrylic paint.
6. Ongoing problems with acrylics.
7. Some advantages of acrylics.

 Notes

There is no power on earth that can break the grip
of a man with his hands on his own throat.
—*Arthur Miller*

Notes

In every painting a whole is mysteriously enclosed,
a whole life of tortures, doubts, of hours of
enthusiasm and inspiration.
—*Wassily Kandinsky*

 Notes

We are such stuff as dreams are made on;
and our little life is rounded with a sleep.
—*Prospero in* The Tempest

6. Carpentry 101

The BM basics (Before Machines).

My daughter has suggested that I write about some of the basics of dealing with wood and the associated tools of the carpenter, since not every emerging artist will have had the opportunity to gain a working knowledge of such things. Let's take a few pages, then, to walk through some of the basic concepts of the carpentering business.

HAMMER AND NAIL

Every tool is shaped the way it is because that is how it will best work. A hammer will hammer—if you let it. Many times I have seen someone choking a hammer, grasping the handle right up where the metal head is, leaving the major portion hanging out the back part of their hand. It is painful to watch their frustration. If a hammer worked well with little or no handle, it would be made that way. Try the following. First, tap the nail in so that it will stand free. Now grasp the hammer as far back as you can and let the head fall from a vertical to

horizontal position, striking the nail. The weight of the head falling starts to drive the nail in. You could drive the nail all the way in this way. Once you understand the mechanics of a hammer, you can add as much force with your arm as is comfortable. If you are having trouble with the wood splitting, try flattening the point of the nail with a couple of whacks of the hammer. Now instead of a chisel end on the nail which splits all before it, you have a flat head which will collapse the cellular structure of the wood rather than splitting it. No more split wood. Some take the direct approach and pre-drill the wood. If the problem persists, you are using too big a nail. Some woods are just prone to splitting, and there is precious little you can do about it.

It is easy to get confused over which particular nail to choose. For building stretchers, choose a coated nail. The heat friction generated by pounding the nail in melts the coating and lubricates the nail. Once it is in and the nail has cooled, the same coating sets and holds the nail in. The coating grips the wood, and doesn't pull out easily. For framing, use a finishing nail with a small head that will countersink easily. As to size, I tend to favour a one-to-three ratio in terms of penetration: one-third on the side with the head and two-thirds on the other side. If you are still confused, don't be afraid to ask the person behind the counter at the lumber store. Simply tell him what sort of job you are doing and he'll take care of the rest.

THE SAW

There are basically two kinds of saw: crosscut and rip. (This isn't completely true, but let's keep things simple for the time being.) You can easily find out which is which by lightly running your fingers down the teeth. I said lightly! Crosscut saw teeth have a definite bite as each alternate tooth is flared to opposing sides and you will feel the little points. Every other tooth is flared out in the opposite direction.

This is done so that the act of sawing will also clear away the sawdust and, since the cut is wider than the thickness of the saw, stop it from binding. Rip saws are meant to saw with the grain rather than across the grain like the crosscuts and usually have no set. A regular cross-cut has 16 teeth per inch and a mitre saw has 32 teeth per inch. While I don't want to muddy the water for you, there are some other intriguing alternative saws available. A Greek saw is made of thinner metal, is much smaller, and looks a bit like a child's toy. Nonetheless, it has a very efficient design. Watching Greek carpenters saw a 4" plank twelve feet long with this "child's toy" was an eye opener. Its secret is that the teeth point the opposite way. Standard saws cut when the blade is pushing away. With a Greek saw, the cut is made on the pulling. In addition there are a variety of Japanese saws. Some cut on the pull, some on the push, and some on the push and the pull. Those clever guys!

The actual sawing part of the operation is deceptively simple yet difficult to do well. Placing your thumb along the edge of the cut line, simply draw the saw towards you. Since the teeth have the pointy side facing away, the points will skip over the top scoring it. The weight of

What distinguishes the artist from the dilettante?
Only the pain the artist feels. The dilettante looks
only for pleasure in art.
—Odilon Redon

the saw will establish a channelled groove that the teeth can run in for the pushing part. Often people get into trouble by not establishing a deep enough groove. If the saw is skipping around and you find yourself sawing your thumb or a new line that isn't where you want it, this is likely the problem. Once you have a reasonably well-defined channel, simply push the saw forward. The weight of the saw and the teeth biting as they are supposed to will cut the board. No straining or undue force is needed. If the teeth are sharp, the weight of the saw and the teeth do the rest. If the saw does stick and bind after all that, try putting some soap on the saw.

THE PLANE

The best thing anyone can do before using a tool is simply to look at it and consider why it is the way it is. There are basically four parts to a plane: a flat metal bed with the blade stuck through it at an angle, a wooden knob in front, and a full hand grip in back. The flat bed keeps the cut level, and the blade is angled so as to get a good bite. The front knob guides it where you want it to go and allows you to apply pressure to initiate the bite of the blade. The back handle is sloped ideally for simultaneous forward and downward thrust. The forward and downward pressure keeps a good bite on the blade as it is pushed along. It all sounds so eminently sensible. Design almost always belies function.

BEYOND THE BASICS

Now that I have told you about the basics, let me introduce you to the real world. I have three hammers and very rarely use them. One of the things that you are going to want for your studio is a compressor. Having one opens a lot of possibilities beyond spraying paint. Most tools are available in an air-tool format. Sanders, nailers, chisels,

planes, and goodness knows what else. I admit to having four nailers, which is a little on the obsessive side. If you can possibly afford a staple gun, it will pay for itself in no time. After having mine for a year, I realized that I couldn't afford not to afford one. It has really become indispensable, turning most studio drudge into a breeze. What used to take me three days now takes one. While it is something you can do without, it is an option you shouldn't overlook. For an emerging artist, the choice between new clothes and a nail gun is fairly obvious.

WOOD

All wood has a grain. This means that in one direction the wood tends to split and in the other it is very stable. Of course that is the reason there is a crosscut (against the grain) saw and a rip (with the grain) saw. Another factor that can affect wood is where it is grown. Whether or not it has a long cellular structure will determine its flexibility. The rate of growth will determine whether it is hard or soft. It has been my experience that some of the so-called soft woods are pretty darn hard. Usually the artist deals with soft wood because it is so much easier to handle for everything the artist wants to do. If you

An artist, under pain of oblivion,
must have confidence in himself, and listen
only to his real master: Nature.
—*Auguste Renoir*

do succeed in getting a staple into hardwood, you then have the problem of removing it should you so desire. My painting wall is spruce plywood, nice and soft. I have had walls of fir that were so hard, it was difficult getting the staples out without tearing the canvas. Now there is some mega-pain: a finished painting, ready to stretch, that gets torn taking it off the wall! For my purposes, the soft spruce is absolutely splendid! I'd like to replace it, but haven't been able to find any. That's not quite true. They tell me that if I bring in a boxcar of it, they will get me some. It is the best surface I have ever worked on. The spruce plywood they use for carpet underlay is also very soft and excellent. The problem is that it is available only in 4' x 4' x ¼" sheets. If you do use it, the back will have to be reinforced and you will have to construct some sort of structure on which to hang a bunch of them.

The whole question of wood is difficult. Whatever good wood there is in the country we don't even get a sniff at. It all goes for export. We are offered the rejects. That is just the way it is. About the only decent wood left to buy is cedar. It is reasonably straight. My personal preference, however, is spruce, which is getting more and more difficult to find. I don't have confidence in cedar for larger stretchers. It is probably a failing on my part rather than a problem with the wood. Because I use spruce, there are some givens I have to work with. The wood is green[†] and will definitely warp. If you can buy a bunch well ahead of using it, you may avoid the worst of it. Take

† We use the term "green" to indicate wood that is recently cut and still damp. The term "kiln dried" refers to wood that is predried in special drying kilns. Kiln-dried wood is a lot more costly and for the most part is fir. Fir is a wood I try to avoid. It splinters a lot and always wants to split when it is nailed. The splinters are sharp and most usually end up stuck in my fingers or hand where they tend to fester and cause an infection. Fir is not my favourite wood. I'd stay away from it if you can!

about ten green boards and tape them together tightly, roughly every two feet. Stack them somewhere high in the studio (where it's warmest) and forget about them. I like to leave them at least a month, and preferably longer. This is the poor man's kiln drying. With the understanding that knot-free wood is a dream, I try to select wood with small knots and as straight as I can find. Larger knots indicate more eventual warping of the wood.

There is a way of dressing a log into lumber that minimizes warpage. There also is a cheaper way which yields more wood, but which results in wood that has unequal tensions automatically built in. Guess which one the lumber companies use. Wood is predestined to warp because of the way the lumber companies process it. Knowing this, we can minimize the problem by designing a system that takes warpage into account. For a long time I tried to combat warpage by making stretchers bigger and heavier. Naturally enough, I ended up with stretchers that warped in a bigger and heavier way. The answer for me was to go the other way—make the exterior wood light enough that the interior structure of corner gussets and cross-braces simply corrects whatever warpage there might be.

Learn silence.
With the quiet serenity of a meditative mind,
listen, absorb, transcribe, and transform.
—*Pythagoras*

Over the years I have tried using better wood (it still warped). I have tried everything from 2" x 2"s to 1" x 4"s with cove moulding on top to floating the canvas off the wood. I have tried finger-joint wood and cheap wood that has dried and set in the studio. The last is as good as any. I've used it off and on for the last ten years. I say off and on because when someone suggests a new method, I usually try it. I haven't found anything better yet but I try to be an optimist and when another system surfaces, I will give it a try on principle.

SUMMARY OF TOPICS COVERED IN THIS CHAPTER:

1. An overview of common carpenter's tools and their usage.
2. An overview of wood, what to avoid, and how to compensate for inevitable warping.

 Notes

The toughest thing about success is that
you've got to keep on being a success.
—*Irving Berlin*

Notes

All we are given are possibilities—to make
ourselves one thing or another.
—Joséé Ortega y Gasset

7. Framing and Presentation

Getting the right angles right.

The function of a frame is threefold: to protect the work from damage, to enhance the image, and to provide a transition from the world of the painting to the world of reality. Works of art are windows to another world, and the frame is the window casement. Frames can enhance the work and contribute to the success of a painting. They may also contribute to its failure.

EXPECTATIONS/REQUIREMENTS OF THE FRAME

My main demand in a frame is utilitarian. A work of art is under stress when it is being moved. In a gallery, this is a continuous process. It is being shown, put away, and—hopefully—brought out again. We may assume that a work in a commercial gallery is at continuous risk. Since I know the frame is going to get beaten up in the gallery process, I don't put a "five-star final" frame on the work. A gallery frame should be simple and yet do what it is supposed to do. (There is every possibility the gallery will sell the customer a frame to "enhance" the

painting. Everybody has to live and it is okay with me.) Besides, most people who buy my work like to put a frame on with which they feel comfortable.

The usual rule for framing is "the smaller the work, the larger the frame." Barnett Newman's favourite method of framing was masking tape around the outside; his paintings were of the very large variety. While visiting Newman in New York, a friend of mine leaned against a painting so large that he thought it was a wall! What a wall!

FRAMES MADE SIMPLY

Over the years, I have settled on two very simple frames: a simple cap for the linen liners of small frames and a simple strip frame for the canvases. I stress the word *simple* in both cases. As artists we have enough on our plates without complicating things.

I usually set smaller works in linen and finish off with a simple cap frame. Smaller works tend to have a more constrained energy, so they need the linen to allow the energy to pulsate a bit. High-energy smaller works need the tranquil space of a linen liner before hitting the moulding frame cap that is the transition to the wall and the physical world. It is a shame to see a small painting with just a cap on. It seems to me that the linen energizes the work and really enhances it.

There are standard sizes—for instance, 12" x 16", 16" x 20", 18" x 24", and 24" x 30"—for which it is easy to get preconstructed linens. It is wise to use pre-fixed sizes, since this lowers costs and speeds up production. Many artists keep a studio frame on hand in the sizes that they commonly use. Popping a work in a frame to see what needs to be done or to show someone the work is quite useful.

For canvases, I use a thin strip of wood usually painted one of the neutral colours found in the painting and a recessed thin strip of matte black. The recessed black allows the painting to float in a well

of night, while the thin strip, which is mainly protection for the work, relates architecturally to the wall. Sometimes when the work is a vertical and the bottom and top not an issue, I will leave the strip frame off, too, framing only the sides. I like this look, as it gives the appearance of drapes or curtains being pulled, exposing what is behind the wall. Of course, when the work travels, there is a piece put on the top and bottom to prevent damage.

On large strip frames I put the top and bottom strip on first. The sides are last, covering the end grain of the top and bottom.

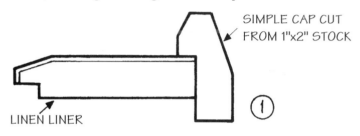

SIMPLE CAP CUT
FROM 1"x2" STOCK

LINEN LINER

①

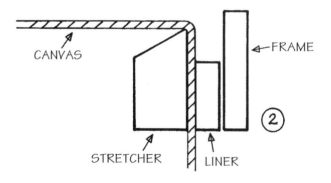

CANVAS

FRAME

STRETCHER LINER

②

FRAMES: —FOR LINEN SPACER
 —FOR FLAT MOULDING

I use a poor man's framing jig for cutting the angles. I got the idea from an expensive jig that I saw in a framer's shop. The beauty of using a jig such as this is the certainty of a 90° corner since the saw is cutting both sides in the same configuration. If one side is cut to 46° the other side will be cut to 44°. Having the ruler as the straight edge means you can get an accurate inside measurement. Just for that alone it is worth using the jig. Having it ended some major studio frustrations for me. If you are doing any framing, I suggest you build or acquire one.

For a small work in a standard size, you might find a suitable frame in one of the "superstores" that seem to sell everything. You may have to paint and stain it a bit, but if it is cheap enough, it might be worth it. Framing shops often have frames that can be bought cheaply because they weren't the right size, or are of the "used"

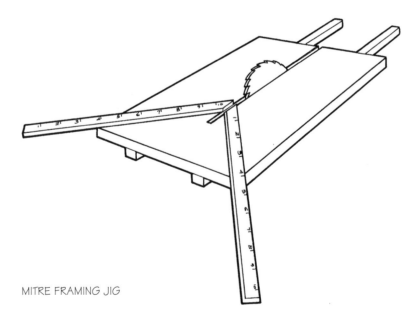

MITRE FRAMING JIG

variety. There is nothing wrong with doing a painting to the size of an available frame.

If you have someone else frame your work, remember that the professional artist assumes responsibility for what his or her final work will be—where it starts, and where it ends! The people who frame works of art aren't mind-readers. They do not know what your wishes are unless there are explicit instructions on the work. Allowing third-party control of image is fraught with difficulty at best and is most often a recipe for disaster. If you think you can give a work to a framer and expect some smudges removed you are living in "La La Land." If the framer has to ponder whether the fingerprints are part of the work or an example of sloppiness, his decision will inevitably be "part of the work." It's simply less work that way. Unless you tell him, how can he be expected to know it wasn't part of the work? It is the artist's right and responsibility to the collector, to history, and to the work itself to be in charge of all decisions affecting the way in which the work is perceived. I have a long-standing agreement with all the people who frame my work that they are not to use nonglare glass. If I had wanted to blur the surface of the work I would have done so. Nonglare glass has one surface sandblasted so that it won't have glare. While this does remove glare, it also eliminates completely the possibility of seeing the work exactly as the artist made it.

DANGERS TO AVOID

Don't roll drawings! If you absolutely must roll a work, roll it with the image on the outside. It is much easier to straighten out this way. Of course, no work should ever be rolled anyway. Remember that matte board comes in two sizes: 32" x 40" and 40" x 60". Govern yourself accordingly. Large glazed works should really be glazed with Plexiglas (thermal acrylate) rather than glass for safety's sake. If you

> What is commonly called *ugliness* in nature
> can in art become full of beauty.
> —*Auguste Rodin*

are using Plexiglas, the good news is that scratches can be polished out, it doesn't break, and it can be worked easily using simple workshop tools. Of course one has to remember that it is a thermal acrylate. Sawing with a table saw will often result in melting the cut which naturally rejoins itself in a blobby sort of way. My method of circumventing this is to adjust the saw to its slowest speed. Faced with a saw that doesn't have a variable speed, I make very small "bites," usually taking four passes to get through a one-quarter-inch thickness. The bad news about acrylates is that they age and are electrostatic in nature. When "plexi" first appeared on the market, it seemed that a lot of people's prayers were answered. It was touted as having a better refraction than glass. Best of all, it didn't shatter when it was hit with a hammer! Wow! Of course, they forgot to mention how easily the surface scratched or exactly what the electromagnetic nature of the material really meant.

In this game, we can all get burned and lessons are learned the hard way. The Royal Ontario Museum framed a couple of Frank Brangwyn's pastels in Plexiglas, recessing the images. A few days after putting them up on the wall, the cleaning ladies were going around and cleaning all the "glass" surfaces. They were horrified, as was the

director, to discover that rubbing the surface had built up a static charge that pulled all the loose pastel off the surface of the paper and redeposited it on the underside of the Plexiglas. Lest you think this has no relevance for you, heed the following. If you are doing large graphite drawings, you will find it necessary to use an acrylate such as Plexiglas to frame. Given the nature of acrylates to build up static electricity and given the nature of graphite, which is very slippery and merely sitting in the tooth of the paper, it is only a matter of time before the majority of the graphite will redeposit itself on the acrylate surface. Once it has left the drawing surface, there is no way to reverse the process.

Often framers have strange and curious preoccupations. My framer is definitely on the "buggy" side about hairs. Quite often he will get the work all put together, framed, and closed, only to discover on final inspection that there is a dog or cat hair somewhere on the work. This discovery forces him to take the whole thing apart and start over again. He was most insistent that I pass this observation along. If you can't keep your framer happy, who can you keep happy?

COSMETICS AND PRESENTATION

When an artist uses acrylic, it is common for pigment to bleed through to the reverse side of the canvas. Sometimes this is the result of working wet in wet, and other times it is simply the nature of the pigment used in manufacturing the colour. Many pigments are dyes rather than solids, and these are the pigments that often bleed through. Whatever the case, it always leaves the canvas with an unsightly blemish that might very well detract from a sale. In the normal course of events when a collector is purchasing a work, there will be the obligatory check of the reverse side for condition of the work. This is the point where a little bit of knowledge can really be

dangerous. Having read somewhere about the oxidation of oil paint destroying the canvas if unchecked, the collector views discolouring with great suspicion. Often he or she will back out of an impending sale at any sign of bleed-through colour. I have had personal experience with dealers who are equally in the dark. They are not to be blamed for their prejudices. It is simply where their heads are at.

It is important that you read carefully and in its entirety the following method of dealing with the problem before attempting any quick fixes. Our aim is to get rid of the offending discolouration, returning the surface as closely as possible to the nice off-white surface it was before. It is folly to simply paint the back of the painting white. There is every possibility that if the canvas or linen is a loose weave, the white on the back could very well bleed through to the front. This would ruin the work, of course. Before giving it a coat of white, I always lay in a good coat of transparent acrylic. Once the surface is well sealed, the white can be put on and the dealer has an additional sales pitch: "The artist cares so much about his work that he sizes the back of the canvas as well as the front."

CANVAS REPAIRS

In the normal course of events, the artist will be called upon to make repairs to canvases. The most common mishap is caused when someone (you[†]) has set it against a chair, and the arm or some other part has pushed the canvas out of flat, leaving a lump or bump. Simply damp the back of the spot and it should, on drying, return to its normal, flat surface. Those are the easy ones to deal with. More difficult are actual tears in the canvas.

For tears, take the canvas off the stretcher and lay it flat on a

† As Pogo was wont to observe, "We has met the enemy, and they is us!"

surface covered with polyethylene. (It would be a shame to repair the canvas and discover later that you successfully repaired it and glued it to the table at the same time.) Do a temporary, simple stretch with staples, and clean up the edges of the tear. Perhaps some of the weave is hanging in loose ends and needs to be trimmed. When the edges are cleaned as well as they can be, cut a piece of canvas substantially larger than the tear you are to cover. The rule of thumb I use is "the larger the tear, the bigger the overlap." For a one-inch tear, I will overlap an inch and a half on either side. Recently, a painting of mine had an adventure with a forklift that left an off-vertical eleven-and-three-quarter-inch tear. The canvas patch I used overlapped about nine inches on either side and four inches on top. This was probably overkill, but the painting had received some real trauma and I felt it better have the additional material for a comfort zone to withstand the restretching. I sketched the outline of the patch with charcoal (a totally inert substance) on the canvas back. Using a roller, I worked a generous amount of full-strength Lucite 44 (acrylic gloss medium) into the weave of the canvas inside the charcoal outline. Once the canvas was well saturated, I did the same to both sides of the canvas patch, working it thoroughly into the fibres of the fabric. I waited until the two surfaces were tacky to the touch, then put the patch over the tear and, placing some polyethylene on top, used a hard rubber roller to "work" the two materials together. After the Lucite 44 was well rolled in, I brushed an additional layer over the edges for good measure. (See the colour insert between pages 240 and 241 to see the tear and the finished painting after repair.)

There are two schools of thought regarding this point in the repair process. One method is to cover the repair with polyethylene, put a piece of plywood on top, pile some heavy cans of paint on, and go away. The other method is to stay really close, give it the odd roll

with the roller, push it down with your fingers, keep a vigilant eye on it, and worry a lot. I favour the latter approach. I already have a considerable investment in the painting and I have a problem with trust. In the past, I have had the occasional failure where one corner has lifted up, creating an additional hassle that had to be dealt with later on. Give everything ample opportunity to set and cure before turning the painting over. For me, "ample opportunity" is a minimum of twenty-four hours, and I am more comfortable with thirty-six.

Once the work is stretched, there will often be an open spot where the patch is showing through. This of course indicates that there is a hole in the surface that will have to be filled. There certainly was with my painting that the forklift went through. My solution was to take a tracing of the offending area and cut a piece of canvas to the exact dimensions which I subsequently glued in from the front. If the dip is of a smallish nature I would probably opt for some polyfilla or some calcium carbonate mixed with Lucite 44. If you use polyfilla, remember that some Lucite 44 on the surface will provide a nice ground to work over. My last act was to chronicle on the patch the way in which the painting received trauma and all the steps I took in repairing it. This chronicle also included the date on which it was all finished and my signature.

SUMMARY OF TOPICS COVERED IN THIS CHAPTER:

1. Some simple frames for small and large works.
2. The dangers of Plexiglas.
3. The importance of presentation.
4. Repairing a torn canvas.

 Notes

Simple pleasures are the last refuge of the complex.
—*Oscar Wilde*

Notes

No artist is ahead of his time. He is his time.
It is just that others are behind the time.
—*Martha Graham*

8. Building a crate

If you plan to make a name and a living as a professional artist, you will have to market your paintings in more than one city. It is an undeniable truth that your paintings will be much easier to sell on the home front if they are being marketed and sold somewhere else. As one of the collectors in Regina observed to me, "If you are that good, why are you still here?" The only logical answer I could give was to shake my head and walk away. It is a truism that a prophet is without honour in his own village.

However, getting a work of art from here to there presents its own problems as the following story so aptly illustrates. A soldier adventurer who was part of the court of Charles I overheard Charles waxing poetic about a particular work of art in Italy that he greatly admired and wished to acquire. The soldier departed for Italy where there was a war going on, and, as luck would have it, he acquired the work through force of arms. Since it was in an overly large bulky frame and he was on horseback, he cut it out of the frame with his

knife. Folding it up neatly to fit in his saddlebag, he raced off in the general direction of England with the smug knowledge that once Charles saw what he had obtained, his fortune would be made. On seeing a work of art that he had cherished utterly destroyed by a barbarian, Charles immediately banned the soldier from court for the rest of his life and told him that he should count himself lucky his life was being spared so that he could spend the rest of it making atonement for his precipitate actions.

Obviously, the work of art should arrive at the gallery in the same pristine condition that it left the studio. In extreme temperatures and over long distances, crating and shipping art is a challenge.

CRATING—THE ARTIST'S RESPONSIBILITY

Some artists say the problem of transporting works no longer exists because there are firms that specialize in moving paintings about the country. These do exist, and should you choose this method, it will certainly make life a lot easier for yourself. A simple phone call and they arrive with the white gloves to take care of everything. The demand created by public art galleries brought these firms into existence, and it is the patronage of these galleries that they chiefly rely on. Their fee schedule reflects it.

Unfortunately, most artists are not independently wealthy, as public art galleries seem to be. Taking responsibility for crating and transporting his or her work is important if the emerging artist is to come to grips with the "bottom line." The more self-reliant an artist is, the more he is in control of his destiny and his finances as well! To help you become self-reliant is, in fact, the main object of this book. I know from experience that the smallest hint of success will bring the most amazing array of leeches out of the closet! I am completely amazed at the variety of ways which people devise for relieving me of

whatever monies I have acquired from my art.[†] Assuming that you have decided on a career in art as a possible means of self-support, I offer the following as an introduction to one of the more challenging aspects of the business of being a professional artist.

A LITTLE BIT OF HISTORY

When I started out in the game, knowledge of how to build a crate was essential if you were living in the West. The galleries were in the East. It was that simple. Quite often the size of the work I shipped was governed by my ability to build a suitable shipping crate at the end of the exercise. The frames got narrower as the paintings got larger. When you had to pay shipping both ways only to be rejected by the jury, the sort of work you sent tended to be on the smallish side. It was usual for artists in the West to send works 2' x 3' and smaller to major shows in the East.

In 1960, a small group of us in Regina put an end to this by sending large major works to a National Gallery juried show. This was a first for those on the receiving end, and we created quite a stir doing it. I will never forget watching the crate's dimensions assume the astronomically large size of 6' x 8'. The biggest I had seen previously was 2' x 3'. This large crate forever changed the national scene. As it turned out, we were on the leading edge of a wave. Other artists began sending large works too.

The need for a large crate spread much faster than the knowledge of how to make one. Some artists built poor crates, overinsured, and

† Some artists are unwilling to accept responsibility for anything, even the paint on canvas. They sacrifice not only financial control, but artistic control, by sending the rolled-up works to the dealer who decides where to stretch to and how to frame the work. Abdicating to a dealer the responsibility of cropping the work is folly bordering on madness. The artists who choose this path are essentially telling the dealers to make the paintings, since it is the dealer who decides where the work will begin and end!

> Asked to define sculpture, Jules Olitski said it was
> the stuff you tripped over when you were backing up
> trying to look at a painting in a gallery.

prayed for a miracle accident so they could pay the rent and eat well. Inevitably, there were some large payouts. As a result, it has become almost impossible to find a carrier who will accept insured art works for transit. This situation has made it very difficult for those of us who are acting honourably and doing a professional job of crating our works. It is still possible to find a carrier, but don't expect to be able to insure the crate for its proper value. Those who have preceded you have destroyed that option.

THE PURPOSE OF A CRATE

A work of art is most vulnerable in transit. Once the works have left the studio, the artist is no longer in charge. There is no way of knowing how they are being treated or from what height the crates are dropped as they are shifted from one method of transport to another. We can reasonably assume that there will be at least five different times in the crate's journey that it will go through the process of changing vehicles. Whatever form of transport is used, there will be continuous movement, whether it is chugging along on a train or bumping along a highway on a truck. A crate's one and only

responsibility is to protect the work of art from any and all kinds of damage that might possibly occur. Let's look at some of the potential problems:

- Painting surface damaged by scraping or holes poked in canvas.
- Damage from the elements—heat, cold, or moisture—if left outside.
- Fire.[†]

Crating works of art is always a paradox. While the works must be held securely, they also must be able to float in all directions: up, down, forwards, backwards, and sideways. To accomplish this, we must cradle the work in a material that has a cushioned give to it. The choice of what to use is usually governed by availability. Anything that has limited cushion effect is good. I have used everything from scraps of shag carpet to rolled up newspaper. Styrofoam, bubble-pack, foam rubber, and carpet underlay are all good materials to use. Anything that has a certain amount of resilience will work.

OVERVIEW AND DESIGN CONSIDERATIONS

Distance: If the distance is negligible, and the carriers trustworthy, I often settle for wrapping works in cardboard. Sometimes I take chances I would not dare to take if the works were going on a longer journey, or with a carrier I wasn't familiar with. A nifty and easy way to pack paintings on a short haul is accomplished by using cardboard

[†] Saskatoon artists Bill Perehudoff and Dorothy Knowles had an entire show consumed by fire as it sat in a storage shed in eastern Canada awaiting trans-shipment. In a "catch-22" scenario, the price of insurace for full value was prohibitive so the show had been undervalued for shipment. As of this writing, I am unaware of any artists who insure their work full value in shipment. The shipper is shocked when he sees the real value and often refuses to accept the work. Who could afford the insurance anyway? Works in trans-shipment are usually accompanied by much angst and plenty of prayer. In most cases, that proves sufficient.

mirror containers that movers have. These contract and expand and are very handy for moving works over short distances.

Weight: Choose materials and a method of construction that will give you the maximum strength with a minimum of weight, minimum cost of materials, and minimum time spent on actual construction. I recently built a crate using Coroplast. Coroplast is the plastic wafer board that looks like corrugated cardboard. It reduced the weight of the crate by more than seventy-five percent. In addition it provided its own vapour seal. In limited situations, I think it could prove to be a very useful and attractive alternative.

Here is another lightweight, easy-to-make and easy-to-handle crate. While I haven't used it myself, I have seen it in operation and I think it is a sensible option. The key to the system is making works that are the same size and never putting more than four works in a crate. Cover two works that are the same size with polyethylene, put on corner protectors, and tape them face to face with 2"-wide 3M tape. Put 2"-thick sheets of styrofoam cut to size on either side of the works and tape all together using 2"-wide 3M tape. Cut pieces for the top and bottom, and finally for either side. Use the tape liberally on the bottom side because that is where the foam might get damaged.

Number of Uses: Another important consideration is how often the crate will be used. I didn't allow for this when I crated a show travelling to eight different galleries in two provinces. When the show finally returned to me there was very little left of the original protection I had built into the crates. Gallery damage reports kept getting worse as the crate's condition deteriorated along the route!

Size Considerations: When deciding what size of crate to build I first group the works by size into comfortable "moving and lifting" groups. Not only do you have to lift them out of the studio; somebody else has to do the lifting on the other end, too. I have been guilty of building

a crate that I could move, while forgetting that not everyone else has my size and strength. It is wise to keep this in mind and to design your groupings accordingly.

If you do nothing else, *be sure that you can get the crate you are about to build out of the room and the building you are making it in.* I have seen some awfully red faces when a beautifully built crate was too large to get through the door or down the stairs. Sometimes it gets through the door, down the stairs, and can't make a tight corner to get it out the front door. Yes ... all of the above have happened to me! While my solutions were devilishly creative, and quite clever, I would not wish the pain on anyone. The corresponding consideration is, of course, to make sure, if possible, that the crate will get into the place you are sending it to. Many paintings are unpacked out of doors (increasing the possibility of damage) because the crate is too large.

"USER-FRIENDLY" CRATES

Experience has shown me that a crate will be handled according to the way it looks. If it looks like it means business, it will get better handling than if it looks like a piece of junk. It may not be better built, but it will command attention. Build the crate with the same care and pride you took in making the works it will contain.

I still don't know where I am going to sleep tomorrow.
—*Claude Monet letter*

Remember that someone you will never see is in charge of handling your crate (and your works). Make the job as easy for that someone as is humanly possible. Handles are a case in point. I make them 27 to 30 inches off the floor, so that gripping the handle to move the crate and straightening the knees will lift the crate about 3 inches off the floor. In addition, I round the lower edges of the lift handle so that the sharp edges of the wood aren't cutting into the mover's hand. I started doing this for my own convenience. To my surprise, the person who picked up the crate for shipping thanked me for my consideration. I have been doing it ever since.

Always keep in mind the function of a crate. Its only reason for being is to provide safe passage for the works it contains. Think of the works as royalty. The closer you get to them, the more safeguards there are. All nails and screws, wherever possible, should face outwards rather than inwards. A nail or screw that has worked loose in transit has less chance of doing irreparable damage if all points are facing away from the works. However, it is not a wise idea to have points of screws or nails sticking out all over the crate. The people who handle them along the way do not take kindly to this and we definitely do not want to anger them! If nails or screws are sticking out, use a hammer to turn the points back in. It will give added strength to the crate. If you are using good-one-side plywood, have the good side on the inside. Always keep in mind that the crate exists to assist the works of art that it contains, and govern yourself accordingly.

In order to assist the person or persons at the receiving end of the process, it is vital that a simple, clear, logical order be followed in crating the paintings. This is especially important if you are crating a show that will be going to more than one place. Put signage and instructions on the crate that someone in grade three can understand. Print logical and unequivocal instructions on the side of the crate as to the

correct procedure for packing and unpacking the works (the same person may not do both tasks). While your show is on, there is a good chance that the crate has been left outside in the elements (due to shortage of space) and all the careful interior cradling that you have constructed with due care and concern is thrown in a heap inside. If a different person is recrating the show, he or she won't have a clue as to what goes where, and may come up with something creative to get the job done. Multiply this by a factor of five (or whatever the number of stops in the tour) and what is eventually returned to you will have precious little resemblance to what you sent out.

RECYCLING AND STORAGE

The chief problem with crates is that you only need them when you need them. At all other times, they are a hindrance and a nuisance! Of course, crates can be used for stationary storage of works in the studio—if you've got the room! If you have a crate that has been kicking around for a while, chances are that, when you need to use it, it has been outside and is exhibiting climate rot, or that it's not the right size. Having hit these walls a number of times over the years, I devised a system of semi-solutions. My crates are designed in a modular manner so that they can be dismantled and stored easily. When I need another crate, I rummage through my pile of crate parts. By adding various modular sections from former crates, I can usually come up with something that does the job. Although not as pretty as I would like them to be, they seem to get there and back in reasonable condition. The modular sizes I deal with use 4' x 4', 4' x 6', and 4' x 8' sections of plywood. This is a measure I have instituted because of the constantly rising price of wood. When putting handles on the end of the crate, I'm careful not to cover the screws that are holding the sides on so that these are easy to disassemble later.

BUILDING A CRATE: STEP BY STEP

Crate building tends to generate a lot of dumb mistakes. Most have to do with size! The most common error is not allowing adequate space for the frame; the second most common error is forgetting to add the thickness of the end to the length of the top and bottom. The wise crate-builder will continually check space allotments and measurements—not just as in the old adage "measure twice, cut once," but over and over again. It will pay off. You don't want to come to the awful realization that the paintings will not fit in the crate you made for them. Remember to build the crate so it can go through the door, in the elevator, or down the stairs!

Here are the steps I follow in preparing works for transport:

1. After the works are framed, I create the first layer of protection by covering the faces with a polyethylene sheet for moisture seal as well as protection against scrapes and dust particles (sawdust especially). After the plastic is stapled on, cushion the corners (see illustration on page 127).

2. Separating the works into similarly sized groups that an average man can lift, I determine the maximum dimensions of the works the crate will contain. Armed with these dimensions, I sit down with a pad of graph paper and, working from the inside out, I determine what size the crate must be to contain the works, making sure to leave room for the "float" and side walls. Usually assigning something like 3" to one square of graph paper, I visually assemble the constituent parts of the crate on the paper, writing in the measurements and drawing to scale. There are fewer mistakes using a multiple check system. Making allowances for cushioning and cradling the works on the inside, I eventually come up with the size I will be dealing with. I then double-check

my measurements. Whenever possible, I establish standard sizes that can be used again and again. For me, the canvas stretcher depth is 1½". To protect the surface, the frame has to be a minimum of 1¾". These are givens. I try to do two paintings the same size so that they can be taped together face to face, thus affording the maximum of protection. Add a ¼" allowance for the corner protectors and you are up to 4" for two works taped together.

3. For works that are over 4' x 6', probably three is all you will get in a crate. Under that size, you can probably get six in. The exercise in counting off the space needed for the walls of a crate that will hold four works goes as follows:

¾" (so-called 1" x 2") + ¼" plywood for back of crate = 1"

4" (two paintings strapped together and cornered) x 2 = 8"

¾" (so-called 1" x 2") + ¼" plywood for front of crate = 1"

two 1" styrofoam sheets to float works front & back = 2"

= 12"

This calculation determines the thickness of the crate—that is, the width of the bottom, top, and end walls.

4. Having determined the thickness of the crate, we can now deal with the size of the actual crate. Plan the interior so that you are using space in the most efficient way and add between 3" and 6" to the largest vertical and horizontal dimensions. I prefer to have 6" of space, if that is practical.

5. Once I have these dimensions, I can figure out the other dimensions of the edge of the crate. We have already figured out the width in step 2 so once we have the height and length we can make the decision as to what sort of crate it will be. If the vertical dimension is over 4', I usually build a cap crate. If it's 4' or under, I use the regular, run-of-the-mill variety. There is nothing

worse than an unnecessary crate in the studio. It is also disheartening to watch a good crate that you've invested time and money in disintegrating in the weather outside. So what to do? My answer to the problem is to build crates using 4' x 4' and 2' x 4' modules. The pieces store easily and are there for reassembling with additions or deletions as the case may be. When you carry on an art business in a confined space, you have to get pretty creative about "things" in the space. As you can see from the drawings of crates on pages 124-126, the 4' x 4' and 2' x 4' modules work reasonably well.

6. Remember to put your good surfaces on the inside. The crate is made to protect the paintings, not to look good. I know that earlier on I said it was important for a crate to look good, and this still holds. If you pay attention to the little details on the outside, it will be enough to communicate to whoever is handling it that there is something of worth inside. Start off with the bottom. With the bottom piece cut, put a couple of skids on, as per illustration. Make another for the top of the crate. When you make

I think people who are not artists often feel that
artists are inspired. But if you work at your art
you don't have time to be inspired.
Out of the work comes the work.
—*John Cage*

the vertical ends, be sure to add on the 2" thickness of the combined bottom and top lengths.

7. If the crate is on the smallish side, once the top, bottom, and ends are put together, it would be a good idea to put the handles on. I prefer to use plywood so it won't split and I position the handles about two feet from the ground. For most handlers, this will mean a slight bending of the knees to use the handles. If I am constructing a cap-type crate, I join the two ends to the bottom and stabilize the crate with one side wall. Now that we have all the dimensions of the crate more or less pinned down, and the side walls built, let's start putting it together. You will probably have to get creative when you are putting the constituent parts of the crate together. Hold the side wall vertical by placing it in a vise, by temporarily tacking it to a wall or table, or by having someone hold it. Once it is stable enough to nail or screw, place the bottom with the skids flush with each end and attach. This is where an electric drill really comes in handy. My preference is to use drywall screws. Position the other side wall flush with the edge and end, putting one screw in at the end to hold it. Now you can put screws in down the edge, removing whatever it was you used to temporarily keep the other wall vertical. Remember that we are dealing with cheap wood that a lumber company would have been too embarrassed to sell twenty years ago. It is most likely to be warped. Always start your screws or nails at one end and proceed to the other, correcting the warp as you go.

8. Lift up one end and put the top under the two vertical side walls. This is necessary because of the extra length of the side walls. With the side walls off the floor the appropriate amount, it is a simple matter to screw or nail the end walls. Once both ends are on, turn the crate over.

9. Prior to packing the paintings, put in whatever system you are using to cushion them from the bottom. Next, put the paintings in, making sure either to seat them in the slots you have provided or to rest them on the "cushions" the right way.

10. Insert strutting and superstructure as necessary to stabilize the works as per the various illustrations I have provided.

11. Before you put on the top, check everything to see if it conforms to the basic rules of free float in transit.

12. With a red plastic marker, circle on the outside the screws to be removed in unpacking. Label and affix an envelope on the inside with a list of contents and unpacking instructions.

13. Put the top on and do the appropriate signage on the sides. Whenever I think of appropriate signage I always remember being advised by the National Gallery to put "cabbage" on the sides of our crates to get good treatment in transit. I've forgotten who said it but I remember the looks of absolute incredulity on the artists' faces when they were told to mark their crates as cabbages. I can't think of a single artist who did.

It is important to provide your work with a barrier to moisture. The minimum requirement is a sheet of polyethylene stapled over the canvas. If you can afford it, also staple a layer of tarpaper to the inside of the crate for additional protection.

As I said before, when you crate paintings you must cradle the works in such a way that each is allowed to float independently of its neighbours in the crate. Since the corners of a painting are its most fragile part and most likely to be damaged, the first thing we will want to attend to is cornering. After we have the plastic stapled over the face of the work, we can proceed to wrap the corners in whatever material is available. It could be bubble-pack, foam rubber, or something as basic as four or five sheets of newspaper folded over; what you

> When Earth's last picture is painted, and the
> tubes are twisted and dried, When the oldest colors
> have faded, and the youngest critic has died, We
> shall rest and, faith, we shall need it—lie down for
> an eon or two, Till the Master of All Good Workmen
> shall put us to work anew.
> —*Rudyard Kipling*

use doesn't matter so long as the corners are guarded. After this has been done, proceed to place the works in the crate while following the cardinal rule of having each work float in all dimensions independently. See illustrations.

When you crate works, start by inserting the largest works in the crate; finish with the smallest. The person who is faced with unpacking at the other end is able to see at a glance the work ahead immediately upon removing the face of the crate—assuming that they have removed the face they are supposed to remove first (which is why it is best to indicate clearly which side that is!).

I have drawn the three basic types of crates you will come into contact with most often. While the illustrations on the following pages show a variety of crating procedures and protocol, the crate you make will more than likely be somewhere between what is illustrated and a simple roll of cardboard around the work.

TYPICAL PACKING CRATE (front and top load)

A. Walls constructed of ¾" plywood and screwed together.

B. 2" x 4" or 2" x 6" skids on the bottom to get it off the floor (water) and facilitate moving.

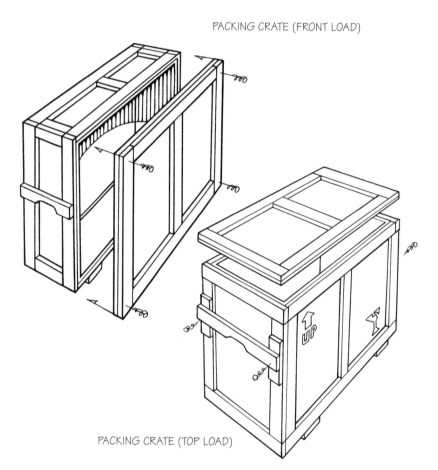

PACKING CRATE (FRONT LOAD)

PACKING CRATE (TOP LOAD)

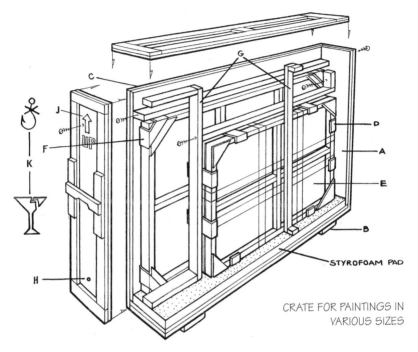

STYROFOAM PAD

CRATE FOR PAINTINGS IN
VARIOUS SIZES

C. Module wall of crate formed by ¼" plywood reinforced with 1" x 2" struts two feet from end and 1" x 4" in the centre, assuming the crate is eight feet long.

D. Foam rubber inserts to allow the work to float.

E. Painting.

F. Foam to protect corners of the work.

G. Interior bracing to cradle the painting.

H. Screws holding interior cradles in place circled in red with order of removal clearly marked.

J. Top clearly indicated with felt marker.

K. International symbols for USE NO HOOKS and FRAGILE in felt marker.

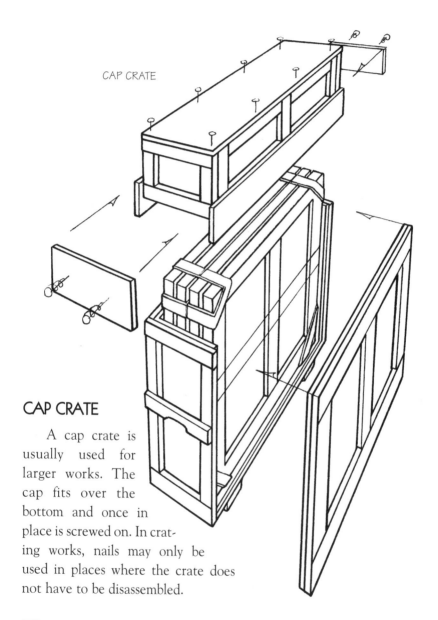

CAP CRATE

CAP CRATE

A cap crate is usually used for larger works. The cap fits over the bottom and once in place is screwed on. In crating works, nails may only be used in places where the crate does not have to be disassembled.

SLOTTED CRATE

A slotted crate is most commonly used when you are travelling a show of drawings or watercolours that are glazed and the same size. This crate usually has a foam rubber bottom allowing the works to float while their other movement is gently restrained by the slots. Usually the slotting is covered in felt or something equally soft to cushion the movement of works. One point to remember when you are crating glazed works is to put a grid of masking tape over the surface. If the glass does break, the masking tape will hold it in place and arrest the possibility of doing further damage.

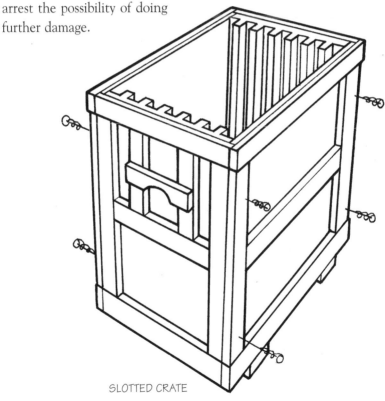

SLOTTED CRATE

CRATE HANDLES

The three most commonly used crate handles are polypropylene rope, standard metal, and wood. Pick the appropriate handle for each crate. Use the rope handles for a lighter crate. (The top illustration shows the steps in making a polypropylene rope handle. With one end knotted, thread through holes, and knotting other end, fuse with heat.) Use wooden handles for your heaviest crates. I use the standard metal handles most often for a small slotted crate that contains drawings.

TYPES OF CRATE HANDLES

CRATING VERY LARGE WORKS

Just before we leave the matter of crating, there is one additional matter I should mention. I am currently in the process of crating a work for Toronto that is too large to send as it is. I will have to fold the work to send it. This involves some special considerations. Simply cutting the stretcher in half and folding the work isn't an option. That puts the paint film under undue stress where it is folded. The possibility of doing irreparable damage to the work is such that a way must be found to alleviate and defuse the stress of the fold. Crating extra-large works for shipment is a two-stage procedure which requires considerable forethought. When constructing the stretcher, keep in mind that a 50-centimetre section in the centre will be removed so that it may "break" in the middle. The illustrations

FOLDING STRETCHER WITH SADDLE (1)

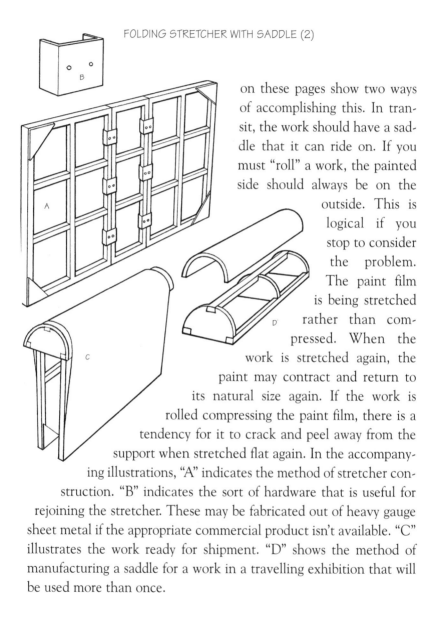

on these pages show two ways of accomplishing this. In transit, the work should have a saddle that it can ride on. If you must "roll" a work, the painted side should always be on the outside. This is logical if you stop to consider the problem. The paint film is being stretched rather than compressed. When the work is stretched again, the paint may contract and return to its natural size again. If the work is rolled compressing the paint film, there is a tendency for it to crack and peel away from the support when stretched flat again. In the accompanying illustrations, "A" indicates the method of stretcher construction. "B" indicates the sort of hardware that is useful for rejoining the stretcher. These may be fabricated out of heavy gauge sheet metal if the appropriate commercial product isn't available. "C" illustrates the work ready for shipment. "D" shows the method of manufacturing a saddle for a work in a travelling exhibition that will be used more than once.

AFTERTHOUGHTS

Since penning the first edition, I have had some additional thoughts on crating works. After forty years of the "same old same old," rethinking this crucial part of the strategy has been an interesting process.

I had been making crates for shipping paintings around the country for over forty years when someone put a forklift through a crate I had thought invincible. I had always believed a "well-made" crate would command respect from those who handle it. In December of 1998 I learned otherwise. If someone wants to put a forklift through a crate, it doesn't really matter how well made it is. Making the crate look invincible was, as it turned out, *not* in my best interests. A crate that looks invincible is treated differently than something that looks vulnerable. The incident was a wake-up call that prompted me to rethink my whole shipping strategy.

There has been an explosion of new plastic materials that are light, durable, and resilient. Being resilient is quite useful. If that ill-fated crate had been built with a material that gave a little bit and was a lot lighter, it might have survived the forklift attack. Instead of sitting there like the Rock of Gibraltar as an immovable object, the crate might have simply bounced off and fallen over. Had this happened, the operator would probably have been alerted that there might possibly be something wrong.

Of course for works that are travelling to more than one venue, I would still recommend the more substantial, traditional approach to crating. However, most crates are for one-time usage only and the introduction of plastics has substantially changed my strategy.

My new take on one-time crates is to contruct the crate from the inside out, opposite to the usual method. First, I try to make works in

> You often find your destiny
> on the path you take to avoid it.
> —*Chinese proverb*

pairs so they can be put face to face. Putting two sets of two together makes the crate about as heavy as I want it to get. Starting with a skin of plastic, I wrap the two paintings together with a product called *flat twine*. Anyone who has been to a lumber superstore will recognize the flat twine as the plastic film they use to tie-wrap materials together. The beauty of this particular product is that it wants to stick to itself, as well as to contract. This has the effect of holding the two works together very securely without damaging them. If I'm crating two sets of two paintings, I use the flat twine to tie them all together. Using 1" high-density styrofoam, I construct ends, top, and bottom, tacking them loosely together with masking tape. At about this point in the procedure I usually ask myself whether I am really sure I want to send off $30,000 worth of paintings in such a flimsy manner.

Now that the dimensions of the crate are established, I skin the exterior with Coroplast (the plastic sheeting that looks like cardboard), wrapping it around the bottom and folding it over the top so that the entire surface is completely skinned. I use masking tape as a temporary holding device. Doing a final wrap horizontally and vertically with the flat twine pulls the whole crate together as well as providing handles for moving the crate. The result is a surprisingly

lightweight crate. The truckers who do my pick-ups have been doing so for the last twenty years. They are always surprised at the lightness of the crate and occasionally ask, "Are you sure you put the paintings in?"

SUMMARY OF TOPICS COVERED IN THIS CHAPTER:

1. Necessity for knowing how to build and pack a crate.
2. A generic crate and its anatomy.
3. Different kinds of crates and how to construct them.
4. How to organize and pack a crate.
5. Short haul versus long haul and other solutions.
6. Observations and problems to watch for in building crates.
7. The modular system of crating.
8. Floating a work of art in a crate.
9. Proper protocol for labelling a crate.
10. Crating large works.
11. Additional thoughts on the use of light plastics as an alternative for crating.

 Notes

The worst part of success is trying
to find someone who is happy for you.
—*Bette Midler*

 Notes

Art is the incomprehensible density of cosmic forces
compressed into a small space.
—*David Bomber*

 Notes

I don't think you can prevent an artist from being
and I don't think you can cause one to be.
—*Robert Engman*

9. Photographing Works

The mysteries of parallax.

The ability to photograph a work well is almost as important as the work itself. Career decisions such as whether you are headed for the dumpster or the stars are often made on the basis of the reproduction of a work rather than on the actual work. If the reproduction doesn't "image" the work in an accurate and sympathetic way, it becomes a destructive rather than a positive force.

GETTING STARTED

Let's begin with some assumptions. The first is that you have a reasonable camera and accessories. The second is that you know how to use them. If you don't, buy a book on photography and familiarize yourself with it. The other understanding we must have is that we are artists, not photographers. I know enough to take reasonable slides and pictures of my work, and that is all I want to know. I'm juggling enough other things as it is. There are some images, therefore, that we artists shouldn't even try photographing. Sometimes it is better to

admit defeat and get a professional photographer to take the shots. Black-on-black and white-on-white are two possibilities that I would never even consider trying to photograph. What we'll deal with here is the usual run-of-the-mill imagery.

Even with run-of-the-mill photography, there are a few stumbling blocks and many details to keep in mind. Photographing a painting that is varnished often results in glare knocking out as much as 75 percent of the image. It is the nature of a photograph to be perceived as a work of art in and of itself, so remember to isolate the work from its environment, filling as much of the viewing area as possible while still maintaining a sense of scale. Objects that are not part of the painting yet in the photograph will often seem to be part of the work of art. Of course once you isolate the work there is no reference to scale. You may overcome this by including a yardstick on the side to provide that sense of scale.

STEPS TO SUCCESS

The technology of film is so advanced that, for our purposes, we don't have to worry about fast or slow film. I usually have good results using a film speed of 400.

I prefer to photograph outside on an overcast day. The even, natural daylight means that I don't have to worry about hot spots, glare, and all the other problems that shooting with artificial light presents. When I must photograph inside, the following is what I generally do:

1. Cover the painting wall with a dull black cloth. This is done for two reasons: first, the black will eliminate glare bouncing back into the camera; second, black around the works really enhances the images.

2. Position the work on the wall so that it is in the center; level the horizontal frame and the vertical picture plane. This is best done

with a level rather than trying to eyeball it. If you have a little extra cash, you might want to try a laser level. They are pricey but will save you a lot of time and frustration. The crosshair option guarantees that the camera is positioned in the centre of the painting. (I also use mine when I am tacking up a canvas to paint. The horizontal reference guarantees a level canvas.)

3. Place a Kodak colour bar and grey scale below or to the side.

4. Set up your camera so that the lens and the center of the painting are at right angles to each other and at the same level. Make sure that your lens is holding the same vertical and horizontal plane as the painting. I have a little plastic level I keep specifically for this purpose. Failing to get everything lined up correctly results in the print exhibiting "parallax." This is when one or more sides won't be square and one side is bigger than the other. It can escape notice in the viewfinder yet be very noticeable on the print.

5. Using 3200° Kelvin lights, set them at 45° angles to the work as far back as you can. The lights should have wide-angle bell reflectors so that the light is diffused as much as possible. To check how well you have done this, hold a pencil about six inches off the

The only reward one should offer an Artist
is to buy his work.
—*Auguste Renoir*

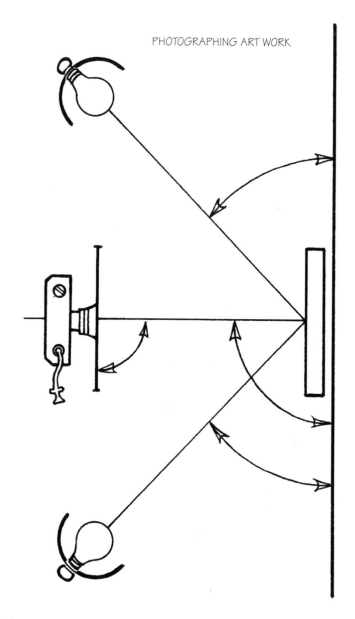

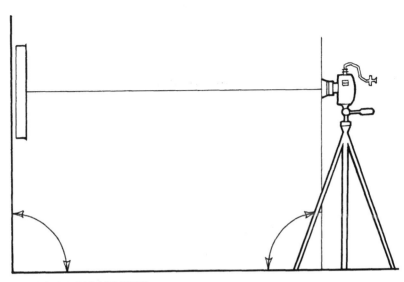

PHOTOGRAPHING ART WORK

centre surface of the work to be photographed. The shadows on either side should be uniformly dark and equidistant from the centre. Do this in each of the corners, too. The shadows won't be equidistant but they should be the same tone value. It is important that the work be uniformly lit. Using your best artist eyes, get directly behind the camera at exactly the same level as the camera and look at the way the work is lit. Is the light uniform over all the work? Can you see any hot spots? If there is a hot spot, you will have to get rid of it. Be innovative: I have hung plastic and such things as cheesecloth to diffuse the light a little. Of course, once the light is diffused from one side this will put the other side out of balance which will also have to be addressed. If you are using an automatic camera, don't worry about the low level of light. The painting isn't going to move, and whether it takes the

camera $1/250$ of a second or five seconds hardly matters, as long as you use an offset shutter release. The process of taking a photograph is always the same. The shutter is opened and stays open until enough light has been gathered to process the information.

AFTERTHOUGHTS

In the three years since this book was first published, computers have, of course, continued to change the way we work. Let me walk you through the methodology currently in vogue that I recommend and use.

If you hate computers, don't have one, and refuse to get one, you might as well skip over this section. To do so would be a mistake as everything seems to be headed for a digital horizon. First of all, let me give you a first-hand example of just how efficient computers can be.

Recently, I wanted to digitally record a major travelling historical exhibition of my work. The exhibition was at the Mackenzie Art Gallery in Regina. Given the size of the exhibition and based on past experience, I booked three days to accomplish my goal. I appeared at the gallery Monday morning, the show was recorded by noon, and I was back in Calgary that night. The beauty of the "system" was that even though we were photographing really large works, I knew I would be able to correct parallax with the distort and skew features of my software, so I wasn't spooked by the problem.

My "system" is an inter-related high-end digital camera and computer with appropriate software. My camera is rated 4.3 megapixel, which means that it gathers sufficient information to produce an 8" x 10" image virtually indistinguishable from a real photograph. My computer has a USB port, which means I can enter the information about the photo directly into the computer. Once it is in the computer I can open it in a software program for manipulating and enhanc-

ing photographs. I can straighten something crooked, make the colours a little more intense or a little brighter — or toned down, for that matter. I can produce the work in greyscale which is useful to check out tonal values. All in all, there are any number of ways in which I can examine and change the nature of the work. The range of options is seemingly endless.

SUMMARY OF TOPICS COVERED IN THIS CHAPTER:

1. Establishing scale when photographing.
2. The use of natural light and Kodak colour-correction strips.
3. Photography setup in studio.
4. The digital world.

 Notes

Extreme remedies are appropriate
for extreme diseases.
—*Hippocrates*

 Notes

The artistic temperament is a disease
which afflicts amateurs.
—G.K. Chesterton

Notes

Nothing is interesting if you are not interested.
—*Helen McInness*

10. Inventory, records, and all that jazz

All the stuff you didn't want to hear.

In 1976, a Revenue Canada sweep of West Coast artists had as its main targets Jack Shadbolt and Toni Onley. Revenue Canada usually squeezes the big guys. When there is enough blood on the floor from the big guys, the rest of us get into line very quickly. Toni tackled the problem with his customary flair by publicly burning his works. Jack Shadbolt dealt with it in the dignified manner we would expect from the senior statesman of Canadian art. On the witness stand, wearing a three-piece suit and looking very senatorial with starched white shirt and conservative tie, Jack drew himself up to full height and delivered the pronouncement: "Just because I look like an accountant, doesn't mean I am one."

Before delving into the mysteries of record keeping, it is important that you ask yourself some questions. Do you believe accounting and inventory necessary and important activities of a professional artist? Do you plan on being successful? If your answer to the first question was "no" and your answer to the second was "yes," you have

a significant problem. You see, if you work at your career, there is a good chance that success will come to pass. When this happens, you acquire a visibility that spells an end to the "luxurious anonymity" of failure. The loss of anonymity ushers in attendant problems. This is okay when someone calls you by your first name at gallery openings. But when the tax department decides that it is the appropriate year to delve into the affairs of artists in your region, they don't choose at random! Candidates for audit are chosen to achieve the maximum effect with minimum effort. As I said earlier, when the big ones are squeezed, the smaller ones get in line real fast.

In criminal law, you are presumed innocent until proven guilty; in tax law, you are presumed guilty until proven innocent. Having been through this particular exercise myself, I can assure you that it isn't much fun! If they say you owe them $50,000, you do, and they want it immediately. Their policy is: "Pay it now and prove us wrong in court. If you are right we will give you the money back with interest."

Dorothy Knowles of Saskatchewan got so rattled by a tax audit that, on being shown three Polaroids of her work, she denied having made them! This event immediately perked up the ears of the RCMP,

Artistic temperament sometimes seems a battleground, a dark angel of destruction and a bright angel of creativity wrestling.
—Madeleine l'Engle

who thought that they had uncovered a major international forgery ring. I can sympathize with her.[†]

THE TRIALS OF TEDDY

Coming out of art school in the mid-1950s, we understood the politics of despair. There was no Canada Council to spoon-feed us and no hope of earning a living from our art. We relied on peripheral activities to keep us alive. I've worked variously as a sign writer, window dresser, art director for a TV station, neon designer, designer of store displays, and finally as a professor of painting in a university. None of us thought it strange that we couldn't do art full-time. Art was the important mission we had predicated and dedicated our lives to. Simply put, it was our "habit"! We all had other jobs which enabled us to make a living. We lived in a world where we did not expect to sell our art; nor could we foresee a time in the future when such a thing might happen—so why bother keeping track of expenses?

So I didn't! Bopping along the great highway of life, I never kept track of any expenses incurred in the making of art. Canvas, brushes, paint, studio space, and all the other expenses were paid out of pocket. It didn't occur to me that some sort of record should be kept, so I had no system for keeping track of anything. I didn't even bother keeping an inventory of work. To be frank, I thought that artists who did that sort of thing were being more than a little pretentious.

There are two events in my career that changed my mind. The first and more minor of the two was the event of finally selling some

† A small digression: Nathan Stolow of the National Gallery uncovered a major Group of Seven forgery ring when the paintings were x-rayed. On the x-ray it plainly said MADE IN JAPAN. As it turns out, the plywood they were using had MADE IN JAPAN stamped on the inner piece. Only in Canada!

art after eight years of obscurity. To my naive surprise, the tax man would not take my word about the expenses I had incurred, but was more than willing to take his "bite" from the money I had made. Without records, I didn't have a leg to stand on and I suffered a considerable financial loss. At the time, an artist was allowed to go back five years in terms of expenses. After this little adventure, I started to keep records—of a sort. I used the "shoe box" method. You just throw all bills into a box and, yes, a shoe box was and is the best! At the end of the year, you take them out and sort into categories. I really resented the lost painting time, never really understood the process, and was half-hearted about the whole thing.

Event number two was my big adventure! One day I was finishing a watercolour entitled *dance of the scissors*—two large scissors dancing across a tartan plane! How apropos! The phone rang, and my wife took the name and number to call back. Neither the phone number nor the name was familiar. When I returned the call, the mystery caller advised me that he was from Revenue Canada and said he would like to come out and see me. It was close to lunch, so I suggested the afternoon. He replied that he would come right over. WELL! Twenty minutes later I answered the door to two people. The Revenue Canada fellow was accompanied by an RCMP officer! WELL...WELL! They came in and requested that I hand over all our records. My wife withdrew from the room (I didn't even know where they were kept) and returned with two shoe boxes. By this time, we were serious enough about accounting to keep two boxes: one for the current year, and another for all previous years. I learned later that it is standard procedure to have an RCMP officer with a search warrant ready in case the person being investigated refuses to surrender the records.

From here on in the whole thing plays out like a bad LSD trip. I

was summoned for a noon appointment (HIGH NOON?) the following day with the person who was in charge of the overall investigation. To this day I can hardly believe that his name was Wolfe. The evening before, over a few drinks with friends, I had intimated that when I met this Wolfe I had in mind to introduce myself as Ted Rabbit. My preparation for the meeting consisted of acquiring the services of a bank employee who said that he would take care of my books. As it turned out, his first official duty was also his last.

The officer assigned to my case led us into a conference room with a long table. We sat at the end closest to the door and Mr. Wolfe sat at the opposite end. Since he was sitting in front of a window, his features were backlit and not readily discernible. One could definitely see the whites of the eyes of my newfound accountant. It sure wasn't looking good.

The investigator looking into my affairs began his recitation of the—in his words—"woefully inadequate state" of my records. "Mr. Godwin's records and inventory are incomplete, and his accounting leaves a lot to be desired." The shadow at the other end of the conference table pondered this state of affairs for a few moments and made his move. Turning his head slowly and moving from the shadows into the light, he looked at me with an intense gaze and said,

The only thing you have to fear more than failure
is success.

"We're on to you, Godwin, and we're going to get you! You're going on the accrual method." A stunned silence followed, broken only by a gurgling sound in the throat of my new accountant who then mumbled something about not being familiar with the way we had been keeping records, that he was of no help, and that he thought it best if he left. Getting up and exiting, he made good his word. My first question after recovering from the shock was to enquire just what "accrual" meant. I didn't know what it was, and refused to believe it when I was told. After some twenty minutes of explanation, I was plunged into the deepest pit of despair I have ever known. It felt like the gates of hell were closing on me and I was powerless to do anything about it. Let me explain.

The accrual method of accounting is a particularly vicious method of bookkeeping. Those who use this method pay tax on all work in the year in which it was made, whether it is sold or not. It finally sunk in that they were demanding I immediately pay tax and back-tax on all the work I had ever made, and that I would have to pay tax on all work I was going to make whether it sold or not. I suggested that they were requesting I become bankrupt and cease being an artist. The reply I received was that that wasn't their concern. I told them bluntly that if this was the case, I would burn all my works in front of their building rather than be forced into bankruptcy as they were suggesting (this was ten years prior to Toni Onley's burning).

I found myself writing to the prime minister, the leader of the opposition, my member of Parliament, and anyone in authority who I thought might help. Over the months, Revenue Canada became a little easier to talk to, although not much. This was the start of a three-year relationship that really wasn't much fun. I spent many days down at their office in a small cubicle with two people who wrote down every word that was uttered. They required that I co-sign both docu-

ments as being accurate before I was allowed to leave. During these sessions I would be shown a Polaroid (I have no idea where they got the pictures from) of a work that I had done as much as ten years previous. They asked who I had sold it to, when I had sold it, how much I had been paid in cash, how much by cheque, and if I had been paid in cash, what I did with the money. Three years later and some $15,000 out of pocket, it ended. They still have our records, and although I could donate them to the archives, I'm not asking that they be returned. Although this all happened back in 1974, I am simply too afraid to ask for them for fear the pain might start again. Just writing about it gives me the willies. It was not a happy time, but I did learn some very valuable lessons.

We now keep accurate accounting and inventory records. The method of accounting that I use is that a work of art is worthless until it is sold. This is actually a very sensible system for all concerned, including Revenue Canada. A painting from the early years that I couldn't sell for fifty dollars was recently sold for $15,000. Revenue Canada was quite happy to receive their cut, and because I waited until the work was sold to declare revenue, I wasn't forced to choose between burning it or declaring bankruptcy. I suppose we should

On an instrument you start from one tone.
In painting you start from several.
—*Paul Gauguin*

thank Revenue Canada for showing us the error of our ways. I hope you enjoyed reading the foregoing more than I enjoyed remembering it. More importantly, I hope you will learn from my mistakes, and pay close attention to the following notes on inventory and accounting!

INVENTORY

Before getting into the logistics of a sane inventory and accounting system, I should warn you about some pitfalls of the gallery game. Basically, commercial galleries are nothing more than a shell game with artists and collectors as sucker bait. Now what I just said is obviously not true in all instances. As a matter of record, in my experience, it has seldom been true. Having qualified all of that, however, I will serve you better if I instill a healthy state of paranoia relative to all gallery dealers. It is a position of strength from which to operate!

There are many dealers who are legitimate business people with honour and honest intent. The problem is that there are some who are as crooked as the day is long and, if I can't tell them apart, what chance do you think you have? A gallery may be a smoke-and-mirrors operation or it may be legitimate. Either way, no one is the wiser until the balloon goes up, and then it is too late. Remember that anyone can rent a space, call it a gallery, and find gullible artists who will let

Works of art are landscapes of the mind.

them have work on consignment. There are always more artists than there are galleries and often artists will take the chance and hope against hope. As long as these dealers keep appearing in $800 suits exuding confidence with the kind of oleaginous smile that they are famous for, there will be artists and clients only too willing to be fooled. Sitting and having a cup of coffee with one of these barracudas, I was startled when he sat down and exposed the sole of his shoe which was worn right through! That said it all to me.

The point is that, even though not all dealers and galleries will use smoke and mirrors to take advantage of the unwary artist, and even though many are quite trustworthy, and some entirely so, you still ought to be responsible and accountable for your own inventory and accounting. Some dealers have a numbering system known only to themselves. Others list by media. Some use alphabets and numbers in mystical ways which confuse and obfuscate. Whether or not they do this intentionally is a moot point. You should consider not only tracking your inventory with some sort of logical system like the one laid out below, but also cross-referencing your work to the particular inventory system that individual galleries use. Doing so will save you a lot of hassle and time later on. Pulling my works out of a gallery was a lesson in confusion. Reconciling inventory listings from their system and inventory listings from mine was like having to pair up apples and oranges.

There are many different methods for keeping a clear and concise accounting of what you have done, when it was done, what it is made of, its monetary worth, its location, and its size. Some systems assign number designations, while others assign letter codes. Some artists take Polaroid pictures of everything they have done; others inscribe the completion date (say 21-3-94) on the back of each painting, using that code for all other references to the work. Some have a sheet for

each work, modelled on the condition report of a painting for a gallery. The bottom line is that these systems all work if you work at them. Following is what I feel is the minimum information an artist ought to keep in his or her inventory. Beyond that, find your comfort zone and go with it.

YEAR: Max Bates once told me never to put the year of the painting on the painting. In his words, "Collectors get funny about years; they have their favourites." This advice is excellent, as some collectors do get "funny" about years. Having said that, we still have to have some notion of when the work was made. The best place for that sort of information is in your inventory listing. Whether you are filing the records manually or in a computer, assigning a "year" enables you to file the works in chronological order.

TITLE: The inventory method you choose may determine to a certain degree what you end up calling the work. Titles are often determined by the amount of space available. Many will choose to put their inventory on some sort of computer and computers are notorious for allowing only so much space per entry (although this is changing with the newer programs).

MEDIA: Over the years the computer has forced me to create a code for media. My code is as follows:

The journey is its own reward.
—*Homer*

Oil/C	oil on canvas
Oil/P	oil on panel
WC	watercolour on paper
A/C	acrylic on canvas
A/P	acrylic on paper
Ink/P	ink on paper
MM	mixed media

SIZE: Size should be listed in centimetres with the height of the work always listed first. For a long time, I was guilty of putting the measurements in feet and inches. A gallery director brought it home to me when he said, "Get out of the trenches, Godwin, the war is over. The only people still using feet and inches are old fossils just too set in their ways." This last remark got my attention.

PRICE: Price should be self-explanatory but, as usual, things are more complicated than that. The price that you have in your inventory should be the retail price the gallery charges, with applicable federal taxes included. At the bottom of the inventory page you send to the gallery, it should be noted that GST has been included and provincial taxes should be added where applicable. Most of you will have some sort of computer system to keep track of all this. Those of you who don't should really think about getting one. Computers are user friendly, cheap, and don't mind taking care of all the stuff we artists hate.

DISPOSITION: The disposition entry is supposed to tell you where the work is. It should come as no surprise that this is a large grey area. It is one thing to write something under this heading denoting the whereabouts of the work. This may or may not tell you where the actual work is. The fact is that sometimes you know, and sometimes you don't know. However, putting something down here will at least give you a starting point for any enquiries.

At this particular point in my career, I would really like to know where my works are. Given the state of my early records, finding them all would be an absolutely hopeless process. At one point in my career, I couldn't be bothered with such mundane detail and now I am paying the price for it. When I have a major retrospective that will be a summing up of my career as a painter, it will be incomplete because of my poor record keeping.

PROVENANCE: Every work of art has a provenance. Provenance is the term that is used to denote the history of the work. It might read something like:

Consigned to gallery	March 1991
Sold to X Corporation	November 1992
Consigned to Auction	June 1993
Purchased by H. Brown (address)	June 1993
Exhibited in artist retrospective	October 1996
Donated to National Gallery	December 1996

REMARKS: This entry is to record any anecdotes about the work.

Whatever system you choose, be fanatical about keeping it up-to-date. I now consider inventory in the same ilk as brush cleaning: just one more thing you have to get used to doing on a daily basis. Once you get the habit and get used to the regimen, it isn't all that bad.

A WORD ABOUT COMPUTERS

A computer is by far the best way to keep inventory records, do your accounting, and keep up your correspondence. At this point they are all user friendly and it is quite easy to get comfortable with one. If you are starting out, don't go looking for the current state-of-the-art, super-high-performance model. Look for the second-hand computer shop in your city and go with a friend who knows something about them. Your shopping list is simple: something that will handle your

accounting, inventory, and correspondence and possibly some simple graphics, as you may want to design a brochure or poster for an opening. If money is a problem, the graphics potential is nice to have but not necessary. The best way to learn how to use a computer is simply to turn it on.

It isn't absolutely necessary to have a computer, just as it isn't absolutely necessary to have an electric stapler. If you do get a computer and it all seems a little foreign to you, just remember the sage words of a nature guide. A prospective client asked him if he had ever been lost. His reply was "No—but I was some confused for a week once!" Having a computer will just make life easier.

ACCOUNTING

Whether you have a computer or not, there is still the matter of keeping a set of books. If you don't have a computer, I suggest you buy a bunch of paper folders. Label them appropriately, file in alphabetical order, and slip each receipt in the proper file. Once you set the system up, it is a simple matter to sort through the files every three months, getting some sort of idea where the money is going. Establishing the file will not only create a place to put receipts but will also help you to remember to keep the receipts you should be keeping.

Whether you use a computer or a paper system only, following is the chart of accounts (along with pertinent remarks) that I suggest you start with:

INCOME
- **Bank account**
- **Sales revenue**
- **Other income**
- **GST refund**

EXPENSES

- **Advertising/Sales/Promotion:** Anything you spend in the advancement and promotion of your career goes under this heading. If you are having a meal with someone you hope will be, or presently is, promoting your career, it may be deemed a business expense. If you do charge it as a business expense, be prepared to defend it. Note who was at the supper and what was discussed.
- **Accounting:** All expenses in regard to keeping your accounts balanced. Accountants, etc.
- **Art Shows:** All framing, freight, packing supplies, invitations, posters, and sundries associated with the mounting of an exhibition.
- **Art Supplies**
- **Auto:** Fuel and repairs associated with reasonable business expenses such as sketching in the country or taking your works to a gallery. Since it is hard to separate from your personal use, this area is usually dealt with on a percentage basis.
- **Bad debts**
- **Bank Charges**
- **Business Insurance**
- **Charity**
- **Commission:** Any expenses—paid to a third party—incurred in procuring a job.
- **Clothing:** Clothing bought specifically for use in studio or for an opening. If you plan to use the clothing for anything other than specific art events, charge only an appropriate percentage and be prepared to defend it.
- **Credit card charges**
- **Dues:** Fees paid to professional associations.
- **Employment Insurance**

- GST
- Provincial Tax
- Medical
- Memberships
- Miscellaneous
- Office supplies
- Photography
- Postage Supplies
- Rent
- Rent on equipment
- Subscriptions
- Supplies
- Tax
- **Telephone:** A reasonable percentage and actual long distance receipts of calls to dealers. This can be a one hundred percent charge if the phone is in an off-premises studio.
- **Travel:** If the trip is a career move, hotels, meals, and taxis are allowable expenses.
- **Utilities (gas, electric, and water):** For an on-premises studio, work out the percentage of space the studio takes up overall and charge that. Off-premises, of course, claim everything.
- **Wages**

The foregoing is a fairly comprehensive chart of accounts for an artist's business. The bottom line is that keeping track of both inventory and accounts is a "must." Whatever model you choose, remember that in all likelihood it will be a " 'til death us do part" scenario. I tend to do inventory updates whenever my wife can get me to stand still long enough. Now for some closing thoughts on the subject.

While fear of Revenue Canada may be the primary reason for paying attention to this stuff, there are other very good reasons.

When you establish a system of accounting, you realize that there are items you could have been listing as expenses that you never bothered with. As soon as you deal with a gallery, records and accounting become a very real priority, because you will want to be able to double-check and confirm the gallery's record of your account. Lastly, there is the conundrum of your mind. If you don't record it, chances are it may be lost. One of the great problems I encountered was that I didn't have a provincial tax number to collect the tax revenue that I was supposed to be collecting. The Saskatchewan government solved that for me. They assessed me $950, which meant sales of $19,000, at a point when I had sales of less than $2,000. This seemed a little unfair. I pointed this out to them, but got only this reply: "Pay it now and take us to court where you'll have a chance to prove us wrong. If you do prove us wrong, we will pay you back the money with interest." I didn't have money to take the Government of Saskatchewan to court so I paid up and shut up.

Inventory, records, accounting, and all that other stuff seem so irrelevant when you are starting out and just trying to make a good painting. The problem with this attitude is that it initiates an habitual way of looking at things that will eventually do great harm.

Why mourn the cocoon
when the butterfly has flown.
—*Taoist meditation on change*

It works this way. If you have been acting in a businesslike, professional manner, there is a good chance that Revenue Canada will believe that you are what you say you are. We would do well to remember that Revenue Canada would have labelled Vincent Van Gogh an amateur. After all, he sold only one painting while he was alive. Act like a professional and you will be a professional.

What you live with, you learn.
What you learn, you practice.
What you practice, you become.

SUMMARY OF TOPICS COVERED IN THIS CHAPTER:

1. My encounter with the tax man.
2. The importance of keeping an accurate inventory.
3. Some accounting tips.

Notes

What is certain is that putting a bit of nature in place
and drawing it are two entirely different things.
—*Edgar Degas*

Notes

It is a tale told by an idiot,
full of sound and fury, signifying nothing.
—*William Shakespeare*

Notes

Drawing is not the same as form;
it is a way of seeing form.
—*Edgar Degas*

11. Being a professional

Talking the talk and walking the walk.

There is an old joke in academic circles that stealing from one is plagiarism, while stealing from more than ten is scholarly research. That particular piece of "turf" which an artist calls his own is often cobbled from a number of different influences. Whatever that special thing is, it becomes a personal signature. Other professional artists recognize "turf boundaries." When I spent the day with another artist and our cameras, I didn't photograph when we were on his turf. No point! When we hit what he referred to as a "Teddy pond," I shot a roll of film, and he didn't take a shot. This was as it should be. No artist wants it said that he is copying someone else. It will be hard for you, as a relative newcomer, to find a corner of the field that no one else has laid claim to. While it's a tall order when so many have gone before, it's not impossible.

TURF INFRINGEMENTS

While attending a faculty show at a prestigious art school, I was

appalled to see that one faculty member had shamelessly copied the style of a fellow faculty member. Subject matter, colour range, style, scale, and even brush stroke. Since the works of both artists were hung in close proximity, the viewer was invited to make the obvious comparisons and conclusions. Was this image-stealing? If so, who said it was his "image" in the first place? Maybe the imitator admired the other's style and was simply doing a work in that style to understand it? Was it possible that he wasn't aware of what he was doing? These are some of questions that surface for contemplation and conjecture when I see "turf infringements."

TURF: ITS PLACE AND IMPORTANCE IN THE SCHEME OF THINGS

After you have left art school and have begun the journey of self-discovery, the matter of image is the most important concern you can possibly have. An extension of self, image is the one thing that will set you apart from others and determine whether your journey is perceived by others as successful or not.

A unique image will not come overnight, nor will it come from a mind that has become calcified, clogged, or cluttered with the wrong stuff. It was a great shock for me to discover that television is aimed at a grade five to grade eight mentality. That's wonderful if you happen to be in grade two. In my opinion, the "boob tube" can, will, and does stunt intellectual growth, serving to keep you in a state of arrested intellectual growth if you let it. Having said this, I admit to freely watching it in the late evening. It slows down my brain speed and helps to unravel the concerns of the day.

Probably the best story of "image concern" I have ever heard is one which Jules Olitski related to me. Before Jules emerged as an international abstractionist of note, he had a successful career as a

portrait artist and a somewhat checkered career dealing with clients. Their demands were many and varied: features enlarged or diminished as whim dictated and even one client who insisted his wife keep looking more and more like Marilyn Monroe. Eventually it just got too much. He said that he had the sense of having strayed from the path he had chosen and of being locked into something that he didn't want any part of. After honouring the contractual obligations he was committed to, he gave himself a year to remember what it was he started out to be.

Jules soon found that years of academic training and portraiture had taken its toll. Academic training and programmed brush memories of the right hand kept getting in the way. His answer? Paint with his left hand! Part of Jules's mission was to disarm and de-program the knowledge of the academy. He felt that if he could accomplish that, he might reach the remembered feelings of a child's first encounter, and perhaps harness these creatively. However, it soon became clear that the eye and the mind with its accumulated academic overburden were also getting in the way.

His approach to the dilemma had the beautiful simplicity and

Don't be afraid in nature: one must be bold,
at the risk of having been deceived
and making mistakes.
—*Camille Pissarro*

directness that is the hallmark of greatness. For six months he paint-ed blindfolded and left-handed! To go to the studio every day for six months and do what Jules did illustrates a level of commitment that few are willing to undertake. It is just that sort of commitment and undertaking that is at the heart and soul of every successful artist.

Wherever it is that you are led, develop an intelligence that is acquisitive and inquisitive. Art school is merely the first building block in a process that will continue as long as you live. The intricate architecture of your being, psyche, and mind is something only you can direct the construction of. There is a Taoist meditation that says, *"Treat your mind and body like a temple. Take care of it and nourish it well so that the gods will want to live within."*

There is nothing inherently wrong with making a work similar to something someone else has done. We've all done it and it comes under the heading of growth. The problem arises if we don't grow beyond it. In this game it is not where you start that is important; it's where you end up that really counts!

YOUR PIECE OF TURF

The ways that an artist can arrive at a unique image are almost limitless. The common denominator is the acquisitive and inquisitive mind. For some, a sound system in the studio may provide the break-through. For others, a sentence from a book or a line from a poem, or perhaps the memories of your earlier years. Whatever it is or will come to be, you are always in control of what is influencing you. If you like sunrises, get up in time to absorb them. Be a sponge in life; drink deep of it, let it roll around in your noodle, and see what comes out. I believe that being contemporaneous and "of your time" is impera-tive. Although fraught with difficulties, it is still the way to go.

Even though I hate sharks, when the movie *Jaws* came out, I went

> Keep away from people who try to belittle your ambitions. Small people always do that, but the really great make you feel that you, too, can become great.
> —*Mark Twain*

to see it just to keep in touch. I see nothing out of the ordinary in going to a CD release party of a blues artist and then listening to classical music on the way home. True artists are vitally involved in all aspects of their immediate environment.

When computers first appeared in the mid-1970s, I had to make a tough decision about whether I was going explore what these new miracle-machines were or whether I was going to throw in the towel and calcify. With much nervousness, I finally went into a computer store. Standing behind a six-year-old kid, I watched him move something around on the table clicking it. Oblivious to me and glued to the screen, he was making a succession of interesting things happen on the computer. As I watched him, I knew that this was something I had to deal with. Absolutely terrified, I bought my first computer: an Apple 64K. That was a long time ago. Today, you could buy for under $15 what I paid $3,000 for. In addition, computers are now so user friendly that anyone can handle them. There are second-hand computer stores everywhere and anyone can pick up a system for under $200. Because it will handle bookkeeping, inventory, and correspondence, it has become a natural and necessary adjunct to a

studio operation. Once you have one, you will wonder how you ever got along without it.

The process is ongoing. I am on the internet and have a home-page. Surfing the net is almost fun. I don't want to calcify so I try to keep up with what is new. Some things, like video games, I stay away from as they are too addictive. If you are a movie buff, don't wait for movies to work their way into the video stores. Most of the movies that are interesting and that might bring change just won't make it that far. I try to see at least one new movie a week just as I try to catch any performer of interest who comes through town. The acquisitive and inquisitive mind of the artist puts all the events of life into the "meat grinder" of his or her head. Once the information is there, curi-ous connections can be made, translating into a one-of-a-kind image at the other end. Through our art we share the journey, and each journey is unique. Of course, don't forget to go to the studio on a reg-ular basis to excise and exercise the connections. The studio is the place where it all comes together.

STUDIO COMMITMENTS

It is a good idea to make a specific time commitment to the stu-dio. Your other job will subsidize the studio, and put the veggies on the table, but always remember that your real job is to make paintings. Commit to studio hours as regular as those of your other job. Even if you don't have anything specific in mind, it is important to be in the studio at regular intervals. The mere act of sitting in the studio space is often enough to get you started on something even if you think yourself dry of all inspirations. One mark leads to another, and you are into it. Artist Doug Morton had a large family and a regular nine-to-five job as a salesman. He always confounded me with his output of work, often doing more than the university instructors, all of whom

had much more time. When I cornered him on the subject, he looked me in the eye and related his daily regimen. Getting up at 5:45 a.m. in the morning, he would paint in the studio until 8:00 a.m. His studio was adjoining their living space. This left him one hour to shower, change into a business suit, and drink a cup of coffee on the way to the office for 9:00 a.m. Business til 5:00 p.m. and home at 5:30, he would spend the evening with the family until 9:00 p.m., at which time he would proceed to the studio and paint until midnight. On weekends he followed what the rest of us did, spending the entire day in the studio. Sometimes being short of time is beneficial because it forces you to be serious and disciplined about what you do with your time.

When you are in the studio, it really doesn't matter if what you do turns out to be a stinker. It's in the studio and private. Often the best works and ideas arrive this way. Making a mess scares me so much I get right to work on it because I know I can do better.

Over the years I have found it a wise policy not to immediately destroy a work that did not live up to my expectations; instead, I just put it aside. Often I find my initial assessment wrong. Clement Greenberg once remarked that the only works that interested him

were those works that elicited emotional responses, negative or positive. Works that angered or got under his skin often turned out to be the most interesting over the long haul. In at least two instances, areas of exploration I initially thought irrelevant and inconsequential became meaningful enough to eventually occupy me for a number of years. I am convinced that an interesting body of work has been lost to us because young artists who don't understand what they have captured in their art have destroyed their own works. If you do something that either scares you, angers you, or is something you don't comprehend, put it in a corner of the studio and have a look at it in six months or a year.

CAREER COMMITMENTS

Your first and foremost responsibility is to yourself and the thing we call art. The marketplace and its concerns are somewhere else and should not influence you unduly.

Occasionally professors get enmeshed in trivia, forgetting the broader picture. There are those who say that if they did have a better grasp of the broad picture, they wouldn't be teaching in the first place.

> All painting is an accident. But it's also not an accident, because one must select what part of the accident one chooses to preserve.
> —Francis Bacon

I am not one of those. Higher education is an excellent route for the aspiring young artist. You can get there without it just as you can get to New York walking, but it sure helps to take a jet.

The primary thrust of a young artist must always be a greater understanding of self and self-worth. Take what the professors are telling you and store it. It may or may not be useful. Whatever you do, throughout the exercise, keep watering, nurturing, and weeding the private little garden that is your innermost being. The education you get will give you some of the tools you will need for the journey. Just some, not all. If education doesn't give it to you, it will give you the smarts to figure out where to find it. Don't expect to find the answer in whatever hip, with-it art magazine that is enjoying its brief moment in the limelight. Over the years I have witnessed the rise, decline and fall of a number of art magazines that supposedly had the answer all artists were seeking on how to be rich, famous, *au courante*, and *avant garde* at the same time. It is pathetic to watch graduate students hover over the mailbag and witness the so-called "lucky one" who grabs it first and starts making bad copies of the latest style in vogue.

Ideas, trends, and movements evolve, devolve, and dissolve with the blink of an eye or the click of a mouse. The ferocious speed that everything seems to move at these days is exhilarating, alarming and addictive all at the same time. The first instance of the "instant" phenomenon in the art world was the New York movement popularly known as Abstract Expressionism. Virtually overnight, artists from Tokyo to Tuktoyaktuk were doing large colour drip and slash paintings. It is easy to see in hindsight that the movement was driven by the print media. *Time* magazine, *Life* magazine, and *Art News* were the unnatural parents of the movement. I say unnatural because we may also lay at the feet of these magazines the profound change in attitude that came to perceive art as a fashion commodity. Fashion, by

definition, is cyclical. Whatever is fashionable and in vogue is automatically passé by the very fact of its popularity. For the artist, it is interesting to try to anticipate waves. Find something that isn't "in" and persist in doing it until it does come in. You might be very popular. It is a truism that the act of painting is reinvented by each new generation.

Jules Olitski's show at Andre Emmerich's gallery in New York was such an occasion. The times were characterized by a general belief that painting was a dead form. In a brilliant move, Jules had removed the subject matter from the centre of the canvas to the edge. Doing so created a new dialogue about figure-ground relationships. What an opening it was. One could sense the electricity in the air. The sheer genius of the move blew me away and energized me at the same time. For years afterwards, from Tokyo to "Wrinky-Dink," Saskatchewan, and other points of the globe too numerous to mention, "Olitski Edge" paintings kept popping up. None of the copies that I have seen so far can hold a candle to the original works.

Rather than wasting time trying to imitate and follow something

It is impossible to repeat in one period what was done in another. The point of view is not the same, anymore than are the tools, the ideals, the needs, or the painter's techniques.
—*Pierre-August Renoir*

that is already past its prime, the serious, young professional is better served immersing his or her being in contemporary culture. Be a sponge and let it all sink in. If you are a true artist, your head will know what to do with it. There is more to be gained from watching the ten o'clock news than from reading the latest art magazine, and more to be gained from listening to the new music or seeing the latest blockbuster movie than from attempting to imitate the latest trend from New York. Always remember that Mecca (New York to the rest of us) is just another regional area with ultimately little, if any, relationship to our personal concerns. I've always liked Ken Lochhead's observation that "you go to New York to see what to do—and what *not* to do!"

If you have good knowledge of your craft and practice it diligently, and if you have a reasonable amount of intelligence and keep your mind open to what is happening around you, there is a good chance that you will be able to make a sound contribution to the human dialogue that can withstand the test of time. It's okay to look at art magazines provided you keep the whole thing in perspective. The real problem is they are very seductive. It is all too easy to relinquish important image decisions that are your responsibility in favour of a rolling bandwagon of something from somewhere else.

If there is one thing that you take from all the above, I hope it is the simple idea of following your nose. How true it is that play is the work of the artist. In our "play," we see deeper meaning and translate that to canvas or clay, paper or stone. That is our mission. If our play in any way helps others on the journey, our lives are enriched as are theirs. In truth, the sum becomes greater than the individual parts. Eric Clapton didn't start out wanting to be rich and famous; he simply wanted to be a really good guitarist. The rest just happened along the way. So it is for us. To some of us will be given fame, to others

money, and to some rejection.[†] To all of us is given the journey, and that is riches enough.

SUMMARY OF TOPICS COVERED IN THIS CHAPTER:

1. Turf: infringements, its importance, how to find your piece.
2. The importance of making a commitment to studio time.
3. Be attuned to the world around you.
4. Follow your nose.

[†] Vincent van Gogh didn't sell anything while he was alive. Milton Avery sold little if anything while alive. This is a common story in the art world. Think of what rich legacies they and so many other artists who were not fortunate enough to have been blesssed by fame or fortune have left us. I spent many years in the wilderness. Thinking of people like this certainly helped me to keep going in those years.

Notes

Nothing can come out of the artist
that isn't in the man.
—*H.L. Mencken*

Notes

Those that can, do; those that can't, teach;
and those that can't do either become critics.
—*George Bernard Shaw*

12. The Business End

Dealing with dealers and other assorted sharks.

To those of us who knew other times, the changes to gallery fee structures are both astounding and alarming. When I began, an artist complained about the newly instituted 75/25 split, with the artist getting seventy-five percent. It had been 85/15, but in the modern world (what we now call the olden times), the dealers said that if they got twenty-five percent, it would enable them to discharge their responsibilities more professionally. Through the years, I have watched the artist's percentage erode mercilessly and relentlessly. Of late, I have heard of 35/65 splits, with sixty-five percent going to the dealer. Who said all the sharks were in the water?

SURFACING

The serious artist will eventually face a time in his or her life when there are no walls left to put paintings on, corners to put sculptures in, or friends he or she has not already given work to. When you reach the point where the stuff you have is too good to throw out and

there is too much of it, the time is at hand to pursue alternatives. There are three basic options: destroy it, paint over it, or try to sell it. I like the last option as it helps me support the habit. In fairy tales, this is the time for someone to appear dressed in white with wings and a wand—an extremely rare occurrence in real life.

Because the fairy godmother usually doesn't show up, the emerging artist is most vulnerable. Any hint of amateurism will send signals of vulnerability. Dealers are quick to pick up on this and take advantage. Be forewarned. Having a studio full of good work and successfully marketing the stuff are two different things. How one surfaces, when one surfaces, and where one surfaces are all of great concern.

THAT WAS THEN...

When I was making my moves, the situation was quite different. There were very few commercial galleries. Artists had no option but exhibition venues in public galleries. The National Gallery of Canada had cut a deal with major regional galleries to hold juried exhibitions on alternate years in the late 1950s. Artists could send to a juried biennial exhibition at the National Gallery one year and to a juried show at Art Gallery of Ontario on alternate years. In addition, there was the Montreal Spring Show at the Musée des Beaux Artes, and the Winnipeg Show at the Winnipeg Gallery. As well as these national shows where we tried our luck against the best, there were also lots of smaller regional shows. The interesting thing to note is that the number of artists on the national scene at that time was small enough to deal with as a unit.

One started by sending works to these juried shows and hoping that the visibility of the "meat market" venues would bring offers for one-man shows. The works were all gussied up, matted in frames, and nestled in the crates much in the manner of a young knight in shining

armour about to go out on a great quest. As I put the finishing touches on a crate of paintings about to leave the studio for an upcoming tour, it was always the same. I was totally convinced that this time I'd have the big breakthrough, the sell-out show! All the fame and recognition that had eluded me up to that point would be mine. In due time, the works would return: frames chipped, glass cracked or rattling around loose in the crate, the packing a jumbled mess. Opening a crate with works and packing material thrown in willy-nilly is pretty heartbreaking. Whoever did the last packing had made a critical "statement" about what he thought of the works. In those days, many of the people who worked in galleries were amateurs and volunteers. Works that went out glazed, taped, wrapped, and secured in felt-lined slotted crates came back in terrible shape.

...NOW IS NOW

The world is different today. Many artists have lost confidence in public galleries. I find this quite interesting. There is every chance that artists who choose to pursue "surfacing" in a public gallery will hurt rather than enhance their chances at financial success in a commercial gallery. Most public galleries pursue an exhibition policy of anti-saleable art. It seems that if you are successful commercially, you are a failure on the public gallery scene and vice versa. For those who choose to pursue a career of showing in a public gallery, there is a good chance the person sitting at the desk with the clicker that tallies up how many have come to the gallery makes substantially more than the artist whose works are on the wall. However, if you choose the commercial gallery route—and I heartily recommend that you do—there are some things to watch out for.

Many years ago an artist friend was visited in his studio by a dealer from Winnipeg. The dealer was favourably impressed and indicated

to the artist he was sure his stuff would sell. After assuring the artist that they would do well on the proceeds, he returned to Winnipeg to set the whole thing up. In due time, airplane tickets arrived for the artist and his family. The dealer picked them up by limousine at the airport, checked them into a hotel, and treated them royally, taking them to wine and dine at the best restaurants in Winnipeg. They lacked for nothing. When the artist returned home, all we heard were stories about how well he had been treated. Not only that, the show was almost a sellout. We were, of course, most envious. One month later, he received a cheque for $170. Enclosed with the cheque was an itemized list of all expenses including airfare, limousine service, hotel and restaurant bills, framing, rental charges for the gallery space, and the long distance phone bills!

The foregoing brings up rule number one when dealing with dealers. Make sure that you know exactly what the rules of the game are before any contractual agreements are entered into! Have an exact understanding of what the division of fiscal responsibilities are—in other words, ask "*who pays for what?*" and make sure that you have the answer in black and white with both your signature and the dealer's signature on it. I cannot emphasize this enough. Don't be afraid to ask exactly what the financial arrangements are! If you are dealing with honourable people, they will be forthcoming in all details. If they aren't of the honourable kind (and there are many good dealers who fall into this category), you should know it at the outset, and protect yourself as well as you can, to minimize the inevitable. Totally honest dealers just don't last in a business that is as tough as the art business is, so you can expect a touch of larceny even in the best. It is my contention that most artists get into trouble because they don't want to know how bad the deal is. They try to keep the rose-coloured glasses and a smile on even when the smell of the

> Shoot for the moon—
> if you miss you'll end up in the stars.
> —*Artie Shaw*

muddy brown stuff is making breathing difficult. In the 1990s, a Montreal artist was ripped off by a Toronto dealer for over $50,000. When the "oversight" was discovered, the dealer conned the artist for some more work to help retire the money owing. Go figure. Even more amazing is that when the artist finally put the matter in the hands of lawyers and severed all connections with the gallery, the dealer had another well-known Toronto artist in the bag right away doing the same thing over again. And they say denial is a river in Egypt.

I'm quite fond of an old Chinese story about a silk merchant who had to travel the silk road. Since the only people he could find to go with him were known criminals, he had an eye painted on his lid by an artist so that when he slept, he appeared to have one eye open. The criminals watched him throughout the trip and were nervous wrecks by the end of it since every time they went to rob him, he was lying there with one eye clearly watching their every move! The moral of the story is to sleep with one eye open when you are dealing with shady individuals. Dealers often fall into this category so remember to always sleep with one eye open.

Rule number two: have a firm understanding of what the gallery

payout policy is. Some dealers will remit a cheque to the artist immediately upon the work leaving the gallery, others when the work is paid for. Some do it every three months or every six months. There are dealers who will pay you the money owing only when you happen to walk into the gallery and embarrass them into action. Some dealers just never pay…period. That's the way it is. Get used to it.

Ideally, commercial fine art galleries are the bridge between the collector and the artist. If things are working the way they are supposed to, dealers and galleries turn art into money for the artist, and money into art for the collector. In the way of all things natural, they skim off a bit of the money as it passes through their hands. Wise artists and collectors don't begrudge the skim. Dealers earn it. Someone rents a space for a month and puts up a sign that says "Gallery." Artists see the sign and say, "Would you sell my work for me?" The dealer says, "Sure—just leave them." Collectors see the sign and wonder if there is anything of interest. With a few wrinkles and variations, that is all that a gallery is. Following is a description of the four arrangements which can be entered into between artists and galleries: consignment, outright purchase, gallery rental, and contract salary.

CONSIGNMENT

The most common arrangement for an artist to enter into with a gallery is *consignment*. The artist retains ownership of the work until it is sold. When the work is sold, the dealer owes the artist the percentage of the selling price that was previously negotiated.[†] Let's look at a typical scenario for this arrangement.

† When I started out in the game, some forty years ago, the split was 85/15 in favour of the artist. Now, 50/50 is the norm. I have heard tales of some cases in New York which were 75/25 in favour of the dealer. Usually when it is this horrific kind of split, there are mitigating circumstances that make the pill a little bit easier to swallow.

The artist has an exhibition of ten works priced at $1,000 per work. The negotiated split is 50/50. There is every likelihood that the gallery will also request a split on the expense of the invitations and the opening night (cheese, wine, etc.), which might total as much as $1,000. As a general rule of thumb, exhibitions don't sell out, so let's count on sixty percent being sold (sixty percent is actually on the generous side). This would generate $6,000 in sales. First of all, we subtract the fixed expense of the dealer's cut, leaving the artist with $3,000. Out of this, the artist pays a thousand for framing the show and five hundred as his or her share of the opening night expenses. That leaves the artist with $1,500 and four as yet unsold paintings at the end of it all.

OUTRIGHT PURCHASE

The above scenario doesn't sound all that attractive. In fact, a dealer may point this out and suggest an alternative arrangement: an outright purchase. In this scenario, the dealer purchases the entire show outright for a more attractive percentage—let's say the figure he mentions is forty percent of the anticipated $1,000 retail price. He gives the artist a cheque for $4,000 and now all the expenses are his. Sounds nifty, doesn't it!

When he mounts the show, though, he puts a price tag of $2,000 on each work. Since he now owns the work outright, there is absolutely nothing the artist can do about it. The contract probably requires the artist to be on hand to answer questions on opening night. He has to smile in the gallery while his works are being sold and he isn't getting any of the proceeds! Selling at a lower price than an established market price is a betrayal and slap in the face to anyone who has bought the work. So once the new price scale has been established, the artist can't go back to selling his work at what he feels is a

justifiable price. All the dealer has to accomplish to break even is the sale of three works. Dealers do have expenses! The rest of the works he can sell as pure profit. It is a fairly safe bet that the artist chosen for this treatment already has a well-established national reputation. The dealer probably has the three sales lined up ahead of time. Although, as I've described it, this may sound like an unattractive option, this arrangement may actually appeal to the artist who has had to hound a dealer for money from a sale six months previous.

Marilyn Levine is a Saskatchewan artist who has done well on the international scene. Her first big show in New York was an outright purchase show. At the opening, she not only watched her work being sold for two hundred percent of what she normally charged, but also witnessed a brisk trade going on amongst those who attended; some of the people who made purchases sold them on the same night to other collectors for three times the gallery purchase price!

GALLERY RENTAL

A third possibility for mounting a show is for the artist to rent the gallery space for an allotted period of time, putting up his own work and taking it down when the run is over. Mounting your own show is

There are no wrong notes;
some are just more right than others.
—*Thelonius Monk*

such a bad idea I only mention it so that I can tell you why you shouldn't do it. Track record and name recognition is accomplished over a period of time. Unfortunately, the artist is often his own worst enemy. You can easily see that standing in front of your own work telling a collector that it is a good buy and that the artist is a rising star on the scene just won't wash. This is what a dealer does best, why you should have a dealer, and why your works should be in a gallery.

CONTRACT SALARY

One other arrangement between artist and gallery is for the artist to be under contract. In this scenario, the artist is given a wage, and the gallery owns the entire output. This is very rarely done and, to be honest with you, it gives me the willies to think of someone looking over my shoulder telling me what to paint. It would also be very scary to realize that I could never keep anything that I had done. Another question that I've always had about this sort of an arrangement concerns the creative thinking I do at night. Would that be owned, too?

CHOOSING A GALLERY

We should also be aware of and sympathetic to the dealer's problems. It is important to remember that the dealer is the custodian of the dreams, hopes, and aspirations of about twenty artists. Any more in the stable and someone is going to get short-changed. Even with twenty, someone is still getting the short end of the stick. There are those who shy away from galleries with more than fifteen artists. Of the artists that are represented, there are likely no more than three or four who are getting the sort of play that all should have. Stars to some, these are actually the workhorses of the gallery. Their sales subsidize the introduction of the unknown artist (that's you). Just remember that once upon a time they, too, were unknown. They

achieved their current status in the gallery because the dealer can count on them for quality product and sales performance. Sales keep the lights on and the door open. When a gallery starts the slide into bankruptcy, it is usually for one of four reasons: bad bookkeeping, drugs, bad stable, or buy-back. The first three are reasonably easy to spot if you are keeping your eye out for such concerns. The buy-back is another story and it is the one gallery situation that can blind-side you.

Buy-back works this way. If the purchaser doesn't like the work in the first year, the gallery (if it is reputable) will take it back, letting the full purchase price apply to any other work in the gallery. The "buy-back" is really dangerous for all except the purchaser. It is easy to see how problems can arise when a "sold" work—for which the artist has been paid and the gallery's profits spent—re-enters inventory.

Sometimes the money that should be paid to the artist goes to the light bill in the hope that the next sale will avert the inevitable descent into chaos and bankruptcy. The slide is often almost imperceptible and, for the most part, impossible to stop. The juggling of finances to stay afloat gets increasingly creative. Many galleries are under-capitalised, "fly-by-night" operations. They have your work, they haven't paid you for it and, yes, it really is scary.

When I meet a new prospective dealer for the first time, I'm very busy checking body language, gestures, eye movements, and anything I can think of to give me some idea of what the reality is behind the mask.

THE ARTIST-DEALER RELATIONSHIP—SUMMING IT UP

Artist-dealer relationships are very much like marriages. If it turns out to be the sort of relationship that you are comfortable in, it will probably last. I've been with one of my dealers for over fifteen

years, and with the other one for over thirty years. Once in a gallery, there is ongoing worry about whether you are on the front or back burner. The dealer chooses whether an artist's works go on the wall or not, and whether his or her name is "talked up" to collectors. Many artists "die" prematurely while their works gather dust in storage at the gallery. If this is the case, there are a number of possibilities as to why: the work isn't good enough, it is priced too high, the artist is too "difficult" to deal with, or the artist has been caught "back-dooring."

BACK-DOORING

Quite often artists will get calls from collectors or art consultants to see if they can come to the studio and purchase directly. No purchaser really wants to pay the fifty percent to the dealer and the artist often resents letting the dealer have it as well. The fact that the collector became aware of the artist's work through the diligent work of the dealer is often lost on artist and collector.

Dealers do all the promoting, pay wages, take care of the rent, and make sure the light bill has been paid. They earn their money. I know of one artist who took great delight in the practice of back-dooring, actually selling for less out of his studio than he charged the gallery.

Vision without action is a daydream.
Action with vision is a nightmare.
—*Japanese proverb*

Dealers just can't live with that kind of thing and, as desirable a commodity as this artist was, all the dealers dropped him. After all, dealers talk to each other! When the word is out that an artist has been caught back-dooring (and he *will* be caught), no one will touch him.

Who can blame the dealer for quietly putting the artist's work away in a lower drawer if he gets wind that the artist is stealing sales behind his back. When asked about the artist, he may say something like: "We're not recommending him at present as his work seems a little weak of late." Some artists have had the skids put to them and not realized it until it is too late and their career is in the dumpster. I can assure you that this sort of thing certainly inspires loyalty in the other artists the gallery handles.

Dealers are not in the game purely for the love of art. If they are, there is a good chance they aren't successful. The artist must remember at all times that the dealer is in business for himself and must make the exercise profitable to stay in business. Artists who back-door their dealers do so at their own peril.

CO-OPERATIVE GALLERIES

Quite often a young artist's first gallery will be a "collective" or a co-operative run by artists. I do not consider them viable. First, such a gallery is usually a "friends" operation, and there may come a time when you are on the wrong side. Secondly, it is usually self-serving in that the person sitting at the desk quite rightfully pushes his or her own work. Thirdly, everyone involved is an amateur in the matter of selling a work of art, including yourself. The bottom line is that the "irritants" outweigh the "comforts." Furthermore, because it is a co-operative, all the responsibilities of running the venture should be shared equally. This rarely happens. The less attractive aspects such as cleaning up, handling shows, and accounting still need to be

tended to and it always seems that one or two don't do their fair share. Nonetheless, some seem to make it work, and if you can put together the right "chemistry," the co-operative gallery is an alternative.

SUMMARY OF TOPICS COVERED IN THIS CHAPTER:

1. Historical overview of artist–dealer relationships.
2. Strategies for "surfacing" with historical overview.
3 Some horror stories of what can befall.
4 The nature of a commercial gallery operation.
5. Alternative gallery options.

Notes

Life must be lived forward.
But it must be understood backwards.
—*Soren Kierkegaard*

 Notes

The modern architect is, generally speaking,
art's greatest enemy.
—*Auguste Renoir*

Notes

What Degas called "a way of seeing" must
consequently bear a wide enough interpretation to
include *way of being, power, knowledge* and *will.*
—*Paul Valéry*

13. Contracts

Getting a good grip on meaningless paper.

Now that we have a fairly good understanding of what is involved in the marketing of our art, it is time to get down to some of the details. Following is a brief overview of contracts, together with some models gathered from various sources over the years.[†] There was a time when people thought that contracts were the way to go. I believe that was when they hadn't been tried. Now the popular model seems to be the traditional "good faith" handshake. I still get very uncomfortable letting someone I hardly know who is living three thousand miles away have about $50,000 worth of art on a goodwill handshake. To my mind, the better route is a combination of the goodwill handshake and the contract! The old rag that a contract isn't worth the paper it is written on may be true but a piece of paper

[†] The contracts and comments in this chapter are intended to provide useful guidelines for the reader. Neither the author nor the publisher can assume any liability whatsoever for problems that may arise from their use or for any errors or omissions, information or misinformation contained in them. Potential users should seek skilled legal advice before finalizing any written agreement.

is better than a handshake in most bottom-line situations. After signing a contract, I always smile and, shaking the person's hand, say something like: "I am sure I will never need this but let me assure you that it will certainly help me sleep a bit easier at night."

In our business, it so happens there are a number of rather unusual situations that can leave the artist out in the cold. Chief among these are bankruptcies and natural disasters. Dealing with undercapitalised galleries (what other kind are there?) means dealing with the possibility of bankruptcy at any moment. It is vitally important to have proof of sole ownership of the works in order to establish clearly and unequivocally that those works in the care of the dealer are solely owned by the artist and are in the gallery, or in transit to the gallery, at the dealer's risk. I know of two artists whose works were destroyed in transit to a gallery. The artists were unprotected, losing both the works and the money. Over $100,000 went up in smoke. I have also heard of artists who aren't there when the sheriff padlocks the door or when the landlord is taking works off the walls to make up for the rent owing. What does he care who owns them? Often, it seems, the artist is standing way down in the line of priorities in such cases, even though the artist's work is the principal product. Rent, electricity, water, computer stores, and furniture all seem to be ahead of the artist when the house of cards collapses.

Contracts are intimidating because they are written in language with which we are unfamiliar. The language of contracts (legalese) is a precise form of English language that lawyers created to talk to other lawyers. The good thing about it is that it is very precise, meaning exactly what it says. The bad thing is that we usually don't comprehend or understand what it says! If it scares you and me, it is probably scaring the others who are signing it as well. Perhaps they will honour the agreement more.

It is quite likely that when an artist and a dealer are discussing the future they may use the same words but see quite different visions. It is simply human nature to see more clearly that which we want to see. The worth of a contract is that it takes the divergent views of artist and dealer and, using a give-and-take system, brings them to one view. To sum up, a contract tries to bring both parties to a mutually agreed upon position.

There are many pros and cons regarding contracts. Everyone has to figure out what is best for them. If you need a contract for something that isn't covered, simply take parts that fit, add what needs to be added, and make your own. If it sounds and looks official, you're halfway there. In the sample contracts that follow, the indented explanatory notes in italics are mine.

CONSIGNMENT CONTRACTS

The following consignment contracts are working documents that have been used. For the most part they are without prejudice to either artist or dealer. The first two contracts, both of which allow for an "arm's length" partnership, are followed by another artist-gallery contract which is probably closer to the sort of relationship a gallery would like with an artist. In the third contract, the artist has to ask not only what colour of toilet paper he or she may use, but also how many squares! Very scary!

CONSIGNMENT CONTRACT #1

THIS AGREEMENT made and entered into this _____ day of _____ 20___ .
BY AND BETWEEN _____ GALLERY LIMITED, hereinafter called the Gallery;
and _____, hereinafter called the Artist;

> *It is important to establish at the outset who the contract is between. The terms "Artist" and "Gallery" can then be used*

throughout the contract and everyone knows exactly who they refer to.

WHEREAS the Gallery is engaged in the sale of works of art;

AND WHEREAS the Artist has created and does rightfully own and possess certain works of Art;

AND WHEREAS it is the intention of the Parties that the Gallery shall be the sole artistic representative of the Artist in _____ with the exception of the _____ Gallery in _____;

AND WHEREAS it is the intention of the Parties that title in and to the said works of art shall remain in the Artist and such work shall be consigned to the Gallery both as to the existing works delivered and all future works delivered by the Artist to the Gallery.

NOW, THEREFORE IN CONSIDERATION of value hereby acknowledged and received, each Party agrees as follows:

1. THE GALLERY AGREES AS FOLLOWS:
 A. That it shall receive the works of Art from the Artist on a consignment basis and that title to the art works belongs to and shall continue to belong to the Artist until resold to a purchaser.

 > *It is quite often the case in legal documents to say the same thing more than once. It lends extra weight to the claim.*

 B. To make reasonable efforts to sell each art work at prices jointly agreed upon with the Artist.
 C. That the Artist retains at all times copyright to all works of art sold or unsold.

 > *Only by maintaining copyright can the artist hope to keep some sort of logical control over the way the image is reproduced. Often a corporation that has one of my works will want to reproduce the work for an annual report, Christmas card, or some such. I usually make a deal for some cards and a byline recognition of copyright.*

 D. To exercise due care in the handling, display, storage, and delivery of the said work until either sold or returned to the possession of the Artist.
 E. To deliver to the Artist, if requested and, in any event, not less than every twelve (12) months during the continuance of this contract, a full and complete statement of inventory and account, setting forth the particulars of the work sold, the payment received, the purchaser's name (if available), and the number of unsold works.

> *When an artist deals with a gallery in another city, it is easy for the gallery to use money owing the artist for more important things like the monthly rent or the designer drug of the moment if they are so inclined. This is a feeble attempt to get some kind of accountability in the process. This is also the hardest single thing to get a gallery to do!*

F. In the event of the sale of such consigned art works, to remit to the Artist within a reasonable period of time after the date of sale the appropriate percentage of the price received (before sales tax) or if the transaction is in the nature, in whole or in part, of an exchange, then the fair market value. Payments shall be made quarter-yearly.

> *Quite often a "reasonable period of time" is whenever you can catch them. Often an artist will drop into a gallery that deals them, and the first words will be "I was just about to mail you a cheque." Yeah, sure! This is a hard one to hold the Gallery to and mostly useful if all goes down the tubes with something really bad like a bankruptcy. A clause like this would greatly assist the artist in getting paid for whatever unpaid sales there were at the time of bankruptcy.*

G. The Gallery may in its discretion offer discounts up to ten (10) percent on retail values which are to be borne equally between the Gallery and the Artist.

H. The Gallery may, as well, extend a commission of up to ten (10) percent on retail value to consultants. Said commissions shall be borne equally between the Gallery and the Artist. Commissions above ten (10) percent shall be at the expense of the Gallery unless approved by the Artist.

> *Often the gallery will say, "We have a client who wants a 40 percent discount. Are you willing to split the amount so we can make the sale?" The gallery is 1,500 miles away. How do I know the client isn't asking for a 20 percent discount, and the Gallery is asking me to bear all of it? Finally, if you let them know that you can be counted on to cut your prices, they will get into the habit of doing so as a matter of course, knowing you will comply. Having said that, there have been times when I have felt it in my best interest to split the discount.*

I. To enter such works of art of the Artist as may be determined by the Gallery

in such shows and exhibits as it may determine appropriate. Any cash award or cash prize other than the purchase price shall belong to the Artist exclusively. The Gallery shall receive its normal percentage on such purchase.

2. THE ARTIST PROMISES AND ACKNOWLEDGES AS FOLLOWS:
 A. That the Gallery is:
 1. The exclusive Agent for the sale of the Artist's works of art whatever the medium, in _____ with the exception of the _____ Gallery in _____, including the right to appoint sub-Galleries in other parts of _____ with the exception of _____;
 2. The Artist's exclusive agent to seek out public and private commissions in _____ with the exception of _____. The exclusive agency to last for a period of two (2) years from the date hereof.
 B. That the Gallery shall be entitled to a commission of fifty (50) percent (prior to any sales taxes, provincial or federal) of the selling price of such work of art. In the event of the outright purchase of a work of art by the Gallery, the Gallery is entitled to purchase such work for forty percent of its retail value.
 C. The Artist agrees that all sales requests in the area of the Gallery's agency shall be referred to the Gallery and no sales shall be made by the Artist directly. This however, shall not be interpreted so as to prevent any gifting by the Artist. The Artist shall, however, notify the Gallery of any and all such gifts made within the area of its agency.

 > *Artists who establish a sales revenue channel prior to a contractual arrangement will have great difficulty in understanding why they should give the gallery a commission for something they had clearly established themselves. What fact apparently eludes the artist is that the person wants to buy more of the art because of the gallery promotion. Should the artist be foolish enough to let such sales take place (back-dooring), it is done so at the risk of losing everything. The art community is always smaller than one thinks it is. News will get back to your dealer, guaranteed. Don't even think of doing it.*

 D. The Gallery shall be entitled to choose from any of the non-committed works available from the Artist whether created prior to the term of the contract or during the term and shall be open to all such works of art in all media created by the Artist.
 E. That the Gallery shall be entitled to its commission whether the work is sold by the Gallery directly or indirectly within the Gallery's area of agency. Studio

sales are not subject to Gallery commission of selling price as outlined in paragraph B (Artist's Section) of this contract, until such time as the Artist establishes a studio within the area of the Gallery's agency.

> *Obviously if your studio were in the area of the Gallery's agency, you would pay commission on studio sales, too.*

F. That in regard to public commissions obtained for the Artist by the Gallery, the Gallery shall be entitled to a sales commission of forty (40) percent.

> *It is the Gallery's position that you wouldn't have received the commission if they hadn't built you up in the first place.*

G. That in regard to private commissions obtained for the Artist by the Gallery, the Gallery shall be entitled to a commission of forty (40) percent in regard to same.

> *Again, they work for it, they get it!*

H. The cost of stretching and framing shall be the responsibility of the Artist. In the event that it is provided for by the Gallery, it shall be an expense to be paid in addition to the commission hereinbefore mentioned and shall be supplied at the Gallery's cost.

I. To provide the Gallery with an up-to-date mailing address dating the currency of the agreement.

3. EXHIBITIONS

A. That the Artist shall have a one-man exhibition at the Gallery at its present location or as relocated from time to time, at least once every eighteen (18) months or as otherwise agreed to by the parties.

> *While this would seem to be for the artist, it is really for the gallery. If they don't like what you are painting, they just aren't showing.*

B. The Gallery reserves the right to make final selections of the Artist's work to be shown or viewed in the Gallery at any time and as well reserves the right to refuse specific works for exhibition.

> *"Specific works" is the porno escape clause.*

C. The Gallery shall bear the cost of opening nights including the opening night party, mailings, and other costs properly attributable to the exhibition of the Artist, all of which shall be in the discretion of the Gallery.

4. PUBLICITY AND PROMOTION

In addition to announcements or notices having to do with the opening of the Artist's show, the Gallery shall from time to time advertise the Artist's show as is appropriate in the discretion of the Gallery; it being the intention of the Gallery to provide advertising to improve the Artist's reputation and to increase the volume of sales of the Artist's work. The Gallery shall in its sole discretion determine the amount to be spent on such items. The cost of any special catalogues shall be borne by the parties as mutually agreed.

5. DOCUMENTATION

A. The Artist shall provide at least one (1) colour slide of each work sent to the Gallery.

B. The Gallery reserves the right to make as many copies of this visual record as necessary.

C. The Gallery reserves the right to choose the visual material used for advertising or promotion of the Artist and the Artist's works in any magazine, book, catalogue or newspaper.

6. TRANSPORTATION

The Artist shall be responsible for the cost of crating and shipping and the actual shipping and crating of his works to be received by the Gallery. In the event that any works must be returned to the Artist, the Gallery shall be responsible for the cost of crating and shipping the works for return to the Artist. At the termination of the contract, if the Artist has not supplied the Gallery with an up-to-date address for shipping or if the Artist cannot be located by the Gallery after it has made reasonable efforts to do so, the Gallery may at any time one hundred and twenty (120) days after completion of the contract dispose of the works in its discretion without liability to the Artist. During the one-hundred-and-twenty-day (120-day) period after termination of the contract, the works shall be retained by the Gallery but without obligation in law and at the sole risk of the Artist.

7. INSURANCE

The Gallery shall provide full insurance coverage of the Artist's work while on exhibition, in Gallery storage, or while in transit by the Gallery within Canada. The Artist shall insure the works in transit to the Gallery. Artist's works shall be insured at full retail price.

8. GROUP SHOWS

The Gallery shall have the right to include the work of the Artist in group shows at the Gallery as it may decide from time to time.

9. SPECIAL SERVICES
 A. The Gallery shall provide the Artist with services for negotiation and communications related to public and private commissions.
 B. The Gallery shall provide for the Artist the services of negotiation and communication with other Galleries, both public and private, related to exhibitions and/or sales of the Artist's works.

10. SALES INFORMATION
 A. The Artist shall be entitled to know the names of all purchasers of the Artist's work from the Gallery, who shall supply the names (if known) to the Artist forthwith after the close of any exhibition and on a quarter-yearly basis thereafter as set out in Paragraph E (Gallery Section) of this contract.
 B. In the event of any sales "on time" whereby the full purchase price of the work is not paid at the time of purchase, but is paid on a "time" basis, the parties agree that when payments are received they shall be divided between the Gallery and the Artist in accordance with arrangements agreed upon by both parties and the commission arrangement provided in Paragraph Two (2) (Artist Section) of this contract. No work of art shall be sold on a "time" basis by the Gallery for more than a year payment period without prior notification and approval of the Artist. In the event of the default by the purchaser of the work of art on a "time" basis, the loss shall be split in accordance with the percentage set out in Paragraph Two (2) (Artist Section) of this contract.

11. ART RENTAL
 In the event that any works of art are rented out by the Gallery for a fee, such fee shall be split equally between the Artist and the Gallery. The Gallery may consign works to art rental services. In the event that any art rental service makes a sale of a work of art consigned to it by the Gallery, the net amount available to the Gallery shall be split in accordance with the percentages set out in Paragraph Two (2) (Artist Section) of this contract.

12. LAW OF THE CONTRACT
 The parties agree that the Law of the Province of _____ shall apply to this contract.

13. RENEWAL
 This contract shall automatically be renewed for yearly periods after the initial term unless either party hereto has given the other party at least six (6) months notice in writing of termination by prepaid registered post and if to the ARTIST, addressed to _____ in the Province of _____ and if to the GALLERY, addressed to _____ Gallery Limited, _____ in the Province of _____.

NO WAIVER OF MODIFICATION

It is further agreed that no waiver of modification of this agreement, or of any covenant, condition or limitation herein contained shall be valid unless in writing to and duly executed by the party to be charged therewith.

IN WITNESS WHEREOF the Parties have hereto executed this agreement, this _____ day of _____, 20____.

[signatures of the parties involved and a witness]

CONSIGNMENT CONTRACT #2

MEMORANDUM OF AGREEMENT IN DUPLICATE BETWEEN _____ OF THE FIRST PART hereinafter referred to as the Artist and _____ OF THE SECOND PART hereinafter referred to as the Agent

WITNESSETH AS FOLLOWS:

WHEREAS the party of the first part (Artist) is possessed of certain works of Art and the party of the second part (Agent) is desirous of acting as Agent on behalf of the party of the first part in the promotion, selling, and general merchandising of the Artist and his work

NOW THEREFORE

In consideration of the premises contained herein and for other good and valuable consideration, the parties of the first and second part do mutually covenant and agree as follows:

1. The Agent will represent the Artist for and in relation to the promotion, selling, and general merchandising of the Artist and his work in the designated area of _____ commencing on the day this agreement is signed and from year to year thereafter. The said relationship may be terminated by either party serving upon the other of them three months notice in writing of the intention to terminate the said agency.

2. The Artist will deliver to the Agent such works of art of the Artist as the Artist shall, from time to time, consider to be reasonable and feasible.

3. Upon delivery of such works of art by the Artist to the Agent, title to the said works and all property therein shall remain in the Artist's domain at the risk of the Agent and the agent shall fully insure said works of art against all manner of risk.

4. Upon delivery by the Artist to the Agent of the said works of art, the company

shall fix the minimum retail price at which each work of art may be sold by the Agent. The Agent shall, in its discretion, with consultation of the Artist and anyone else intimately concerned with marketing strategy, sell the said works of art at any retail price equivalent to or in excess of the set minimum price fixed in respect to each work, and within a period of three months the Agent shall remit to the Artist fifty (50) percent (%) of the actual selling price for the work of art.

> *This seemed like a good idea at the time. Since this contract was made, there have been a few instances of artists who were priced out of the market by dealers who weren't thinking ahead. Thank goodness I had a dealer who was able to convince me of the folly of raising my prices.*

5. In the event the Agent fails to remit to the Artist within thirty (30) days of receipt from the purchaser, it is mutually agreed by the Artist and the Agent such sums shall be considered demand loans accruing compound interest of one (1) percent (%) per month until such time as the Agent's fiscal responsibilities are discharged in full to the Artist.

> *This really sounds good! In actual practice, it is a hopeless situation that has been and always will be a bone of contention. At least a clause like this—even if never adhered to—gets their attention. Hopefully this reminds them that fifty percent of the sale belongs to the Artist and was never theirs.*

6. The Agent may hold and retain no work of art for a period in excess of nine (9) months from the date upon which it receives delivery thereof unless, prior to the expiry date of the set period of nine (9) months, the Artist should, in writing, authorize the retention of the said work of art beyond the set period of nine (9) months. This clause shall not be binding if the Agent or Artist has evidence of other arrangements in regard to specific works.

> *This is one of those "wish-and-hope" situations. Whether you like it or not, works of art have a shelf life. Too long in one gallery, and they become invisible or have been seen so many times by prospective clients that they have become stale. The same work in another gallery is a whole new ball game. I am as guilty as the next person of sloth in this matter. Paintings I should be rotating are often left too long in one gallery.*

7. The Agent shall sincerely and diligently promote the work of the Artist and shall expend such sums of money for such purposes as it may deem appropriate, pro-

vided that costs arising out of promotion of the works of art by the Artist shall be borne exclusively by the Agent. The promotional activities of the Agent shall include sponsorship of various showings, openings of exhibitions, the preparation and distribution of catalogues and other promotional materials, the encouragement of the publication of critical reviews, and all such activities as may be appropriate for the purpose of acquainting the general public with the Artist and his works. In promoting the Artist's professional career, the Agent shall provide the Artist with copies of brochures and publications, articles, and other materials that may, from time to time, be published or distributed as a consequence of the activities of the Agent or which otherwise may come to the attention of the Agent in carrying out its obligations under the terms of this agreement.

8. The Agent shall pay all expenses for the purposes of effecting the deconsignment and return to the Artist of any of the unsold works of art to the Artist and shall cause all works to be properly packaged, and carefully crated, and shall fully insure each work of art against any loss from all causes whatsoever.

9. In every contract of insurance into which the Agent enters, the Agent and the Artist shall be named beneficiaries thereunder as the interest of each of them appear.

If the gallery burns down, the artist is entitled to the monies that would have naturally accrued from the normal sale of his work.

10. Notwithstanding any other provision contained in this agreement, the Agent shall assume full responsibility for each work of art consigned to it or which it has received, and accepts full responsibility for the payment to the Artist for any loss thereof, or any damage that may be incurred thereto; and whether any such work of art of the Artist is sold by the Gallery to a third party or not, the Agent acknowledges and agrees that it will hold all such works of art it has received and all proceeds from the sale thereof in trust for and for the benefit of the Artist.

11. The Artist agrees that there will be no other Agent of the works of the Artist appointed in the market area agreed to so long as this agreement is a good and subsisting one, and the Agent not in default under the terms thereof.

12. The Artist shall pay all costs of crating and transporting the works of art to the Agent premises.

13. The Artist will supply the Agent with any and such promotional material as may come into the Artist's possession to aid the Agent in discharging its obligations as set out in Article 6. In the event of the contract being declared null and void

by either or both parties, the Gallery shall return to the Artist in a prompt manner any and all such promotional material accrued in exercising this clause.

> *If this clause was the only reason you had the contract, it would be enough.*

14. Failure of the Agent to comply with Article 4 hereof shall be deemed to be good and sufficient cause for termination of this agreement by the Artist.

15. All notices which are required to be served by either part to this agreement under the terms thereof may be served by prepaid post to the Artist at _____ and to the Agent at _____. Notices shall be deemed to have been received five (5) days following the posting thereof.

16. This agreement shall be binding on the Artist, his successors, and assigns, and upon the Agent, its successors, and assigns.

> *This is one of the important differences between Contract #1 and Contract #2. Even if the agent or person you have the contract with comes to an untimely end, the person who inherits has a legal as well as a financial and moral responsibility. Most importantly, if the Gallery goes down the tubes, the person who was running the gallery still has a personal moral and financial responsibility.*

IN WITNESS THEREOF the Artist has hereunto affixed his seal this _____

> *Instead of a seal it might be a salmon. The foregoing is an example of lawyer humour. C'mon now, lighten up. If you don't have a seal, a piece of a postage stamp will do.*

[signatures of the parties involved and a witness]

The reader will note immediately some important differences between these two contracts: with the first contract, if the gallery goes bankrupt, the dealer is no longer a company and avoids all liability. Galleries have been known to go into bankruptcy, and it is much better if you have a contract like the second one which states that the

terms are binding jointly and severally. This essentially means that there is personal liability as well as corporate liability—a rather important difference! The third contract which follows is the strictest gallery-artist contract I have seen and, if nothing else, will certainly bring you to an awareness of the sort of thing you might run into.

CONSIGNMENT CONTRACT #3

An agreement with respect to the sale by dealer (hereinafter called WE) of works of art in all media created by artist (hereinafter referred to as YOU) hereinafter referred to as YOUR WORK during the period of ____.

1. We shall have the exclusive right in Canada to offer for sale and authorize others to offer for sale all items of your work owned by you, which you wish to sell. You shall consult with us before arranging exhibits or sales outside Canada and retain galleries of comparable repute for such exhibitions. We will discuss with you and will respect your wishes and any formal commitments we have entered into as part of this agreement. The gallery undertakes to represent the work to the best interest and to use in your favour all the good will this gallery commands from the public, the critics, the collectors, and the museum community at large.

2. We agree to arrange exhibitions of your works in our galleries and other galleries in Canada at time intervals as you and we shall jointly determine. Such works will be sold by us and such other galleries on a consignment basis and, pending sale, title in such works will remain with you. We shall be responsible for all the expenses of such exhibitions (including publicity, advertising, and catalogue costs) and shall bear the cost of shipping all items of your work consigned to our galleries. All your work consigned to us will be fully insured during travel, storage, and exhibition until either sold or returned to you.

 The cost of framing and photography will be for the Artist's account but on request we will make arrangements to advance funds for framing, photography, and supplies at selected art stores. Unless you supply your own photos, photographs charged to your account will be for one photo (black and white or colour) of each work consigned. Duplicates for archives, publicity, magazines, and client requests will be paid for by the gallery.

3. We shall also have the exclusive right in Canada, in conjunction with you, to arrange, and to authorize others to arrange, the publication and/or sale of books containing illustrated reproductions of your work. In respect of any such publi-

cations, we shall assist you with reasonable steps necessary to preserve copyright. In respect of proposed publications outside Canada you shall consult with us concerning any such proposals.

4. The price for which we shall offer each item of your work for sale shall for the first year be in accordance with the attached schedule. Such prices shall be reviewed periodically, and shall be subject to such adjustment as we and you shall jointly determine.

5. We shall have the right to reduce the foregoing agreed selling prices by no more than 10% in order to facilitate a sale to a museum or through a designer to a corporate client.

6. As full compensation for our services and obligations hereunder, we shall receive 40% of the net selling price of each work sold directly by you and we shall pay to you 60% of such net proceeds. In the event that such sales of your works are through other dealers or galleries in Canada as arranged by us, we shall receive 45% of net proceeds of sale and we shall pay to you 55% of the prices defined in paragraph 4.
 With respect to public commissions or commissions for large scale work, the gallery shall receive 20% of the agreed selling price and will undertake, if required, all negotiations, public relations work, distribution of photographic and written material as well as liaison with the client.

7. We shall want to make arrangements for the publishing and outright purchase of some of your graphic editions. In the case of purchased graphic works, the price will be a negotiated amount with you and we shall pay in addition your cost of production; or we are willing to arrange for your editions to be printed by independent studios.

8. We expect you not to make any direct sales of your work and to refer enquiries with respect to your work to us with certain exceptions:
 a) Sales to the Art Bank from the studio and sales resulting from visits to your studio when not arranged by the gallery. In such cases the gallery will be advised of the sales and will receive 20% of the selling price.
 b) Gifts of your work to your immediate family.
 c) Gifts of your work to your personal friends or exchanges of your work with other artists, provided the same are in reasonable numbers.
 The Artist will keep the gallery informed of such sales or gifts.

9. We shall account to you quarterly for all sales made by the gallery during the preceding three months and remit your share of the proceeds with or immediately

after such accounting. Unless we shall have committed to a sale of work involved, you shall have the right, on reasonable notice and at reasonable times, to remove or substitute works consigned to us.

10. This agreement shall be construed in accordance with the laws of _____ and shall be binding upon the enure to the benefits of your and our respective executors, administrators, and successors.

 It may only be amended by written instrument signed by both parties.

 It is in effect for five (5) years but shall continue thereafter from year to year unless terminated by either party as hereinafter provided. On sixty (60) days' prior written notice given to the other party at any time during the term of the agreement, whether during the initial five (5) year term or thereafter, this agreement may be terminated.

[signatures of the parties involved and a witness]

Since I first started writing this chapter, a number of galleries have indeed gone into bankruptcy while others are teetering on the brink. A major gallery that went under left one artist with an uncollectible debt of $6,000, another with $10,000, one with $28,000 and another with something in excess of $45,000. As a matter of interest, it was the artist with $6,000 owing who could least afford it. Of course when you get right down to it, none of them could afford it! A gallery in a major Canadian city recently went under owing one artist in excess of $100,000. The dealer has resurfaced with another gallery and some different artists. The artist who lost the "megabucks" is in a depression and has stopped painting. If the dealer had signed contracts with the artists jointly and severally, things would almost certainly have turned out differently: first, the dealer may have avoided bankruptcy by being more careful about business transactions in the first place; and second, having run into serious financial difficulties, the dealer would be personally liable to the artists, and so would not have resurfaced so soon in another gallery.

AVOIDING AVOIDANCE

As you can see, there are a number of ways in which the artist can interface with the gallery. Having read this far I hope you now have an awareness of some of the pitfalls. As one gallery dealer put it so succinctly, the biggest problem between artists and dealers is that both parties make assumptions based on avoidance. I can assure you that nothing in this section is more to the point or truer. Having been guilty of sticking my head in the sand and hoping for the best, I can sympathize and empathize. The same gallery has generously laid out a list for young (and old, naive) artists to discuss with the gallery owner. This particular dealer is a well-known artist himself and the list is a good one.

1. Percentage commission to the gallery.
2. Payment system to the artist (time frame from point of sale to payment).
3. Discount policies vis-à-vis gallery-artist responsibilities ("good" clients, galleries, institutions, consultants).
4. Shipping responsibilities.
5. Framing responsibilities.
6. Region of sales (exclusivity in what area and what this really means).
7. Frequency of one-man shows.
8. Opening costs (who is responsible for printing and mailing invitations, food, beer, wine, entertainment, etc.).
9. Advertising policies of the gallery (alternative arrangements when the gallery produces a multi-page brochure or advertises a specific artist in a national newspaper, magazine, internet, or whatever).
10. Time frame for return of unsold works.

If you have the guts to ask these questions (and I say that knowing full well that there was a time when I was too afraid), also have the wits to make notes. It isn't a contract but it is a verbal understanding and better than nothing. As for contracts, perhaps we should leave the last word to the Edmonton artist Doug Haynes. Casting about for whatever information I could get on contracts, I asked Doug if he had anything to offer, and received the following reply via fax.

TED

Nope: The only contract I ever had was with —, which became redundant the day after it was signed! (The contract became redundant, not the gallery.)

Doug H.

That was the artist's way of saying the contract was out the window the day after it was signed. If you happen to be hooked up with a dealer who is crooked and out to bilk you, it is a given that you will be "taken." All the contracts in the world won't be of any help. You may be wondering why you should bother with all the fuss and trouble if the contract doesn't completely protect you. Simply put, contracts tend to lessen the pain while not getting rid of it entirely. The best contract is trust and a handshake, and if you find someone honourable you've lucked out. If you are arranging representation in another country or province, I would definitely insist on some sort of contract. Emerging artists are most vulnerable and at the mercy of the gallery. If you get good enough, the gallery might end up being at your mercy—it happens. Watching a dealer being put through his paces by an artist lording it over him is just as odious as watching a dealer turn the screws on a young artist. Neither is a pretty sight. In your dealings with galleries, always do what is right, and try not to carry grudges for those who have wronged you. It will make your life a lot easier.

OTHER CONTRACTUAL MODELS

The following sample contracts cover the areas of rentals, reproductions, and commissions.

RENTAL AGREEMENT

MEMORANDUM OF AGREEMENT made in duplicate this _____ BETWEEN
_____ hereinafter referred to as the "Lessor" ... of the first part AND
_____ hereinafter referred to as the "Lessee" ... of the second part
WITNESSETH AS FOLLOWS:
WHEREAS the Lessor is possessed of a certain work of art entitled _____, hereinafter referred to as "work" by _____ of the City of _____, in the Province of

AND WHEREAS the Lessee is desirous of obtaining the "work" for the purpose of display with consideration of acquisition
NOW THEREFORE, in consideration of the premises herein contained, and for other good and valuable consideration, the parties of the first part and the second part do mutually covenant and agree as follows:

1. The Lessor and the Lessee will enter into a five (5) year rental agreement for the WORK from _____ to _____. At any time during the term of the contract or at least three (3) months prior to the expiry of the agreement the Lessee may contract with the Lessor to extend the Agreement or purchase the WORK outright for the sum of _____ (_____) Dollars.[†] It is mutually agreed to and understood that in the event of a decision to purchase the WORK, such monies as have been remitted to the Lessor during the normal course of the agreement shall be subtracted from the outright purchase price of the WORK.
2. It is agreed that the rental of the work shall be one (1%) percent of the value of the WORK per month, _____ (_____) Dollars[†] or _____ (_____) Dollars[†] per annum.
3. It is further agreed that the rental fee shall be paid in annual installments due on the date the Agreement is signed and on the same date in each successive year the Agreement is valid.
4. The Lessor agrees to suitably frame and install the WORK.
5. Upon delivery of the WORK by the Lessor to the Lessee, title to the said WORK and all property therein shall remain property of the Lessor at the risk of the

† Write out the amount with word and number.

Lessee and the Lessee shall fully insure the said WORK against all manner of risk.

6. All notices which are required to be served by either party to this agreement under the terms thereof may be served by prepaid post to the Lessor at _____ and to the Lessee at _____. Notice shall be deemed to have been received five (5) days following the posting thereof.

7. This Agreement shall be binding upon the Lessor, and upon the Lessee, its successors and assigns.

[signatures of the parties involved and a witness]

If a contract is only as good as the paper it is written on and the goodwill of those who signed it, why are there so many different kinds? Probably the best answer to that is one I found in a fortune cookie. The fortune read: "Hope for the best, expect the worst." These contracts all attempt to define responsibilities in the event that something goes wrong. There are as many contracts as there are concerns and areas to cover. For instance, a contract is vital in the case of a commissioned work: here, the artist can really be vulnerable. Having been down this particular road, I wouldn't dream of starting a commissioned project without a firm commitment and a good contract.

CONTRACTUAL COMMISSION AGREEMENT

AGREEMENT: This is an agreement between _____ (hereinafter referred to as the "client") and _____ (hereinafter referred to as the "artist") for the creation and transfer of the work of art (hereinafter referred to as "work"). All rights and liabilities in the work shall be governed by this agreement.

1. DESCRIPTION OF THE WORK: The work, to be created by the artist, shall be a _____ of the dimensions† of _____ the medium and materials of _____.

† In the case of a three-dimensional, freestanding work, you may wish to insert the word "approximate" to cover the eventuality of the work being a trifle larger or smaller in its finished state.

2. OBLIGATIONS OF THE ARTIST AND CLIENT:
 a. The (artist) (client) shall designate and purchase materials as necessary for the work.
 b. The (artist) (client) shall provide for the framing and the installation of the work, at the (artist's) (client's) expense, subject to the artist's right to supervise and endorse such work.
 c. The client shall bear the expense of any transportation or living costs incurred by the artist away from his or her domain, long distance phone calls, sales taxes and/or customs duties, insofar as such expenses are reasonably incident to, or entailed by, the artist's creation, delivery, installation of the work, or supervision thereof.
 d. The (artist) (client) shall hire and compensate any additional labour services necessary for the creation and installation of the work.
 e. The (artist) (client) shall secure any building permits necessary for the lawful creation and execution of the work.
 f. The (artist) (client) shall hire and compensate any consulting engineering services necessary to the creation and installation of the work.
 g. The (artist) (client) shall provide for the Worker's Compensation coverage of any employee, or employees, of the artist during the creation of the work.
 h. The (artist) (client) shall obtain (fire, casualty, and personal injury liability) insurance on the work to be in effect until (delivery) (completion of installation).
 i. The client shall bear the rental expense of any new and additional work space necessary for the artist's creation or installation of the work.
 j. It is mutually understood by the artist and the client that the work shall be that of the artist.
4. COMPLETION DATE: The artist shall complete the work by _____.
5. FEE SCHEDULE AND METHOD OF PAYMENT: The client agrees to pay the sum of _____ in total payment for the work.
 It is further agreed to and mutually covenanted that the client agrees to pay the artist fifty (50) percent of the total sum on the signing of this agreement. The remaining fifty (50) percent shall be paid as per the following schedule of payments and proof of performance.
 $_____ (_____) Upon certification by artist, client, and an independent visual art authority of the client's choosing that the work is fifty (50) percent complete.

 This amount is usually 25-35 percent of the total fee.

 $_____ (_____) Upon certification by artist in writing that the work has been executed, and the client has verified same. The client shall have the right to view

the work in progress at the time of fifty (50) percent completion and at other times convenient to the artist. If physical viewing is not possible it shall be the responsibility of the artist to provide adequate and reasonable photo documentation of the work in progress.

6. CANCELLATION AND CANCELLATION FEE: The client may withhold acceptance of or payment for the work should any of the following situations arise or occur:

 A. Prior to the work's completion the client observes or otherwise becomes aware of any fault or defect in the work.

 B. The work does not conform to the stated and agreed to conditions.

 It is understood and mutually agreed to by both artist and client that in the event of either occurrence it is the responsibility of the client to notify the artist immediately of his concerns. It is further understood the client's objection to any feature of the work not specifically indicated by the plan but attributable to the exercise of the artist's aesthetic judgment shall not be a basis for withholding payment for the work. In the event the client (unreasonably) rejects the work at any stage of construction, the artist is entitled to keep whatever monies have been paid. It is further understood that all rights attendant to the work including any preliminary sketches or models shall revert to the artist.

7. Copyright: The artist shall retain copyright to the work unless otherwise negotiated.

 If the artist is vesting copyright with the purchaser it is quite in order to be paid for same over and above the sale of the work itself. I would probably ask something in the neighbourhood of fifteen percent.

8. Delivery: The artist shall adequately prepare the work for delivery on or before _____ to the client. Delivery and physical transfer of the work shall be accomplished (by the artist's notification to the client that the work is ready for pickup) (by the artist causing the work to be sent, insured and shipping charges prepaid to the client).

9. Title of ownership: Title of ownership shall pass from the artist to the client upon the artist receiving the final payment for the work.

10. Death and disability: In the event of incapacitating illness or injury to the artist such as would untimely delay the execution and installation of the work, the artist shall notify the client of such delay and the client's obligation to make further payments shall be suspended until such time as the artist can discharge his contractual responsibilities at which time contractually agreed to schedules of payment shall be deemed to be in effect. In the event of the untimely death of

the artist, it is agreed that this agreement be terminated and the artist's estate shall be entitled to retain any payments already made to the artist and further that the estate be reimbursed for any expenses the client would have been obliged to pay the artist. The client shall be entitled to claim the work and any unused materials acquired for its execution. In the event of an untimely death of the artist, the client may have the work completed by another artist without regard to the original design.

[signatures of the parties involved and a witness]

When a work is sold, the corporation or company that purchased it will often want to use the work in a variety of ways. Most often they will come to the artist with a contract that is written in their favour. It pays to have a contract like the one that follows to present to them as an alternative.

LIMITED EXHIBITION & COPYRIGHT AGREEMENT

This Agreement is made in duplicate on _____ between _____ hereinafter referred to as Artist and _____ hereinafter referred to as Licensee with regard to _____ hereinafter referred to as the work

NOW THEREFORE, in consideration of the premises herein contained, and for other good and valuable consideration, the parties of the first part and the second part do mutually covenant and agree as follows:

WHEREAS the artist is the sole owner of copyright of the work and

WHEREFORE the Licensee has acquired the work and may from time to time be desirous of reproducing the work for a variety of purposes consistent with and pursuant to the normal uses to which such imagery may from time to time be used to enhance and further the interests of the Licensee in the normal course of business.

THEREFORE It is mutually covenanted and agreed to for the purposes of this agreement that:

1. For the purposes of this agreement, reproduction rights refer to either photographic or digitized imaging.

2. The reproduction rights do not extend to any items intended for sale or profit by the Licensee.

3. The reproduction rights granted by the Artist are for the exclusive use of the Licensee, their successors, or assigns and as such are untransferrable.
4. The Licensee shall have the right to reproduce the work in whole as hard copy, photographic copy, or in digitized format for the following purposes:
 -Any and all such business publications as may be deemed desirous
 -Public relations or publicity
 -Fine art inventory, archival, and or insurance records
 -Art collection catalogues
 -Greeting or announcement cards
 -Posters
 -Promotional use on company web site
 -Any other purpose consistent with the above
5. The licensee shall have the right to reproduce the work in whole for the purpose of publicizing the work in connection with the Licensee's Art Collection.
6. The Licensee shall have the right to reproduce the work in location photographs of their premises for promotional or advertising purposes.
7. Should the Artist choose to reproduce the work for whatever reason the Artist shall undertake and endeavor to have the work listed as Collection of _____.
8. The Licensee when reproducing the work shall undertake and endeavor where feasible, possible, and or reasonable to acknowledge the Artist and work by Name and Title.
9. The Artist agrees not to replicate the work.
10. This agreement shall be binding on the Artist, his successors, and assigns, and upon the Licensee, its successors, and assigns.
[signatures of the parties involved and a witness]

AT THE END OF IT ALL

There are certainly other horror stories I could tell. I know of artists who have lost everything because they signed a "bad" contract; often, this means not only financial loss, but also the even more tragic loss of their desire or energy to create art.

Any of us are at risk. Many artists can't read legalese and don't want to. They tend to take "readings" from the way a person shakes

a hand or smiles. We artists are often quite gullible and ready to swallow any fantasy offered. If someone says that they are really going to do something for you, it will usually turn out to be *to* you. I have been in the business a very long time and have yet to run into any goodwill angels.

The bottom line is don't let anyone charm, cajole, or bully you into signing anything. It should be a hard and fast rule for all professionals that they never sign anything of a legal nature prior to having someone in the legal profession read it and render an opinion as to the advisability of signing same. Being a professional and acting professionally means taking responsibility for the "business" side of the business, too.

So there is the deal on contracts of various types. It is probably more than you ever wanted to know about this particular end of the business. When contracts are needed, they are really needed. At other times, they are the farthest thing from the artist's mind, and that is where they should be.

SUMMARY OF TOPICS COVERED IN THIS CHAPTER:

1. Artist–dealer relationships.
2. Various consignment contracts.
3. Commission contract.
4. Rental contract.
5. Limited exhibition and copyright agreement contract.

Notes

When you go out to paint, try to forget what objects
you have before you—a tree, a house, a field, or
whatever. Merely think, "Here is a little square of blue,
here an oblong of pink, here a streak of yellow."
—*Claude Monet, conversation*
with Lilla Cabot Perry

 Notes

You've got to keep the child alive;
you can't create without it.
—*Joni Mitchell*

Notes

The artist need not know very much; best of all
let him work instinctively and paint as naturally
as he breathes or walks.
—*Emil Nolde*

14. As I was saying...

Recapping my advice for painters.

This new chapter is in response to comments and suggestions I received after the first edition was published. Many felt that, although this is not a "how to" book, it might be in order to say a few words on the "how to" of painting from this painter.

ON THE SUBJECT OF SUBJECT

Before launching into the making of an actual work it would probably be wise to say a few words about the thorny problem of subject. I have known artists who have thrown in the towel at this point simply because they couldn't decide what was, and what wasn't, appropriate subject matter. Such behaviour has always been a great curiosity to me. When all is said and done the only real subject matter of any painting is quite simply the paint itself. Whether an artist chooses to pursue landscape, still life, the figure, or whatever else, these are all just vehicles that serve to carry the real subject matter: paint.

The artist Maxwell Bates inadvertently provided some of the best advice on the matter of subject. A fellow painter visiting his studio noted that he was working on a series of still lifes. When he couldn't see the still-life setup, he asked where it was. Max replied, "There isn't any! I know what objects there are in a still life so I certainly don't need them to make a painting. Making a setup of still-life objects would be limiting my options. By using the vocabulary of still-life objects I have in my head, I leave all my options open." Once when I visited Max's studio, I saw that he had about twenty-two two-foot-square masonite panels in the studio. Some were stacked against the wall as finished paintings, one was on the easel, and another was currently being used as a palette. On examining the palette, I noticed that colour seemed to be placed without rhyme or reason on the surface. When I made mention of this observation, Max told me that never using a "formal set palette" allowed him to "climb the stairway of surprise" with colour! He also said that when the palette looked more interesting than the painting, he would set the painting aside and paint on the palette. Apparently he produced some of his best paintings that way. The genius of it is diabolical. I have often said to myself that the palette looked more interesting than the painting. Max is the only artist I have ever met who did something about it. It

Real painters understand with a brush in their hand.
—*Berthe Morisot*

all makes sense when you think about it. If your palette is created on the order of "no order," then you are more than likely putting paint down subconsciously in an order pleasing to the paint, or more often, where there is an open space. Brilliant! Inevitably, colours find themselves next to colours that one wouldn't normally consider appropriate. When one does that they really are "climbing the stairway of surprise." Ever since that day in Max's studio I have followed his lead to good effect. I have not, as of yet, actually made a painting using a palette. I can, however, report that placing colour in random order on the palette has freed me from the tyranny of "systems" and has been of great benefit.

For a painting to reach its full potential, there are three "natures" which must prevail. The nature of the artist, the nature of the subject matter, and finally the nature of the materials themselves—all must be present and accounted for in a work. Currently, I really like the bones, or under-painting, of the work to show through as part of the finished painting. This marks a significant change for me. There have been times when I wanted the finished work to have all marks of the "journey" hidden so that the work seemed to appear from nowhere with no history and zero baggage! Now it is the opposite end of the spectrum that I find attractive. I like to leave a bit of the original charcoal drawing and underlying structure of the work showing through, imitating the way that the human figure is defined by the underlying interior architecture of the skeletal structure. Since it is the nature of paint to drip and seek its own level, I also like to have some dripping paint show in the finished product. I feel it makes the painting a little edgy.

In the end, it is purely a personal preference. Just remember that whatever your preference is, subject matter is simply a point from which to start. Currently my subject is landscape; therefore I deal

with the nature of *nature,* letting the rhythms of organic growth and decay have full play. My interest in Taoist philosophy expresses itself in the minutiae and detritus of the cycle of birth, growth, decay, and rebirth. As I work in the studio, echoes of former images often surface. I let them surface and let them show as they will. My canvases are like me: a little complicated and often dark.

Actual elements of nature are simply abstract items arranged and rearranged on the canvas to give a pleasing effect. I never let reality stand in the way of a good painting. When the great Bow River fishing guide Jim McClellan looked at the triptych *Bright Water* with its fall shoreline of dogwood, cottonwood, and fir trees, he said he didn't know where it was. I said, "Take away a few of the fir trees." He replied, "Ahh—I know exactly where it is." My mission is to make a good, coherent painting that echoes and celebrates the nature of nature rather than acting as a simple record of reality. Like Max with his vocabulary of still-life objects, I carry a vocabulary of landscape that I freely choose from to enhance the image. At all times I remind myself that every element of a landscape is simply an abstract item to be moved to wherever it will serve the needs of the painting in the best possible way. One always has to make the necessary adjustments that will bring order to the chaos of reality. If a lake isn't in the proper

Never let reality get in the way of a good painting

place for a good composition, move the darn thing. If the shoreline is uninteresting, spice it up. Add and take away trees or rocks or whatever else is needed to create the best possible view.

During a recent interview, I was asked to explain what my painting was about. I replied, "My paintings are abstractions cleverly disguised as landscapes. It is the Canadian way." I went on to say that I felt most comfortable riding the razor's edge between abstraction and landscape reportage. Anyting more, and the work becomes mere landscape reportage, whilst anything less results in the shattering of the illusion as an illusion.

GROUND REVISITED

Chapter 5 outlines the basic requirements of a painting—support, ground, vehicle, and pigment. Here I want to go into more detail about ground and its importance.

To begin at the beginning, the white ground is the starting point of all of it. The reasons for a white ground on a canvas prior to painting are threefold. First, painting with oil directly on canvas is a definite "no-no"! Why? Because oil paint and canvas are incompatible. The drying oils used as a vehicle in oil painting "mature" by going through an irreversible process known as rampant oxidation. Once initiated, this process will only stop when there isn't any organic material left for it to work on. Since cotton canvas is organic, it will, of course, rot, become brittle, and fall apart unless there is a firewall, or fixed separation, between canvas and paint. Secondly, whatever it is that is being used as a firewall must be able to adhere well to the canvas on one side, and the paint on the other. Over the years (about five hundred) the artist has come to a sort of uneasy peace with all of this. Traditionally the best ground has been rabbit skin glue and calcium carbonate (chalk) with some white pigment thrown in for good

measure. It was the rabbit skin glue that held the chalk together, ensuring good adhesion with the canvas. Rabbit skin glue became the sticky stuff of choice because it is inherently plastic and will not crack the way other animal skin glues do. All this has changed with the introduction of the family of petroleum distillates. Acrylic plastic now does what rabbit skin glue used to do, and it is, in fact, almost impossible to buy rabbit skin glue today.

As one who has bridged the gap between the old preplastic days and the way it is now, I am astounded, amazed, and alarmed at how much the petroleum distillates industry (acrylics and plastics) has taken over almost everything we do. I am typing this on a plastic keyboard while sitting on a plastic seat, drinking coffee out of a plastic cup that is sitting on a plastic desk. It doesn't get any better going to the studio. The ground I use to separate paint from canvas is a top-quality exterior latex acrylic. After the drawing is made, I will use clear acrylic to "lock" the drawing in. Using a brush with plastic "hair," I can then use pigment with plastic as the vehicle for the under-painting. By the way, while I am doing this I am walking on plastic soles and dressed in plastic clothes. But I digress.

Commercial grounds are sold under a variety of names that usually have the name "gesso" in them somewhere. Formerly, gesso meant a formulation of rabbit skin glue and calcium carbonate. Now it usually means a formulation of acrylic with calcium carbonate.

At the outset I said there were three reasons for putting a white ground on a canvas. The third reason is really interesting and very relevant if you are using oil paint. *Pentimento* is the Italian term for the tendency of paint to become transparent over the years. When there is a white ground, the paint will become more and more brilliant as time goes by and it begins to exhibit pentimento. Now here is one of those interesting observations that always grabs me. The worst an oil

painting will ever look is the day it is done. The best an acrylic painting will ever look is the day it is done. The reason for this is the following. Over the years the yellow of the drying oils in oil paint will suffuse the entire painting with a golden glow. Add to this the ability of light to bounce around a bit inside the painting as pentimento occurs, and the painting gets a little more transparent. With the light literally exploding from within you really have a winning combination. I was startled to see a painting of mine in a historical exhibition forty years after I had last seen it. Some of the colour looked like it was exploding from within. It looked so much better than I remembered it, and, as a matter of fact, it was!

PREPARING THE CANVAS

I noted in chapter 4 the perils of applying an acrylic ground with the canvas on a stretcher. Initially, the plastic tightens as it sets, then sags, and you end up having to restretch the canvas. My solution is to use a painting wall on which I stretch the canvas, size it, and simply accept that I will restretch it when the work is finished. It is a system that has worked well for me for thirty years. Originally, I got the idea from Willem de Kooning. While working on his *Woman* series, de Kooning would stretch a large canvas on the wall and start drawing the figure of the woman anywhere on the canvas. At the end of each day, he would frame with silver paint whatever section of the canvas seemed to contain the essence of the image. It was action painting in the truest sense as the image would "move," relocating itself in different sectors of the canvas. Working this way freed me from the angst of ending up with a picture that was only using part of the surface or, worst of all, not having enough surface. I must admit that I haven't cropped a canvas image for a couple of decades now, preferring to simply work the canvas to the edge. This is not to say that I don't crop

an image. I simply confine my cropping to the initial source material.

With the raw canvas lightly stretched on the painting wall, I apply a couple of coats of top-quality exterior acrylic paint. Remember the cardinal rule of putting oil over acrylic rather than the other way around. If you put acrylic over oil you will be able to easily peel off the acrylic layer of paint as there is no adhesion whatsoever. Let me explain why. Oil paint oxidizes, irreversibly drying and changing forever the chemical composition and nature of the paint. Acrylic, on the other hand, only remains set if a stable state is maintained. This stable state can be altered and reversed by the introduction of any penetrating oil such as Xylol. The introduction of a volatile solvent will return the acrylate to a liquid state. It is this very feature that makes it so ideal as a ground. There is just enough "bite" of the oil in the oil paint to soften and grab the surface, producing a sound and stable surface for the paint to adhere to. With the other side of the plastic hanging to the tooth and fibre of the canvas it makes for a very stable surface on which to paint.

DRAWING THE PLAN

Your next move is crucial to the success of the work. This is the moment when you make the marks of the plan that will eventually be fleshed out to become the final piece. Don't use graphite or felt marker to sketch out the elements of your painting. Both have a tendency to migrate through the layers of paint.

For me there is only one acceptable implement (other than paint) for drawing on the canvas and that is charcoal. It is completely inert, easy to erase, won't bleed through, and has been well proven by generations of artists. It is interesting to note that what I use to draw with in the twenty-first century is exactly the same thing a caveman used to draw on cave walls. What a connection.

The charcoal must be sealed in by over-spraying clear acrylic. This locks the charcoal in while bonding nicely to the white acrylic ground. Since the charcoal is simply sitting on the surface it is best to use a low-tech hand sprayer, which you can pick up in any florists' or garden shop. The advantage of a low-level spray is that it won't disturb the charcoal and destroy the drawing. I mention this because I once used my expensive deVilbiss spray gun and compressor to seal a drawing, but forgot that I had last used the compressor with a nail gun. The pressure was set at 50 lbs, and when I pulled the trigger on the gun, I instantly destroyed 30 percent of my drawing by blowing the charcoal right off the canvas. Ouch! Sometimes low-tech is not only better, it is safer! I find that I have to put about three coats on to completely seal the charcoal in. Jules Olitski's watershed 1968 exhibition of colour rain paintings at Andre Emmerich's Gallery was all done using the cheap spray gun that came with a vacuum cleaner. I asked him about it, and he said he liked the irregularities of the spray. Go figure.

EXECUTING THE PLAN

My own "fear of failure" syndrome means that I work to solve most of the painting's problems in the drawing stage. This leaves me with something akin to a simple "paint-by-numbers" proposition. With the work on "safe ground," as it were, it is now important for me to reintroduce some elements of danger that will throw me off base. I pour, splash, and generally rough block colour areas in the work with veils of turpentine washes, letting them all mingle, drip, and mix as they will. The veils impart a lively colour sense to the charcoal line drawing and take care of the tyranny of the white surface.

For me, the process of painting means repeatedly finding a comfort zone and destroying it. It is necessary for me to continually

challenge myself, just as it is natural for me to seek a comfort zone. I think that it is a necessary part of the creative journey to throw yourself off the cliff every time things get too comfortable. In this game, if the path is too easy, it is probably not worth pursuing.

After the "turpentine wash veils" have had sufficient time to dry, I begin the real painting. Beginning with the background areas, I apply paint using pig bristle brushes. Pig bristle is stiff and has split ends, making it absolutely ideal for transferring stiff oil paint efficiently from the palette to the canvas. My choice of brush is a flat French hair as opposed to a German hair, because its longer style allows me to load more paint on the brush.

Use the brush properly. I am always amazed when I see someone using a typical oil paint brush by gripping it with fingers around the metal ferrule. What are they thinking of! If you simply hold the brush at the end, a simple twitch of the finger will translate (with great accuracy) to an inch-long stroke, while a movement of the finger will make a four-inch stroke, the movement of the wrist, a foot-long stroke, the forearm, a yard, and the full arm, six feet and more. Don't choke your brush, and life will go a lot better. Trust me on this one.

At this point I suppose it would be reasonable to say a few words about the oil paint we buy. When I was young, artist's paint was made for professional artists. Most of the paint that is manufactured today has been made for amateur artists, who comprise a much larger market than fine artists. That is rule number one to remember. The second rule is this: get the notion out of your head that someone has made the paint *for you*. Paint manufacturers have two major concerns: shelf life and low production cost (profits). To see what I mean, buy an expensive and an inexpensive tube of ultramarine blue and mix equal amounts of white with equal amounts of the colour in each of the tubes. I can guarantee that the difference of tone between the

two will surprise you. I was amazed how little pigment (the expensive part) they can actually get away with. The exercise is worth it just to understand why you are paying the extra amount of money for a quality product. It has been my experience that insofar as art products are concerned, what you pay for is directly linked to what you get.

In my studio I have a stock of empty tubes that I acquired from a manufacturer. Sometimes when I am working on a larger work that has a good bit of one colour and I don't like the stiffness of the paint as it comes out of the tube, I will "remanufacture" the paint, working it to the viscosity I like and repackaging it in a new tube.

Don't skimp on paint by buying cheap paint, and don't skimp on paint while you are painting. I have been in artists' studios where the collective tiny little bits of colour on their palettes aren't as much bulk as one colour on mine. If the paint is in the tube, it isn't accessible for painting. My palette has a lot of paint on it and there is always a lot of paint left over at the end of a painting, but it doesn't go to waste. I gather it all together, mix it, and put it in one of my empty tubes. Opening one of my unmarked tubes is definitely climbing the "stairway of surprise." More than once, an artist or collector has asked me, "Where did you get *that* colour?" Usually I reply, "Right out of the tube!"

He who fears to fall will never fly.
—*Ukrainian proverb*

When putting in local colour, it is important to choose the fullest tone and richest chroma that one possibly can; it can always be toned down. It is always easier to lighten something as opposed to strengthening it. I work first on the parts that are most demanding, and I most often work from background to foreground. In addition, I pay early attention to areas that are pivotal to the success of the canvas. Quite often I will lay in some "surprising" colour just to remind me that I should always climb Max Bates's "stairway of surprise." I use a clear glass palette and if I want to pull a work toward a certain colour of light, I will paint a piece of canvas the colour I am after and put it under the glass. Then every colour I mix will be seen instantly in its proper relationship. When I paint nocturnes, I use a special palette of dark glass.

EVALUATION AND CLOSURE

When the painting is finished, I stretch the work on a canvas stretcher. Once that is done I make the final visual adjustments that are inevitably needed when two inches is taken away from each side of the work. With the painting stretched and finished, I sit down to have one more long look at it. The final vetting of the image includes an extended look at the work in a mirror as well as looking at it upside down. This may sound a bit strange, but after you've worked on a painting for an extended period of time, you inevitably have "blind spots." These are parts of the painting that you have made a mental note to fix at some nebulous time in the future. The artist's eye then renders them invisible so that you can continue working on whatever has your immediate attention. Well, that is the way it works for me. The "long look" at the end will usually allow these troublesome parts to resurface so that I may address them, and clear them up if they are still a problem. Sometimes they have ceased to be problems because

of adjustments I have made in other parts of the canvas.

The artist's eye can play funny tricks, so anything the artist can do to have a fresh view of the work is both desirable and necessary. I have been very fortunate over the years in having friends who have good, critical eyes. They can always spot a problem much quicker than I. In the early sixties, when I shared a basement studio with Ron Bloore in a downtown Regina hotel, I made regular use of his critical eye to the benefit of my work. In my university days, my colleague Ric Gomez and I would trade mutual eyes. In Calgary, it has been Peter Thielsen (a dealer), and old friends and colleagues Bill Duma and Steve Kiss. Lest I forget, two of the best eyes over the years have belonged to my wife, Phyllis, who is also an accomplished artist. These people have all played major roles in vetting my work. Some still do. Often they pick out something that I had been meaning to do, and quite simply forgot. At times they bring a totally fresh outlook, or views and attitudes that I hadn't a clue about.

I take one more final look after the work has been put away for a couple of months. If it passes muster at this point, I spray a coat of dammar varnish to unify the surface. I do this because I tend to leave a number of primary, intermediate, and finished levels of paint; these various surfaces reflect light differently, creating something of a mishmash. Spraying a coat of dammar varnish unifies the surfaces so that they all reflect to the same intensity. Dammar varnish is suitable because it is inherently plastic and won't produce any stress on a painting surface that is still in the process of final oxidation.

As with many of the materials we use, acrylate look-alikes are marketed as "dammar" or "damar" varnish. I make my own dammar varnish from the original dammar crystals. All you need is a nylon stocking and some turpentine. Put the crystals in the nylon stocking and suspend it in a glass jar full of turpentine.

Your paintings are waiting to be made, and you are the only person who can make them. The basic rule is, if it works for you, go for it. I encourage you to seek new ways of doing things and to rediscover old ways. When I was young, I was told that I mustn't use a slide projector as an aid—it just wasn't done! Now the English artist David Hockney has just written a scholarly treatise revealing that, as far back as the 1400s, artists have been using all sorts of optical aids to assist in the drawing of form. I now use a projector when to do so is useful, and use my eye and hand when it is useful to use my eye and hand. At any rate, I think the war is over. My suggestion is to get out of the trenches and get on with your life, using whatever works well for you.

THE INSPIRATION OF TOM THOMSON

When I came across a couple of late-1915, 8.5" x 10.5" Tom Thomson sketches, I was so impressed that I took digital photographs of them.[†] Full-size digital prints of them now hang on my studio wall as constant reminders to push the edge and not be satisfied with less-than-dangerous, "convenient" solutions. Every time I look at these works, I remind myself that they were painted three-quarters of a century ago by a Canadian artist living in the isolation of the north woods in a sparsely settled country less than a hundred years old with little or no artistic tradition. I am impressed by the sheer brilliance and economy of means in these two works. The brush gestures express the joy of life. The yellow greenery of a tree becomes more tree than tree. In one, the sky is a blue staccato intrusion; in the other, a soft muted sienna. In one, the birch tree trunks are simple, direct, uncompromising, and sure; the other has but a tracery of branches. Both works

† See these reproduced in the colour insert.

are combinations of brilliantly audacious moves.

I wonder if Thomson knew how good these paintings were when he painted them. Odds are that he didn't! He probably knew that something was happening, but wasn't sure what. Lucky for us, he had the good sense to keep the work. The profound message of these two little works is that it doesn't matter where you live so long as you keep the faith, and remember to be dangerous in your execution, taking chances and riding the razor's edge.

THE PROCESS ILLUSTRATED

Reproductions of four of my paintings from a recent exhibition at the Wallace Gallery in Calgary are included in the colour insert between pages 240 and 241. Each reproduction is accompanied by the original slide that provided the inspiration or starting point. I have superimposed a frame to pinpoint how the image was originally cropped. While the overlay of the source image is reasonably accurate, I must note that I frequently excise parts that are uninteresting and expand areas that seem too crowded or close. For one of the works I have shown a progressive record of the painting process.

In *Eventide*, one can clearly see the various ways in which I have made the painting more satisfying. I chose the actual dam as the centre of interest and accentuated the dark of the water by cutting off the background to a narrow band across the top. I thinned out the foreground foliage on the left and added some complementary foliage on the lower right. The foliage on the left as well as "stuff" on the right in tandem with the burnt orange bush in the background form an implied triangular shape which echoes the initial inverted pyramid set up by the dam itself. The rock outgrowth I added in the foreground echoes the pyramid theme as well. Adding the two major logs at each end of the dam gives pictorial emphasis to the "implied visual

pyramid." In addition they give the feel of "fingers" holding up a necklace which might be the actual beaver dam, and the individual hits of red maple leafs in the dam itself read like jewels set in the necklace. It is a feature of my work that there are often hidden pictorial elements with implicit double *entendres*. In the original slide, the whole foreground was hopeless mush with no sense of order at all. I have pretty well discarded it completely. Finally, the rock in the immediate foreground gives the whole work a nice foundation.

While the flavour of the source is maintained, I have taken a number of liberties that enhance and make clearer the true reality. In the best sense, the painting should always look more real than the source material. And if not more real, then at least more satisfying.

The second work is entitled *The Water's Edge*. I chose the title to emphasize the obvious split between what is above and what is below the water's edge. Above is the allusion, the hint, of the colourburst of fall. Below the water's edge, all pretence at reflecting reality is given over to abstract form. It was as scary to paint as it was satisfying! Every once in a while, one just has to throw caution to the winds and simply jump off the cliff. You might as well know right now that it doesn't get any easier, or any better, with advancing years. Operating on "automatic pilot" is something every creative artist must learn to live with, to love, as well as to do! I remember watching the great jazz saxophonist P. J. Perry bring down the house with a solo on the Cole Porter tune "I Love You." When he sat down afterward, it was clear from the way he was looking around that he was completely disoriented. He had been so immersed in, and taken with, the music that he simply didn't know where he was for a moment. He is a good friend and we talked about it afterwards. For my part, I really enjoyed sharing the moment of his "re-entry." It definitely echoed the sort of thing I go through in the studio.

You will easily see the other places where I have taken "liberties" with the source material in *The Water's Edge:* the shoreline, the rock outcropping, adding the rock behind the birch on the left, and allowing the central yellow foliage to float. It took hanging the finished painting on the wall for two days to see that I needed the vertical grey tree on the right to stabilize the composition. Try visually removing it, and you will quickly see how the eye just drifts out the right side of the work.

In *The Dance of the Old Ones,* the problem was almost the opposite. Here there is an interesting shoreline and attendant water reflections. Looking at the slide, I was struck by how much the shoreline stuff looked like thin, old people doing some sort of dance. Once I have decided on a theme for a painting, I try to add visual echoes that will reinforce the theme. Thus it is with the outcropping behind that I have expanded on the theme of old age with the form descending in waves from left to right. Like a murmured memory, the rhythm is echoed by the semi-rising logs on the right. It is often a good idea to have a few verticals and a few horizontals in a work. They establish a relationship with the edge. Every painting is like a window to a strange new world. The established relationship with its environment is the horizontal and vertical axis of the frame. Putting in some verticals and horizontals is a sure-fire way of establishing a sense of stability and a relationship within the canvas.

Finally, I have included *Afternoon Riffle* with photo documentation of various stages in the creative process. After stretching the raw canvas loosely on poplar plywood and sizing it with exterior acrylic, I sketched the composition in charcoal and sealed it with successive over-sprays of clear acrylic. The next part of the process was to apply some very loose washes, letting them drip and run. With the image clouded, occluded, and in real doubt, I started the process of finding

order again by establishing some strong focal points, such as the shoreline rock formation, the bright foliage, and eventually the birch tree trunks. I made this painting immediately after I made *The Dance of the Old Ones,* and the trunks in water on the left are clearly a carried-over "memory" of the earlier painting.

Remember that some rules are meant *not* to be broken and others are. One of the great puzzles of life is working out which is which. For the last word on the subject I will give you a little hint. I became known as one of Canada's great colourists because I deliberately used colour schemes that were outside what was acceptable. If a work began to fall into an acceptable colour scheme, I would consciously throw in some colour that would "wrench" it out of complacency.

SUMMARY OF TOPICS COVERED IN THIS CHAPTER:

1. Some thoughts about subject.
2. The process of creating a painting: preparing the canvas, drawing the plan, and applying the paint.
3. More about paint.
4. A description of the processes involved in creating four specific paintings.

AUTUMN LANDSCAPE, 1915, OIL ON PANEL, 8.5" X 10.5", TOM THOMSON
 (PRIVATE COLLECTION)
AUTUMN ALGONQUIN PARK, 1915, OIL ON PANEL, 8.5" X 10.5", TOM THOMSON
 (PRIVATE COLLECTION)

BACK (ABOVE) AND FRONT (BELOW) OF *CAMERON CREEK* AFTER ITS
ENCOUNTER WITH A FORKLIFT AND BEFORE REPAIR

CAMERON CREEK RESTORATION

PHOTO AND CROPPING FOR *EVENTIDE*

EVENTIDE — KENAUK, 2001, OIL ON CANVAS, 48" X 64", 122CM X 162CM

PHOTO AND CROPPING FOR *THE WATER'S EDGE*

THE WATER'S EDGE, 2001, OIL ON CANVAS, 49.5" X 64", 126 CM X 162.5 CM

ABOVE: PHOTO AND CROPPING FOR *AFTERNOON RIFFLE*

FACING PAGE: THE PAINTING IN PROGRESS

BELOW: *AFTERNOON RIFFLE*, 2002, OIL ON CANVAS, 48" X 64", 122CM X 162.5CM

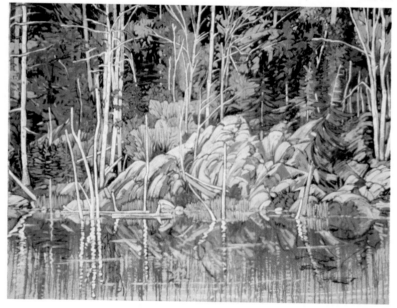

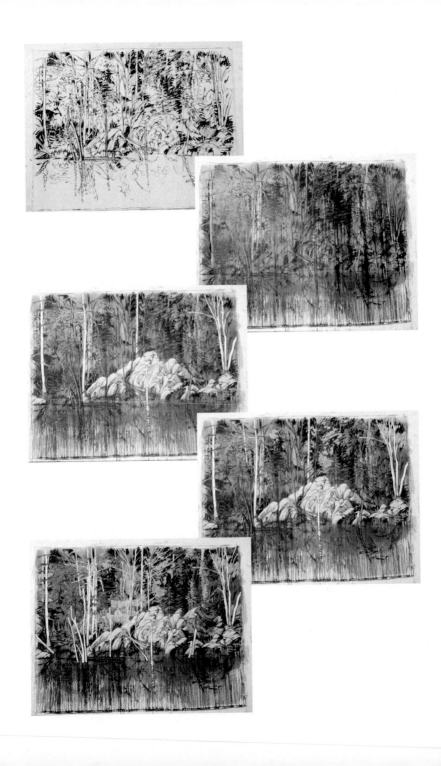

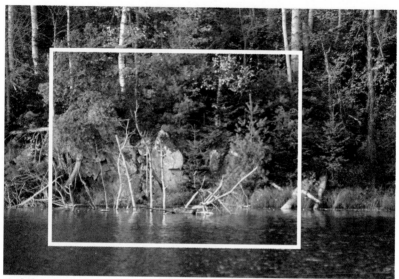

PHOTO AND CROPPING FOR *DANCE OF THE OLD ONES*

DANCE OF THE OLD ONES, 2001, OIL ON CANVAS, 48" X 64", 122CM X 162.5CM

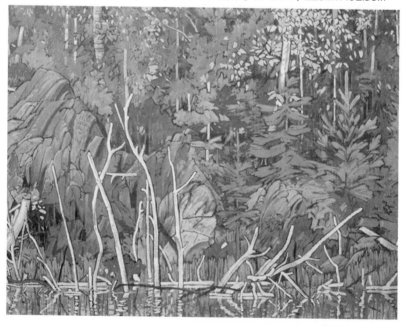

Notes

Though we travel the world over to find the
beautiful, we must carry it with us or find it not.
—*Ralph Waldo Emerson*

Notes

I once told Buck Kerr that painting was difficult because I had to re-invent the process each time I began a new work. His wistful reply: "You're lucky, Godwin. Each time I begin, I think I've remembered."

15. Epilogue

Th-th-that's all, f-f-f-folks!

There is a Chinese curse that says "May you live in interesting times." Mine certainly have been. When I began, being a professional artist wasn't an option unless you were independently wealthy or had someone who would "take care of you." I was told I would never make a living at it and that the art world is full of weirdos, misfits, and oddballs. (As I remarked at the time, "So what's your point?") In fact, I have made a very good living at it. There was a time in the 1970s when I was invited to parties as the token artist. Today there are those who say art is no longer an issue or option. They tell me it is no longer relevant in the age of cyberspace, the world wide web, and all those other recent late-twentieth-century intrusions.

When I began, I was told that I should become a sign painter. Acquaintances, fellow artists, and instructors who were "in the know" said that there would always be a big demand for that sort of thing. Well "that sort of thing" no longer exists. Computers do it all. Someone in a three-piece suit who has no art training sits at a

computer, types out a word, and punches a button. A machine twenty feet away spits out the word in whatever style, size, and colour required! There is no style, class, or elegance associated with the activity but nobody seems to mind. Computers also take care of the illustrating as well. The top illustrators who we longed to emulate and replace such as Bob Peake and Jon Whitcombe no longer exist, nor does the profession. As for sign painters, the gentleman who had the cubicle next to our studio in the basement of the Wascana Hotel in Regina many years ago was one of the last great gold leaf men. I count it a treasure to have known and travelled a bit with him. His kind are no more. What a shame that is.

The art business is strange, curious, and very fluid. For the artist there are limited options, and of those, only two are viable. Move, flow, and tumble with the times or find a niche you are comfortable being an historical anachronism in. What a fall from grace. At one time in history, we artists were the cutting edge of technology. We were the computers with the answers. So-called "scientists" sat at our feet to discover the great mysteries. Now we are the caretakers and custodians of outdated, outmoded, cast-off technologies left on the

How is it that, in the so-called barbarian ages,
art was understood, whereas in our age of progress
exactly the opposite is true?
—*August Renoir*

trash heap of progress. We drift and dream with the leavings of various futures in a comfort zone parallel and contiguous to the mainstream. Painting held its position of importance because cameras didn't exist. Prints such as etching, and later, lithography, were the cutting edge of communication technology in their day. As all these forms of communication were thrown on the scrap heap of progress, the artist kept going over to the scrap heap and picking up a little bit of this and a bit of that, breathing new life into many of the forms.

There are many who say that our whole craft is obsolete and that we who practice it are anachronisms. In truth, many of the new technologies do raise serious questions. With the digital and digitizing technology currently available, I am convinced that it is only a matter of years before we see Billie Holiday, Frank Sinatra, a young Rosemary Clooney, and Nat King Cole in the "movie" they never made, singing separately and together. With the marriage of internet and television and using digital technology, we will be able to access and call up digital facsimiles of great works of art from the world's greatest museums in our living rooms. Living rooms will probably be digitally enhanced nature environments. As we use up our environment outside, we will want to recapture for our interior environment the memory of what used to be. There was a suppressed patent in the late 1950s of a paint that could be electrified, lighting up the entire wall. It was composed of positive and negative particles; by simply imbedding a couple of copper wires attached to a variac and plugging into a socket, one had the option of dialing the level of brightness desired. It doesn't take a rocket scientist to imagine that this technology, in tandem with a computer program, could provide one's living room with pictures of a verdant forest, complete with deer, babbling brook, and bouncing bunny rabbits. Where do you hang a painting on that wall? Today, the experience of interacting with a painting in a

gallery must compete with a virtual reality mask that completely envelopes one's entire being. With all the new designer drugs coming on stream, it seems a little redundant to go to a local art gallery to expand your consciousness.

And yet...and yet...I still prefer the singing silent song of a fifteenth-century icon in an art gallery. At each new meeting, I marvel again at the visual conventions and the masterful way in which the artist has confronted the subject. It is a connection across time that I cherish. With each visit to New York, I make my obligatory visit to the Monet waterlily room in the Museum of Modern Art. Each viewing is a spiritual renewal, a rich visual experience that never seems to dim. I can also go into a gallery and totally get cranked by the work of an emerging artist who has just tapped into the mother lode. Just when I think it's all over, some artist comes along with a new take that blows my socks off, and once again I say, "The king is dead—long live the King." May it always be so.

The primary thrust of the artist must always be directed to a greater understanding of self-worth on the road less travelled. Education will give you the tools and expertise to explore your relationship to life, but that is all. Don't expect people who are still

I can't die. I haven't made my best painting.
—*Edvard Munch, uttered on his deathbed at the age of 80*

searching for the answers themselves to provide your answer to the conundrum.

There are works of art within you that only you can create. It is your mission to find them. Rather than wasting your time trying to imitate, rather than following something that is already past its prime, as a serious professional, you would be much better served by simply immersing your being in contemporaneous culture. Be a sponge and let it all sink in. I can assure you that your head will know what to do with it.

If you have a good knowledge of your craft and practice it diligently, if you have a reasonable amount of intelligence and keep your mind open to what is happening all around you, there is a good chance that you will be able to make a sound contribution to the human dialogue that can withstand the test of time. Perhaps your work will be among those chosen to hang in museums making spiritual connections with people unborn, just as the Monet does for many of us now. On the other hand, maybe your works will be discarded and destroyed. Either way it is none of your concern. The great truth that all artists come to understand is that the journey is treasure enough.

I hope you have found something of worth in the shared journey of the preceding pages and I wish you well on your quest. The profession and way of life you have chosen is noble, solitary and, for the most part, immensely rewarding. For me it has been an inordinately rich journey of discovery that is ongoing. While you will need much courage, strength, and conviction to stay the course, if you seek it, you will find it. As for this little book, take what you find of use, and leave the rest.

APPENDIX

This story was originally published in the *Globe and Mail* on January 6, 1998, page A6. Reprinted with permission from the *Globe and Mail*.

Art Dealer sought on fraud charge
Can't be extradited from Caribbean island despite complaints of unpaid Toronto debts

TORONTO — Two prominent Toronto art dealers have been charged with theft and fraud from Canadian artists allegedly involving art and revenue worth an estimated $200,000.

Toronto police issued a warrant yesterday for Frank Costin, 40, currently living on the Caribbean island of Anguilla. His partner, John Klintworth, 39, was arrested in Toronto Saturday after a year-long investigation by police, then released on his own recognizance.

Both have been charged with 14 counts of theft and fraud related to an estimated $206,000 worth of missing sales proceeds and unsold works given them on consignment when they were joint owners of the Costin & Klintworth Gallery, a leading showplace of Canadian contemporary art until its 1996 closing.

If convicted, Mr. Costin and Mr. Klintworth could serve prison terms of up to 10 years each. However, Canadian law-enforcement officials say it may be difficult to return Mr. Costin to Canada now that he is living in Anguilla, which does not have an extradition treaty with Canada.

Although many Canadian artists have complained for years about the largely unregulated business practices of their dealers, this is believed to be the first time that fraud and theft charges have been laid. The charges stem from a formal complaint made by five artists

represented by Mr. Costin and Mr. Klintworth, who established their gallery in 1987. It is alleged that at the time of the gallery's demise, some artists were left without payment for work sold between 1990 and 1996, and some of their work went missing.

Wynona Mulcaster, 82, a Saskatchewanian now living in San Miguel de Allende, Mexico, says she was one of the affected artists. She alleges she is owed $27,000 on sales of her drawings and paintings, after the 40 percent commission taken by Costin & Klintworth. "This is the second time a Canadian gallery has folded and not paid me what it should have," Ms. Mulcaster said. "I'm interested in painting, in art, and in good will. I'm not interested in muck-raking. I just hope these young men find a way to pay their debts and not go to court."

But police say it is too late, now that charges have been laid. The investigation into the artists' complaints was conducted by Detectives Mike Stowell and Fiona Greenaway of the Toronto police. Four other artists besides Ms. Mulcaster filed a collective complaint with Toronto police late in 1996. They are: David Alexander, 50, of Saskatoon, who said he is owed $19,000 for missing art with a gross value of $38,000 (Costin & Klintworth received a 50-percent commission for sales of his paintings and drawings); Michael Davey, 48, a Toronto sculptor, who says he is owed $4,000; David Wright, a 49-year-old Toronto painter, who says he is owed $3,000 for works sold; and Alex Cameron, 50, of Toronto, who says he is owed $5,000 for missing work with a gross value of $10,000.

Two other artists — John Brown and K. M. (Kate) Graham — named in the claim filed by the five — allege they are owed, respectively, $10,000 and $20,000 by the dealers. However, they are not signatories to the complaint seeking redress.

The Costin & Klintworth Gallery was a member of the

Professional Art Dealers Association of Canada, a trade organization with a published code of ethics. At one time Mr. Costin was a member of PADAC's board of directors, but he was dismissed from the board in 1994 for alleged irregular business dealings. A spokesperson for PADAC said the organization is "not legally empowered to enforce" its standards.

"The options that we have are to expel a member or offer mediation. We are a trade organization, not a policing association," PADAC president Fela Grunwald said yesterday.

Some of the missing art work has been turning up in different collections in Toronto. One of David Alexander's missing paintings, Softer Walls (1992), for instance, is now at the University of Toronto's Hart House. Ron Kaplansky, a Toronto graphic designer and art collector, said he purchased the work almost six years ago from Costin & Klintworth and recently donated it to the university. However, Mr. Alexander says he was never paid for the painting.

Mr. Costin and Mr. Klintworth say they do not know the whereabouts of the missing works. "I wouldn't know about that," Mr. Klintworth said last spring. "I wasn't directly involved in the end there."

Interviewed on Anguilla last March, Mr. Costin said: "I am not currently in possession of any of their art."

After leaving Toronto, Mr. Costin opened a new gallery in November of 1996 with a new roster of artists in Anguilla, a British dependent territory of 8,000 and an offshore tax haven for many Canadians. The Savannah Gallery represents Caribbean works, not Canadian, Mr. Costin said.

When visited by The Globe in Anguilla, Mr. Costin avoided most questions about his former gallery, saying he needed to get "the correct response" from his lawyer, who works for the Toronto law firm

McCarthy Tétrault. Mr. Costin's brother Abraham (Bram), an avid art collector, is a specialist there in commercial real-estate law.

Mr. Costin described his new Caribbean life as "idyllic." He rents part of an imposing white palazzo with views of the Caribbean and nearby St. Barths. He also owns a white Mitsubishi, registered in his name, and on days off often heads for Savannah Bay, where he is a regular at the Palm Grove Bar and Grill.

The Savannah Gallery is housed in a 112-year-old historical building in a commercial and residential area known as The Valley. The former computer store, which Mr. Costin rents, is now an airy space with shuttered windows painted in pastels.

The gallery caters mostly to the white tourist trade. The work, most of it produced by white expatriate artists from Canada and the U.S. living in Anguilla, as well as artists from Haiti, Dominica and Jamaica, sells in U.S. dollars, with prices ranging from $30 for hand-woven baskets to about $5,000 for oil paintings.

Artists now represented by Mr. Costin said that they do not have written contracts with him, but that he has paid them for works sold. "He sends me my share and he also includes an invoice with the name of the print and, if it has a number, a number, and the date of purchase," said Jo-Anne Hill Saunders, subject of a one-woman show last March. "We both have computers and they know that I keep my own records."

If Mr. Costin appears to have prospered since closing his Toronto gallery, the same can't be said of Mr. Klintworth, who is HIV-positive. He has also been on social assistance since at least February, 1996 — four months before the gallery closed its doors. He received general welfare payments through the end of July, 1996, while working at the time as an art consultant for the Toronto law firm Osler, Hoskin, Harcourt.

Mr. Klintworth and Mr. Costin first met in the 1970s when both worked for the late Toronto art dealer Jack Pollock. When Mr. Costin closed their gallery, he changed the locks without Mr. Klintworth's knowledge. Mr. Costin said he had to shut out his partner after an economic downturn that made the gallery untenable, and a decline in Mr. Klintworth's health.

Mr. Costin and Mr. Klintworth will now only likely see each other again in court. But it may take a long time: Even with a warrant for Mr. Costin's arrest, Canadian or Anguillan police cannot physically remove him from the Caribbean to face charges in Toronto.

Last spring, framed against a blue Caribbean sky, Mr. Costin said: "Every day I thank God for giving me a chance to start over again."